Stories in Light

A Guide to the Stained Glass
of the Basilica at the
UNIVERSITY OF NOTRE DAME

Nancy Cavadini
and
Cecilia Davis Cunningham

University of Notre Dame Press

Notre Dame, Indiana

Published by the University of Notre Dame Press
Notre Dame, Indiana 46556
undpress.nd.edu

Printed in Canada by Friesens Corporation

Library of Congress Cataloging-in-Publication Data

Names: Cavadini, Nancy, 1955– author. | Cunningham, Cecilia Davis, 1945–
 author.
Title: Stories in light : a guide to the stained glass of the basilica at
 the University of Notre Dame / Nancy Cavadini and Cecilia Davis
 Cunningham.
Description: Notre Dame, Indiana : University of Notre Dame Press, [2020] |
 Includes bibliographical references and index.
Identifiers: LCCN 2019054884 (print) | LCCN 2019054885 (ebook) | ISBN
 9780268107420 (paperback) | ISBN 9780268107444 (adobe pdf)
Subjects: LCSH: Sacred Heart Church (Notre Dame, Ind.) | Stained glass
 windows—Indiana—Notre Dame. | Stained glass windows—France—Le Mans.
Classification: LCC LD4115.S23 C38 2020 (print) | LCC LD4115.S23 (ebook)
 | DDC 378.772/89—dc23
LC record available at https://lccn.loc.gov/2019054884
LC ebook record available at https://lccn.loc.gov/2019054885

∞ *This paper meets the requirements of ANSI/NISO Z39.48-1992*
(Permanence of Paper).

Stories in Light

For John, with thanks

For my husband, Lawrence, who loves to study the saints
as much as I do

CONTENTS

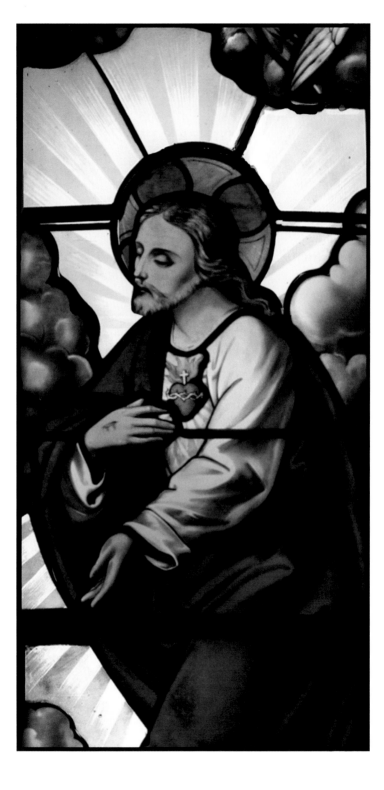

PREFACE

Every year more than 100,000 people visit the Basilica of the Sacred Heart at the University of Notre Dame in Notre Dame, Indiana. They all have questions, especially about the stained glass windows, made in the late nineteenth century by the Carmel du Mans Glassworks of Le Mans, France. This book, written by an art historian and a theologian, is a response to their questions.

Stained glass has been described as the quintessential religious art. It is also a very French art. The basilica's stained glass windows, made in France 150 years ago, are a great treasure and illuminate the nineteenth-century French Catholic faith of the Congregation of Holy Cross, who founded the University of Notre Dame.

The authors would like to thank those whose assistance was indispensable for this work: Fr. Peter Rocca, CSC, rector of the Basilica of the Sacred Heart, for his support of the project from beginning to end and for his helpful suggestions on particular points; John Zack, university sacristan; Fr. Chris Kuhn, CSC, archivist, and Deborah Buzzard of the Congregation of Holy Cross United States Province Archive at Notre Dame, Indiana; the University of Notre Dame Archives; the generous members of the Institute for Church Life–Center for Social Concerns Advisory Council, especially Gayle Richardson for coordination of their support; Stephen Wrinn, director of the University of Notre Dame Press; Matt Dowd, our editor; and Wendy McMillen, the production and design manager at the press.

THE BASILICA OF THE SACRED HEART

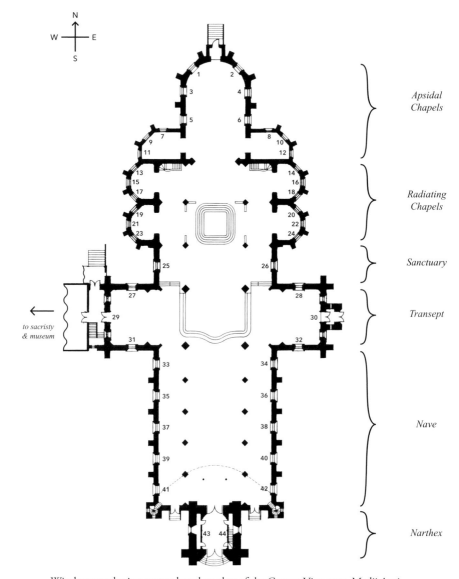

Window numbering system based on that of the Corpus Vitrearum Medii Aevi.

USING THIS GUIDEBOOK

The size of this book is intended to encourage its reading, whether it is placed nearby and read at your own pace or carried with you as you tour the basilica.

A floorplan, found on the facing page, assigns each window a number. As you read, the numbers given at each window's photo provide a way to locate the window in the basilica. These numbers follow the Corpus Vitrearum Medii Aevi: the numbers are assigned beginning in the "front" of a church, with the windows behind the altar, and, alternating each side, finish at the "back" of the church, with the entrance to the nave.

The first chapter of the book briefly recounts the history of the windows. Their fascinating story, interesting in itself, will enrich readers' understanding of the basilica's windows.

The stained glass windows are found in the remaining six chapters that group the windows as they were originally conceived, themed by their location in the basilica. The narthex, nave, transept, and sanctuary chapters contain French Gothic Revival windows, each window containing four scenes. The radiating and apsidal chapel chapters contain windows, each with two scenes, influenced by sixteenth-century Renaissance paintings.

Each chapter provides photos of every scene found in its windows as well as text that tells each scene's story. The windows present complex saints, historical events, and religious beliefs in beautiful, vibrant scenes. The text that accompanies each scene describes what is seen in the stained glass and provides an informed commentary on the windows' significance.

The title of each window is italicized in the text and a photograph of each is placed nearby the text. Italics are also used for the Latin words found in the windows; a translation is always provided following the Latin.

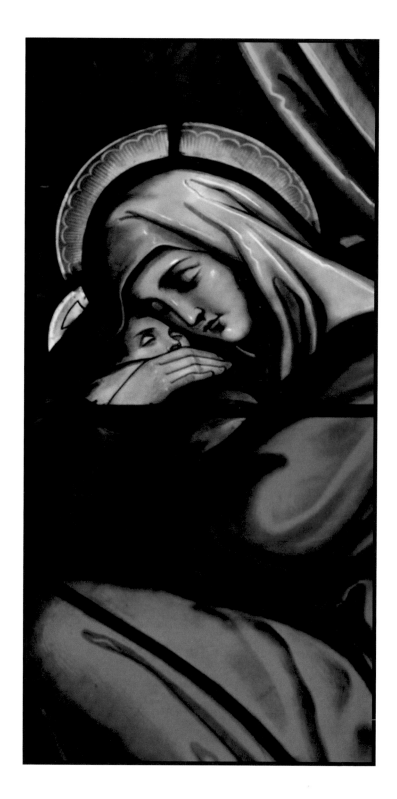

Introduction

The Basilica of the Sacred Heart at the University of Notre Dame holds one of the largest collections of nineteenth-century French stained glass outside of France. The windows, made between 1873 and 1884, are the work of the Carmel du Mans Glassworks of Le Mans, France. The surprising story of how the windows came to be at Notre Dame begins with the creation of stained glass windows by priests and brothers in the early years of the Congregation of Holy Cross, and the daring and unprecedented foundation of a stained-glass business by the strictly cloistered Carmelite nuns who were their neighbors.

THE HOLY CROSS GLASSWORKS

In the two years after Fr. Edward Sorin (1814–1893) joined the newly formed Congregation of Holy Cross in Le Mans in 1839, but before he departed Le Mans for Indiana in 1841 to found the University of Notre Dame, he served as a fill-in chaplain for the Le Mans Carmelites. He would walk down rue de Notre-Dame from the Congregation's house in the Le Mans suburb of Saint-Croix to the Carmelite monastery around the corner on rue de la Mariette. A real and deep affection existed between these two neighboring communities, formalized in a "union of prayer."[1] This friendship followed the members of Holy Cross to Indiana and was then nourished by an exchange of letters and by the many visits of Fr. Sorin on his return trips to Europe.[2]

In 1842, seven months after Fr. Sorin left for Indiana, the penniless Congregation of Holy Cross began to build their church in Le Mans. Made by the priests and brothers with their own hands, Notre-Dame-de-Sainte-Croix took fifteen "long and punishing" years to build.[3] Too poor to purchase stained glass, they hired a Le Mans window glazier named Drouet to close their window bays with white

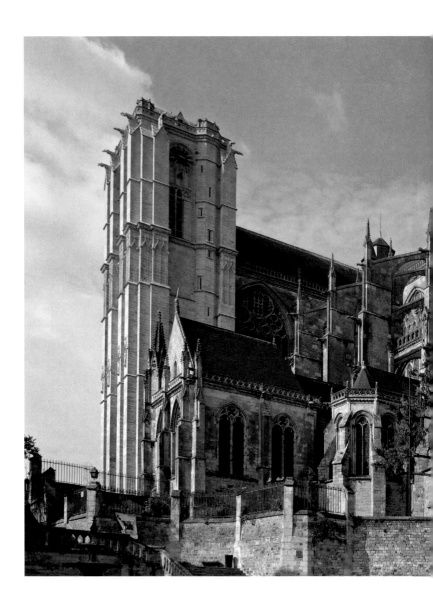

glass. When Drouet suggested the creation and installation of stained glass, to be executed by him, Holy Cross agreed to pay him eighteen francs for each square meter of completed glass.[4]

So began the Holy Cross Glassworks, "one of the most exceptional and most radical adventures in the art of stained glass in the nineteenth century."[5] The Congregation built the special furnace needed for the creation of stained glass, and Fr. Moreau, the founder of the Congregation, blessed it. To Drouet's surprise, his workers were not paid laborers

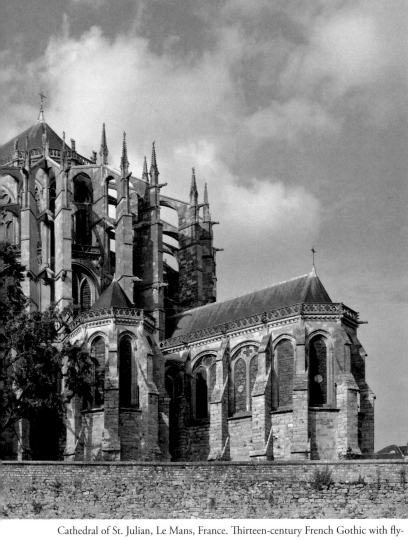

Cathedral of St. Julian, Le Mans, France. Thirteen-century French Gothic with fly-ing buttresses, radiating chapels, pointed arches, and lancet windows of stained glass. Source: Wikimedia Commons.

but members of the Congregation who had no experience in the cre-ation of stained glass.[6] Fr. Philibert, the Holy Cross treasurer, became the glassworks director and managed the purchase of the most expen-sive material: the colored glass they would paint and fire.

As the priests and brothers became more skilled in the technical details of the work, the assistance of Drouet, the only professional in

The First and Second Charities of St. Martin of Tours, Holy Cross Glassworks, 1840. Church of St. Martin in Laigné-en-Belin, France. Source: Gilbert Couturier, "Quatre verrières d'exception," *De tous les coins de la Région*, January 2008, 5.

their workshop, seemed costly and unnecessary. He was let go. To reduce their expenses further, they also decided that instead of paying the high price for manufactured colored glass, they would make their own. With the help of a chemist, they even succeeded in making red glass, the most difficult to produce.[7] The Holy Cross Glassworks existed from 1845 to 1852, and made nineteen stained glass windows.[8]

THE CARMEL DU MANS GLASSWORKS

In 1851, the Carmelites down the street from Holy Cross, also penniless, took out a large loan of 21,678 francs and began to build a chapel. Even with their loan, they could not afford stained glass windows. En-

couraged to make their own windows by Fr. Jean-François Lottin (1793–1868), a friend of both Holy Cross and the Carmelites, they decided to follow the example of the Congregation of Holy Cross. They asked permission to use the Holy Cross tools, supplies, and glass furnace. Fr. Moreau gave permission "on the condition that the said furnace is maintained and kept in good repair."[9]

It is not known exactly how the Carmelites were able to make their windows. They lived a life of strict enclosure, separated from the world. They did not leave their monastery or have regular contact with the outside world. When they did have visitors, they used an internal parlor separated from the external parlor by a grill and a curtain. The Carmelite's eight windows, which featured the history of the Carmelites, were executed "with more skill than anyone had hoped" and were "the most successful attempt [at stained glass window making] that has been made in a long time."[10] Their windows revealed a greater artistic sensibility than those of the priests and brothers of Holy Cross.[11]

Fr. Lottin, who taught at Le Mans seminary and also served as the bishop's secretary, encouraged the Carmelites to establish a glassworks. The nineteenth-century Gothic Revival in architecture and art had brought an immense demand for stained glass windows. In 1835, there were only three glassworks in France; twenty years later, in 1855, there were more than one hundred.[12] The great cathedral of St. Julian in Le Mans, containing stained glass older than the cathedral at Chartres, made Le Mans a center for the restoration and production of stained glass.[13] The Carmelites could pay off their crippling debt and, at the same time, promote the revival of the Catholic faith in post-Revolutionary France. The windows of the Carmelite glassworks, unlike those of the many other glassworks, would be made with hands that prayed. The bishop consented to their unusual project, provided they maintained their rules of strict enclosure.

Creating a glassworks that would guarantee their enclosure in the monastery while providing a tandem workshop outside their walls was therefore necessary. The Carmelite records state that "one night, a woman of the people who refused to give her name came to the [external] parlour" and spoke to the Mother Prioress through the curtained grill.[14] It was, the Carmelites later said, the first indication of the providence of God in their venture. The woman and her husband had worked at a local glassworks. The owner had died, and she and her hus-

band were without work. Her husband, she said, could build them a workshop. Madame Meunier and her husband were hired that night.[15]

The Carmelites carefully orchestrated a business that employed artists and skilled laborers. A special parlor with a large wooden drawer that opened into an external area allowed the sisters to have the necessary relations with the outside workers.[16] The glassworks was ultimately the responsibility of the Mother Prioress, but the everyday concerns were assigned to two sisters: in the original group, Mother Euphémie took care of the administrative and commercial tasks, and Mother Marie du Sacré Coeur handled the material operations. In all, only a few names are known of the Carmelites who were involved in the painting and preparation of the glass: Louise de Jésus, Alphonsine, Hélène de Jésus, Soeur du Coeur de Marie, and Marie du Sacré Coeur. A Carmelite circular letter describes work in 1856: "The older sisters remember seeing Sister Alphonsine arrive, at the hour of the recreation, carrying a little table with glass to cut or to scrape."[17]

The tasks of the external workshop included making preparatory drawings, selecting glass, creating paints and enamels, and firing the glass in the furnace, as well as the assembly, transportation, and installation of the windows. At one point as many as fifty laborers external to the monastery were required, and workers carrying stained glass between the buildings were a regular sight on the rue de Notre-Dame.

Fr. Lottin brought them contracts from French churches in need of stained glass windows and assisted them with sound iconographic programs. He also solicited an acclaimed Le Mans citizen, Eugène Hucher (1814–1889), to be their art director. Hucher, a scholar of stained glass, was well known for the design and restoration of windows and had long desired to be associated with a glassworks. He was interested in the recovery of the glory of French culture and would eventually become the prefect of the Le Mans museum. In exchange for his service as art director, the Carmelites provided a service to Hucher. They applied color to prints of the stained glass windows of Le Mans Cathedral of St. Julien for his publication *Calques des vitraux peints de la Cathédrale du Mans*, released in folios between 1854 and 1864, which helped make him an international scholar.[18] The one hundred prints found in the folios were each hand painted by the Carmelites.

In order to create theologically correct drawings for their windows, the Carmelites turned to the leading Catholic artists in Europe,

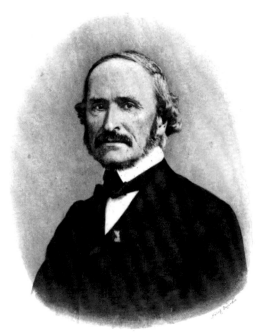

Eugène Hucher. Heliogravure by Paul Dujardin. Source: Robert Triger, *Notice sur la vie et les travaux de M. Eugène Hucher,* Mamers: G. Fleury and A. Dangin, 1890.

those of the Nazarene school, founded in Rome in the early years of the nineteenth century.[19] The Nazarenes believed that "it was art's primary purpose to visualize the essential truths of the Christian faith and to bring them closer to the devout."[20] The artist Johann Overbeck (1789–1869), "a great authority throughout Catholic Europe" and a leader of the Nazarene school living in Rome took an interest in the Carmel du Mans Glassworks.[21] Since he was by then elderly, he gave much of the Carmelite work to his pupil Franz von Rohden (1817–1903). Von Rohden, with a few other artists, "formed with Overbeck an artistic circle exclusively committed to the production and dissemination of artistic objects destined for Catholic devotion."[22]

The Carmelites wanted the windows they produced to be religious art. They did not want to be perceived as a mercantile enterprise. This took precedence over other considerations, including profit. Their prices were modest.[23] They wanted each of their windows to be "an ornament for the house of God and the subject of instruction and edification."[24] Fr. Lottin, always willing to assist, wrote a brochure in 1855, promoting the unusual venture, explaining that "to represent holy things, we need holy souls. . . . Behind the grill of the Carmel du

Mans, we find hands able to use the paint brush. Why not benefit from this, to hasten the restoration so ardently desired of the imagery of our pious ancestors?"[25]

The Carmelites were so successful that they soon had more orders than they could handle, and so in 1854 they hired Carl and Frédéric Küchelbecker, two brothers trained at the Royal Porcelain Factory in Munich. Carl had studied in Rome with Overbeck and had worked in Paris restoring the windows of the Sainte-Chapelle. The Küchelbeckers gave the Carmelite glassworks a distinct niche in the glassworks market because of their unique painting technique called "carmin," a word probably derived from the word Carmel.[26] Research has yet to unlock the mystery of this technique, known for its remarkable aesthetic quality that imparted a high degree of expressiveness to faces.[27] Only the Carmel du Mans windows made between 1854 and 1881 employ carmin. It is notably used in the two great windows of the transept of Notre Dame's basilica, the *Pentecost* and the *Dormition of the Virgin*.

Recognition came early for the Carmelite glassworks, with prizes and medals for their windows at exhibitions.[28] The Carmel du Mans Glassworks existed from 1853 to 1903, and exported windows as far away as Japan. They became one of the most well-known glassworks in France and in Europe.

THE CARMELITES SELL
THEIR GLASSWORKS

Notre Dame's original church of the Sacred Heart, constructed of wood, was begun in 1848, and contained two round stained glass windows, purchased from the Carmelites in 1863. A third window, a gift to Fr. Sorin from the Carmelites, portrayed "The Divine Face."[29]

In 1870, when Notre Dame decided to build a larger, brick church in keeping with Notre Dame's growing importance, Fr. Sorin again turned to his friends, the Le Mans Carmelites, to provide the windows.[30] It would be an exceptionally large order—450 square meters of stained glass.

But by early 1870, the Carmelites had succeeded in repaying their loan, and had begun to look for a buyer for the glassworks. The search was delayed due to the Franco-Prussian War (July 19, 1870–May 10, 1871). During the Battle of Le Mans (January 10–12, 1871) the glassworks was turned into a field hospital for wounded soldiers and civil-

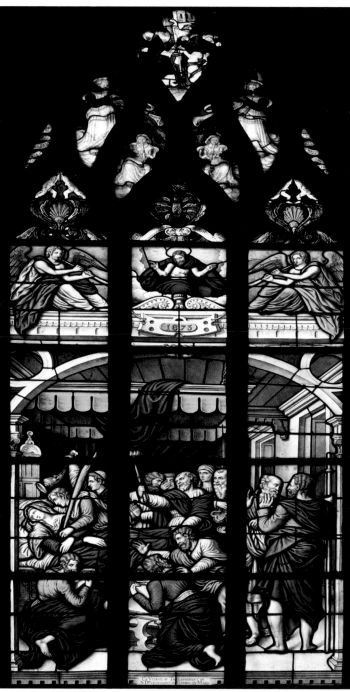

Dormition of the Virgin, 1873, Carmel du Mans Glassworks. Notre-Dame-des-Marais in Le Ferté-Bernard, Pays de la Loire, France. The figures in the basilica's *Dormition of the Virgin* (Window 29) have halos, which were thought necessary in the missionary territory of Indiana. Source: Wikimedia Commons.

ians. France's humiliating defeat to the Prussians ushered in three years of German occupation and very difficult financial times.

The Carmelites, struggling to keep their glassworks solvent, replaced their own chapel windows. They had made their first stained glass windows in the early 1850s, in the silence of their monastery, for themselves. In 1871, they made new chapel windows in the midst of war, to keep their workers employed. Their new windows depicted the saints of their own Carmelite order.[31] The nave windows of the Basilica of the Sacred Heart portray three Carmelite saints, made from the same drawings.

In late 1873, the Carmelites sold their glassworks to an importer from Nantes, Edouard Rathouis, the nephew of their Mother Prioress, Mother Eléonore.[32] Even after the sale, the Carmelites assisted the glassworks and advocated for their artisans and laborers. They intervened when problems arose between owner and workers, and between owner and clients, including a few disagreements with Fr. Sorin.

The sale of the Carmelite glassworks came just months after the work on Notre Dame's windows had begun. Only the first windows to arrive at Notre Dame in 1874 could have been painted by the Carmelites.[33]

Notre Dame had its own worries, including the Long Depression of 1873–1879 and, more locally, the fire that destroyed the Main Building in 1879. Sponsors were solicited to pay for the nave, transept, and sanctuary windows, and included Alexis Coquillard, one of the founders of South Bend and a friend of Fr. Sorin. Sr. M. Germaine of the Passion, CSC, donated her inheritance of seventeen thousand francs to partially fund the sanctuary and chapel windows. In addition, by an agreement with the glassworks, Notre Dame received a ten percent commission on all windows ordered from the Carmel du Mans due to Fr. Sorin's influence. The Carmel du Mans advertisement, translated into good English, appeared in Notre Dame's *Ave Maria* weekly journal.[34] The commissions were applied to the cost of the chapel windows.

The Carmel du Mans did their very best work for Notre Dame's church because it gave them an opening to a valuable market beyond the constant upheavals of French society, government, and finances.[35] The craftsmen who made Notre Dame's windows understood their importance and the possible additional contracts that could result from them. "Throughout the windows," reports Bernard Gruenke, Jr.,

of Conrad Schmidt Studios, who restored the windows in the 1990s, "the names of the craftsmen are inscribed in the lead and glass."[36] These signatures have not been found on Carmel du Mans windows made for any other location.[37]

In 1880, Edouard Rathouis sold the Carmel du Mans to Hucher, who had always wanted to own a glassworks. Because the work for Notre Dame extended over eleven years, from 1873 to 1884, the signature of the glassworks' owner found in the windows reflects the changes in ownership over that time period. "Carmel du Mans, E. Rathouis" can be seen in the nave. The final name, after Hucher's son Ferdinand joined him in the glasswork business, is found in the Lady Chapel and reads "Fabrique du Carmel du Mans, Hucher et Fils, Successors."[38]

Though the glassworks changed hands, the skilled craftsmen and Nazarene designs remained consistent. While Fr. Sorin could have selected an American glassworks that was not an ocean away, or a different French glassworks, such as Lorin of Chartres, who sent to Fr. Sorin the gift of a stained glass of Fr. Sorin himself, he chose to remain with the glassworks founded by his Carmelite friends with whom he shared a union of prayer. The affection endured between Holy Cross and the Carmelites, nourished by memories of Fr. Sorin's frequent visits to the Carmelites and the bond of correspondence that was never broken, even after the glassworks was sold.[39]

NOTRE DAME'S ORDER
FOR WINDOWS

Fr. Sorin always insisted that education offered in a religious setting was "the vital question of the day."[40] The Carmelites saw their windows as indispensible to Holy Cross's educational mission, for religious art "can make a complex and profound theological notion accessible, persuasive and attractive," conveying a religious tradition and inviting devotion.[41] Their stained glass provided a pedagogy that would assist on a daily basis to teach the Catholic faith, as Mother Eléonore once explained, at "the distant mission of Notre Dame du Lac."[42]

Notre Dame's exceptionally large window order allowed for the development of a significant iconographic program for the church. In a letter dated April 23, 1876, Rathouis, then the owner of the glass-

works, noted that, by working with the Carmel du Mans, Notre Dame got "a church [with stained glass] which makes sense, something which commonly occurred in the 14th and 15th centuries and is now so rare, now that everything is done haphazardly."[43] The program intended the windows to be viewed as distinctly focused groups defined by their location in the church. The narthex windows would provide a meditation on the mercy of God, the nave a meditation on the lives of the saints, the transept a meditation on the Church, and the sanctuary would be reserved for the most august saints of the Church. The chapels would be meditations on particular devotions in the Church, and secondary to the main body of windows.

The window's most important image of God is found in the chapel dedicated to the Sacred Heart, "the devotion of the day."[44] Located centrally at the north end of the sanctuary, the chapel contains the only window that portrays the Crucifixion scene. All the basilica windows, as sacred art, provide a visual statement about where God is found in the world. The presentation of saints in the nave and sanctuary—as reflections of the holiness of God—offer indirect images of God. Even the windows in the transept—dedicated to the Church—argue for Jesus's abiding presence in history through the work of the Holy Spirit.

The contract for the windows was negotiated by Fr. Sorin and signed by Fr. Auguste Lemonnier, CSC, who served as president of Notre Dame from 1872 to 1874. Notre Dame's letters to the Carmelites regarding the windows were lost in a fire at the Carmelite archives.[45] No record survives to explain the choices of particular images in the windows, which were selected from the Carmelite's handwritten catalog. Fr. Sorin's *Circular Letters*, however, written to the members of the Congregation while he was Superior General, contain his thoughts on many saints and religious events, and are quoted in this volume with appropriate windows to help illuminate nineteenth-century French spirituality.

Notre Dame's forty-four stained glass windows contain two hundred and twenty scenes. Following the custom of northern France, the stained glass is read left to right, first the lower register and then the upper. There are, in addition, grisaille windows made by the Carmel du Mans in the stairwells to the choir loft, near the church entrances, and in the clerestory.[46]

NOTRE DAME'S
STAINED GLASS WINDOWS

Many nineteenth-century Catholic churches were dedicated to the Sacred Heart of Jesus. Fr. Sorin, ever conscious of the Virgin Mary, "who," he said, "has marked too many days of my life with the indelible imprints of her maternal love," wanted to honor both the Sacred Heart and the Virgin Mary.[47] He dedicated Notre Dame's new neo-Gothic church to Our Lady of the Sacred Heart of Jesus.[48] Notre Dame's windows present the Sacred Heart of Jesus and the Immaculate Heart of Mary, both principal devotions of the French School of Spirituality, which was influential from the mid-seventeenth to the mid-twentieth centuries.

Upon opening the southern doors of the basilica, the visitor enters into a consideration of the Catholic doctrine of the communion of saints, which holds that those on pilgrimage on Earth, suffering in Purgatory, and triumphant in Heaven are all bound together in Christ. Every window is filled not with just words or designs or symbols but overwhelmingly with people, "a great multitude" (Rev. 7:9). The windows portray saints and angels, as well as the sacraments, the rosary, visions and miracles, relics, pilgrimages, confraternities, Adoration of the Blessed Sacrament, intercessory prayer, and a love of the papacy.

Notre Dame's windows reveal the world of its founders in all its richness and complexity. Fr. Sorin was certain that the French Catholic faith he brought with his fellow religious would provide Indiana with the religion, education, and culture it needed. Beginning with *Saint Genevieve* at the entrance to the nave, French history and faith runs like a golden thread through the windows, and includes, for instance, in the nave, *Louis IX* and *Saint Clotilde*, as well as *Louis XIII* in the Our Lady of Victories Chapel. It is found in the penultimate window, *The Homage of France to the Sacred Heart*, with its portrayal of the church of Sacré Coeur in Paris, still under construction when the window was installed at Notre Dame in 1884.

The importance given to royal images in the windows reflects France's traditional royal role as the defender of the papacy. The recall of French troops from Rome in 1871—to defend France in the Franco-Prussian War—brought about the end of the Papal States. It was Fr. Sorin's conviction, as well as the conviction of many members of the Congregation of Holy Cross, that the royal form of government

had been the best for France. He saw no good in the French Revolution or in the century of struggle between government and religion that followed it. "*La povera Francia!* . . . let us pray for her," Fr. Sorin said, echoing Pope Pius IX. "May the Blessed Mary, whose kingdom France always was—*Regnum Galliae, Regnum Mariae,*—save her from ruin!"[49]

Fr. Sorin's decisive and strong leadership in forming Notre Dame and his insight into the benefits of an iconographic program for its church continue even now to offer an education in faith. His lively interest in art and faith gave us, today, a heritage that is an astonishing pedagogy written in light.

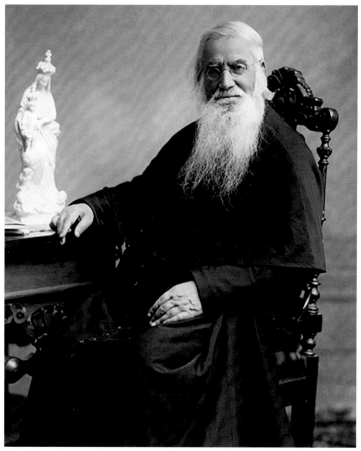

Rev. Edward Sorin, CSC, with statue of Our Lady of Victories. Circa 1892. Source: Wikimedia Commons.

The Narthex

When visitors open the central southern doors of the basilica, they enter a vestibule called the narthex, which leads into the main body of the church. In many church buildings, murals in the narthex or sculpture above the outer central doors often depicted the Last Judgment, reminding those who entered of the final realities of life.[1] The first set of stained glass windows in Notre Dame's basilica, in keeping with this traditional focus, offer a brief reflection on Purgatory and the Last Judgment.

The first window, Purgatory, is an east window, where the first light of day shines. Purifying flames surround a group of naked adults and gather them into a community. They are the souls in Purgatory. An angel hovers above them, holding aloft the Eucharist. The angel's left hand points upward to the top of the scene, where Jesus, seated on a cloud, reveals his wounded side with his right hand.[2] His raised left hand emphasizes his nail wounds, reminding the viewer that Jesus' suffering, death, and resurrection opened the way from Purgatory to Heaven.

In Purgatory the departed faithful undergo the passive purgation of the sins that kept them from the perfect love of God and neighbor. The Pilgrim Church—those still living—give solace to the souls in Purgatory by their prayers, their alms, and especially by having Masses said for them,[3] symbolized by the angel who holds the Eucharist above the souls in Purgatory.

In February 1879, four years after this window was installed, Fr. Sorin established the foundation of the Perpetual Daily Mass at Notre Dame, a "precious boon" available for both "the living and the dead." It was, he said, "probably the first ever established in this country." Fr. Sorin's inspiration was "a good Irish lady, [the] mother of a large family," who had visited him. "She looked fatigued, but happy. 'Tomorrow,' she said, when leaving, 'I shall have another Mass for myself and mine; for, by walking to and from church this morning in-

stead of riding on the cars, I saved enough to have a Mass celebrated.' She said this simply as an ordinary remark, and closed the door."[4]

Two days later, Fr. Sorin established the Perpetual Daily Mass, for himself, his religious community, and all who would give "whatever constitutes a donation, even of one dollar, [and which] entitles each individual donor to share in the benefit of said holy Mass forever."[5] "The blessed poor" became, two and a half months later, valuable friends to Fr. Sorin. "Even the one dollar," by then multiplied many times over, was put to the rebuilding of Notre Dame's Main Building after it was destroyed by fire on April 23, 1879.

In the western window of the narthex, where the last light of day shines, is the second window, *The Last Judgment*. A clothed and disparate group of adults gather. An angel, again midway up the window, is pulling on the hand of someone outside the window. The trumpet has sounded, and the angel has set the trumpet down on the body of a writer who has a quill pen perched on his ear. A hand reaches up into the window, grasps the white undone tie around the writer's neck, and pulls him down into the flames. These are not the cleansing, hopeful flames of Purgatory, but the fires of Hell. The writer pushes back, and the angel's discarded trumpet leads the viewer from the prone figure to the saving cross of Christ, and then up to the face of Christ. Christ has taken his seat. This is the beginning of the Last Judgment. Those to Christ's right, under his raised and pierced hand, look up to Him in hope. Those gathered to Christ's left, under his lowered hand, are in distress. Christ looks directly at the writer.

Fr. Sorin never ceased to decry "modern incredulity," "the noticeable feature of our times."[6] In an 1885 letter written for Notre Dame's student newspaper, he denounced "the increasing denigration of Divine revelation,—as if Divine revelation could not stand the test of science."[7] In a window of an educational institution, a writer being ushered into hell with a quill perched on his ear gives a particularly apt illustration of modern incredulity. In a piece he entitled "An Evil of the Times—Bad Reading," Fr. Sorin wrote: "Atheism is spreading in all directions, carried wide and high by two powerful wings—the [secular] school and the press—in such a manner as was never seen before."[8] Fr. Sorin knew the power of the written word to influence people. Notre Dame printed several publications with its own steam-powered printing press, including the immensely successful weekly journal, the *Ave Maria*, which Fr. Sorin began in 1865, against all advice.

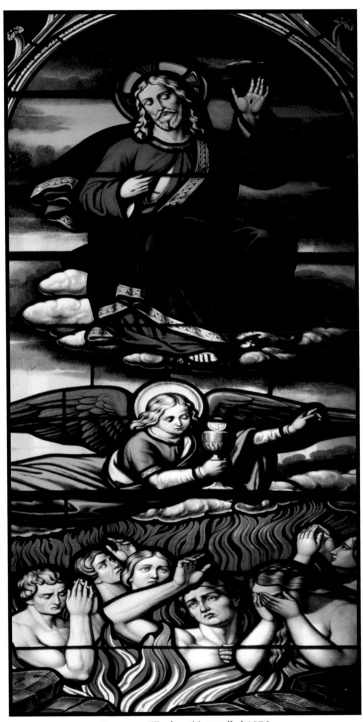

Purgatory, Window 44, installed 1876

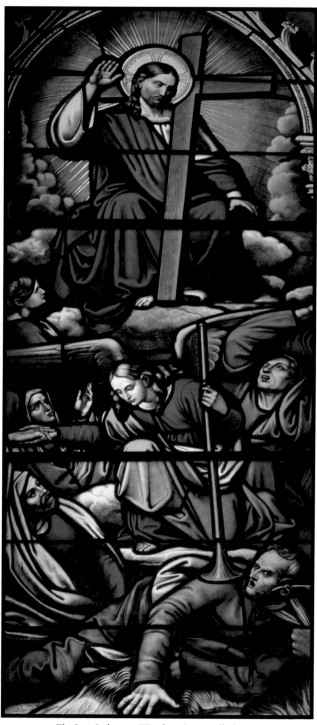

The Last Judgment, Window 43, installed 1876

The Nave

The nave is the main body of the church, set apart for worshippers. The stained glass windows in the nave are filled with forty saints. Each saint is presented twice—in a large image above and in a smaller narrative scene below.

The large image portrays the saint standing in a highly decorative niche, as if a statue in a church, with columns to the right and left. Each saint presents a particular attribute. Saint Crispin, for example, lightly grasps his cobbler's hammer, telling of an ordinary life illumined by love. Saint Genevieve holds her spindle and distaff, a simple shepherdess who helped form a Christian France.

The proportions of the human figure cannot fill the entire tall window, and so the space above each large figure is decorated with gothic architectural elements. There are pointed arches, ribbed ceilings, gargoyles, and acanthus leaves. Below each saint's large image we find their Latin name and sometimes a description, such as *S. Isidore. Agricola Mad.* "Saint Isidore, farmer of Madrid."

The second, smaller image is presented below the large figure. It shows a narrative scene from the saint's life. While the saints' halos for their large figure are a feast of color and design, the halos in their small scene are consistently yellow, to draw the viewer's eye to the saint in the midst of a busy scene. Saint Ambrose stands before the doors of the cathedral of Milan, refusing admission to Emperor Theodosius I. Saint Clare stands on the walls of Assisi, defenseless before mercenary soldiers, holding a monstrance with the Eucharist.

Who are the saints in the nave? They are founders of new religious orders, educators, and missionaries, as were the Holy Cross founders of Notre Dame. They are also young saints, full of faith and courage and remarkable for their years. They are laborers who are defined by

their charity and preaching. They are the noble and the wealthy who used their position and resources for others and to defend the faith. They are second-career saints whose lives reveal an ever-deepening Christian life. This household of saints is made up of all classes, ranks, ages, talents, and states. They lived from the earliest Christian times up to the era of Blessed Mary of the Angels, who died in the eighteenth century and was beatified just nine years before her window was made. All were defined by a life of prayer. All led very active lives. All loved the Church. All were penitents and knew that what they had was for others. "All of which I was apparently mistress, belonged in reality to the poor," Conrad of Marburg records as the dying words of Elizabeth of Hungary.[1]

Curiously, the women saints outnumber the men—twenty-four women to sixteen men. Of the men, only one is a pope and only one is a king. There are three queens. The favorable review of an 1855 book of Fr. Gioacchino Ventura, *La Femme Catholique*, or *The Catholic Woman*, in the tenth issue of the first year of Fr. Sorin's *Ave Maria* journal, helps elucidate. Fr. Ventura notes, "Nothing great or useful has been accomplished in the Church and in Catholic countries without the influence and co-operation of Catholic women."[2] The irreplaceable mission of women in the Church inspired hope that Catholic women, quoting Ventura, "will worthily play the great and important role that Providence reserves" for them.[3] A number of historical examples are provided, even trespassing on the list of male saints, giving a share of their glory to the crucial influence of their mothers. For instance, in the epoch of the fathers of the Greek and Latin Churches, "those great geniuses . . . were often but the precious gifts which the piety of Catholic women gave to the Church, and it is by their co-operation [with their mothers] that they became so renowned and did such immense good."[4]

The mission of women was not limited to their role as mothers, Ventura continues, but included "Catholic women in their households, realizing in full perfection all the precepts and counsels of the Gospel, and contributing by their example as much as the Fathers by their preaching and writings, to popularize sanctity and to form the morals of a Christian people; and again seated on the throne, they labored for the conversion of the Caesars, the overthrow of idolatry and the destruction of heresies."[5] Such women saints are found in the nave windows.[6]

The forty saints in the nave were chosen with particular viewers in mind—the all-male student body, the brothers and sisters of the Congregation of Holy Cross, the all-female students of St. Mary's College, and the local parishioners, as well as those who came to Notre Dame on pilgrimage. Many who worshipped at the basilica attended daily mass and were familiar with the saints and their role as intercessors, as well as the liturgical year.

Certain that the example of a virtuous and holy life could inspire the same in the students, Fr. Sorin constantly encouraged Notre Dame's teachers to exemplify virtue and holiness by their lives. He expected every member of the student body to become a Catholic leader after they completed their education.[7] He understood teachers to be surrogate parents who fulfilled a sacred obligation, "for the training of the child is," he said, "the forming of the man, of the citizen, of the future saint."[8]

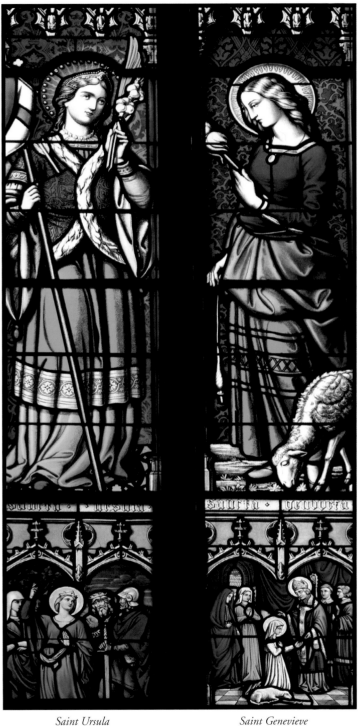

Saint Ursula　　　　　　　　　*Saint Genevieve*

Window 42, installed 1874

Saint Ursula, Virgin Martyr
Roman Britain, fourth or fifth century

Feast: October 21 (withdrawn in 1969 but retained in the Roman Martyrology)

Patron: teachers, young women, students, universities and schools, Catholic education, the Virgin Islands

Attributes: arrow, lilies, women companions

The young woman holds a palm branch and white lilies in her left hand, symbols of martyrdom and purity. In her right hand she holds the Christian Banner of Victory, a red cross on a white ground. The banner symbolizes triumph over evil. These attributes identify her as Ursula, the leader of a pilgrimage of eleven thousand virgins to Rome. Her pearled coronet and ermine fur trim declare her royalty. The arrow of her martyrdom is tucked into her jacket's fold. Red tassels emphasize her distinctive full sleeves, reminiscent of academic regalia, a reminder of her significant role as patron of great medieval universities. The medallion, the small rectangular scene found below each saint, illustrates Ursula's legend at Cologne, Germany. She wears a crown and traveler's clothes and is accompanied by her pilgrim companions. An elderly ambassador dressed in a fur coat presents the marriage proposal of an armed and helmeted officer. Ursula gestures in rebuke, points heavenward, and refuses his offer.

Ursula's fabulous legend, developed over nine centuries as it spread along trade routes, recounts the pilgrimage of Ursula and her eleven thousand virgins. They were martyred in Cologne, Germany, when they refused marriage to Huns. This window attests to Ursula's enduring importance as a patron saint of education. Her legend of a large company of wise virgins inspired Angela Merici to name her teaching order after Ursula. The Ursulines, dedicated to educating young girls, profoundly influenced education in early Canada and the United States. They were greatly admired by Fr. Basil Moreau (and Fr. Sorin) of the Congregation of Holy Cross, who saw Holy Cross as "an apostolic religious community at the service of the church well beyond the frontiers of his own country."[9]

Saint Genevieve, Virgin, Confessor, Patron Saint of Paris
Paris, France, ca. 419/22–512

Feast: January 3

Patron: Paris, France; against floods, famine, drought, and natural disasters

Attributes: young shepherdess with sheep, spindle and flywheel for spinning thread, coin necklace

Saint Genevieve's large image pictures her as a shepherdess with spindle and flywheel, tools for making wool thread. One of her attributes, a coin necklace that she always wore, is explained in her medallion. The medallion illustrates the story of seven-year-old Genevieve being recognized by the Church. Bishop Germanus passed through her village of Nanterre on his way to Paris. Hearing of her goodness, he wished to meet her and ask her if she wanted to consecrate her life to God. This she did in church, in front of her family and the villagers. Germanus gave her a coin to wear about her neck in remembrance of her vow.

Already known for her holy life, at the age of eighteen Genevieve went to Paris and joined a convent. When Paris was in danger of being attacked and destroyed by the Huns, Genevieve convinced the Parisians not to flee, but to fortify the city, gather food, and pray for deliverance. Inexplicably, the Huns turned south and Genevieve was credited with saving Paris and its citizens. In times of siege, Geneveieve went on barges at night to procure food for the people. During times of war, she interceded on behalf of prisoners with their conquerors. A friend and advisor to both Queen Clotilde and King Clovis, she helped to convert Clovis to Catholicism. Genevieve was credited with saving Paris and its people from floods, fire, famine, drought, starvation, and pestilence. Parisians carried her relics in procession through Paris on her feast day and in times of disaster until they were destroyed during the French Revolution. Genevieve's life is well documented with a biography produced just twenty years after her death.

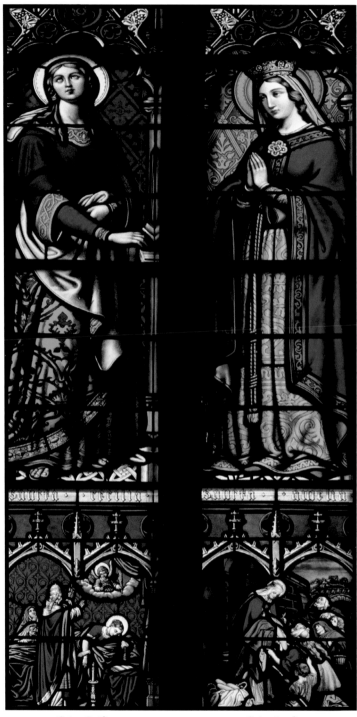

Saint Cecilia *Saint Amelia*

Window 42, installed 1874

SAINT CECILIA, VIRGIN MARTYR
Rome, third century

Feast: November 22

Patron: music, musicians, singers, organists, composers, the Academy of Music in Rome

Attributes: organ, roses, singing, angel watching her

Cecilia, a virgin martyr, plays an organ, looks heavenward in an attitude of prayer, and sings to Christ. From a Roman patrician family, she offered her house as a church. The medallion narrates a legendary scene from her death. Cecilia was called before the throne to sacrifice to pagan gods. She refused continuously and was sentenced to death by scalding in her home bath. This failed, and her beheading succeeded only in leaving three cuts on her neck. Bleeding to death, she was placed in bed, and for three days she preached to the Romans from the scriptures at her bedside. Pope Urban came to honor and bless her. The angel guarding her holds a crown of roses and the martyr's palm.

Cecilia's legend tells that she was pledged in marriage to Valerian, a Roman pagan. Cecilia explained to him that she had taken a vow of virginity and thus her life belonged to Christ, and that an angel watched over her as she sang in her heart to Christ. Wishing to see the angel, Valerian converted and was baptized along with his brother, and then was able to see Cecilia's angel. Cecilia remained a virgin. All three were martyred. Cecilia is one of eight women named in the Roman Canon of the mass. Venerated since the fourth century, she has been associated with music since the sixth century.

Fr. Sorin's favorite Roman church was the Church of Saint Cecilia in Trastevere. In 1865, Notre Dame formed a Saint Cecilia Philomeathean Society to celebrate the arts. On the Feast of Saint Cecilia, the junior class performed music, presented plays written by students, held debates, and delivered speeches.

SAINT AMELIA, QUEEN
France/Belgium, d. 690

Feast: July 10

Patron: women in difficult childbirth, the Caribbean island of
St. Amelia, Maria-Amalia, Queen of the French (1782–1866)

Attributes: a crown and royal clothing, rope belt of wool or silk with
three knots, face as a portrait of Queen Maria-Amalia

Amelia, a seventh-century saint, has the titles of queen, widow, and
saint. Dressed as royalty with a crown of jewels and robed with rich
fabrics, she also wears a monastic cincture, a rope belt with three knots,
representing charity and monastic life. Throughout her life, Saint
Amelia gave clothing and food to the poor and infirm, the young and
old, as seen in her medallion. This portrayal honors Amelia as a patron
saint of the French royal family, because her mature face is a portrait of
Maria-Amalia (reigned 1830–48), the last Queen of the French. Maria-
Amalia also gave away eighty percent of her wealth, and was generous
to Saint Mother Theodore Guerin and her Indiana schools.

Famous in her lifetime, Amelia married the saintly Count Witger
of Lorraine. Together they lived a life of generosity and Christian com-
passion, the Church's ideal of spiritual beauty in their service to God,
the Church, and the poor. They and their children were regarded as
a family who practiced faith, charity, hope, and religion. Amelia and
Witger retired to a joint monastery for men and women and con-
tinued their charity. Her biography tells of an incredible explosion of
great sorrow and mourning when she died. She was buried beside Wit-
ger at Maubeuge, in northern France.

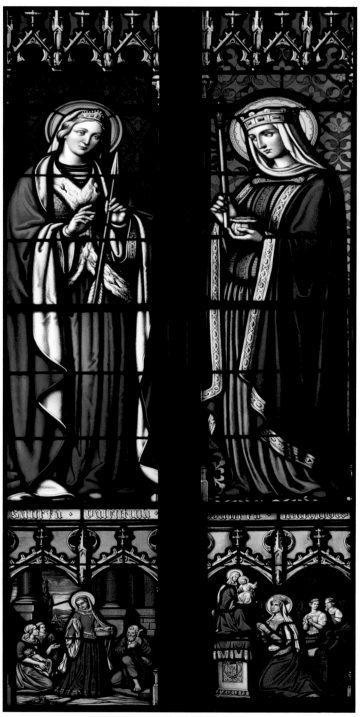

Saint Valentina *Saint Matilda*

Window 41, installed 1874

SAINT VALENTINA, VIRGIN MARTYR
Roman Empire, third century

Feast: July 15, venerated in the diocese of Nevers, France

Patron: boarding school students, vocational discernment

Attributes: arrow, coronet of minor nobility, generosity to the poor

Saint Valentina wears a modest coronet. Her gold-embroidered vest with ermine fur suggests wealth. Her left hand holds an arrow, the symbol of her martyrdom. She indicates this to viewers with her right hand and by the tilt of her head. Her medallion presents a young teenager practicing charity by distributing bread and coins to those in need who are gathered around her—two women, one a mother with her child, and a lame elderly man. She wears clothes that appear more fifteenth-century Renaissance dress than third-century Roman. The architecture suggests the grandeur of the Roman Empire, with the gigantic piers and columns. A castle is visible among the hills in the distance.

Saint Valentina's relics were discovered in the catacomb of Priscilla in Rome in the 1830s. Many of the relics found at this time were sent to France. Valentina was a young martyr of twelve to fourteen years. Stories were written in the 1830s about her charity and martyrdom without any real knowledge of her life. In 1846 her relics were given to St. Gildard's in Nevers, France, a school run by the Sisters of Charity and Christian Instruction. Canonized in 1852, Valentina was named a patron saint for those who boarded and were educated at Catholic schools. The nuns at St. Gildard's sent her relics around France to boarding schools much like Notre Dame and Saint Mary's. This young saint appears in the stained glass windows of the fledgling Indiana college of Notre Dame because of her contemporary popularity in France and her patronage of boarding schools.

Saint Matilda, Queen and Widow
Germania, 895–968

Feast: March 14

Patron: queens, widows, parents of large families, parents of difficult children, Benedictines, Bavaria

Attributes: crown and scepter, purse, a book, an orb with a cross on top

Saint Matilda, Queen of Germania, is dressed as a tenth-century queen. She wears a gown with an elaborate bodice, royal robes, and a crown. She holds up both her scepter and an open sack of coins. They symbolize her sovereignty and her readiness to give to those in need. Her medallion presents her at prayer in an oratory in her palace, indicated by tapestry-lined walls. She kneels in front of her throne before a pedestal with a statue of the Virgin Mary and Child. Matilda had a devotion to the Blessed Virgin Mary, and was known for her dedication to prayer and spiritual readings. Her attendants, however, do not seem to be paying attention to her or to their prayers.

Matilda was the virtuous, intelligent, and strong wife of King Henry the Fowler and mother of their five children, who included the Holy Roman Emperor Otto I and Saint Bruno, bishop of Cologne. Her daughter was the grandmother of Saint Louis IX, king of France. She founded Benedictine abbeys and built churches, schools, and hospitals. She learned to read so she could meditate on the scriptures and instruct converts and the unlearned in the faith. Using her wealth she helped to alleviate the suffering of prisoners. Her husband supported her in all her endeavors. After her husband died, her continued generosity led to difficulties with her children, who exiled her from the castle for a time. Though born privileged, she died penniless because, in her indefatigable charity, she gave away both her dowry and her inheritance.

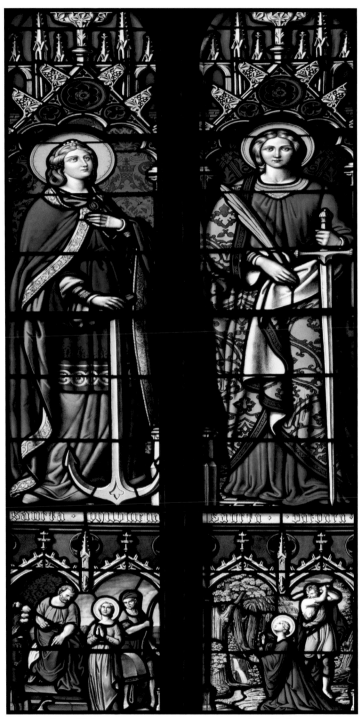

Saint Philomena *Saint Barbara*

Window 41, installed 1874

SAINT PHILOMENA, VIRGIN MARTYR
Greece, late third century

Feast: August 11 in the diocese of Nola, Italy

Patron: young women, children, infants, priests, lost causes

Attributes: anchor, arrows

Saint Philomena wears a red cloak with gold trim and a jeweled diadem crown, as she was a Greek princess. Her clothing suggests the wealth of her social rank. Her right hand steadies an anchor, the symbol of her martyrdom. She looks toward Heaven and her hand is paused over her heart. Her name is Greek and means "Beloved." In her medallion Philomena stands gazing heavenward with her hands clasped in prayer. The Roman magistrate sentences her to death for failing to renounce her Christian faith. He points forcefully to the anchor, threatening her with martyrdom by drowning. An archer with his bow, a fire pit, and a millstone with ropes surround Philomena. According to legend, angels kept her afloat until death came by arrows.

The remains of Philomena were discovered in 1802, in the catacomb of Priscilla in Rome. No reliable historical records prove her existence, but three rearranged ceramic slabs marked her resting place. Her relics were given to the sanctuary at Mugnano in Nola, Italy. Private revelations provided details of her life as a thirteen-year-old Greek princess who was a virgin martyr. In 1835, a relic of Philomena was given to Saint John Vianney, the Curé of Ars. His devotion to Philomena increased her immense popularity in France and the entire Catholic world. Many miracles were attributed to her, and she was canonized in 1837. For the students at Notre Dame and Saint Mary's, Philomena offered the inspiring witness of heroic virtue attained in youth.

About thirty years after the installation of this window, further archeological research raised questions regarding the dating of Philomena's remains and even of the name Philomena. In 1961, the Church described Philomena's historical existence as "undocumented," and her cult was limited to the diocese of Nola, where her remains are still venerated.

SAINT BARBARA, VIRGIN MARTYR
modern day Lebanon, fourth century

Feast: December 4 (removed from the General Roman Calendar in 1969, but not from the list of saints)

Patron: architects, artillerymen, military engineers, miners, workers with explosives, mathematicians, prisoners, against unexpected or violent death, against fire, lightning, for the consolation to die with the sacraments

Attributes: three-windowed crenellated tower, sword, lightning, palm

Saint Barbara, clothed in a richly patterned robe draped over a simple blue gown, addresses the viewer. She holds the martyr's palm branch and the sword of her death. To her lower left, a crenellated tower, one of her major attributes, is barely visible. The medallion illustrates an idyllic wooded scene at odds with the violence about to take place. A small cascade visible between the trees feeds a stream. Barbara kneels, absorbed in prayer, her hands lifted in a final eloquent gesture. Behind her, the executioner is caught in the moment that he begins to swing his sword.

Barbara's frequent depiction in art indicates her enduring popularity. She was invoked against lightning strikes and fire. Though she was said to have lived in the fourth century, Barbara's name appeared only in the seventh century, and was recorded in Symeon Metaphrastes's tenth-century compilation of legends of the saints. Barbara's legend tells of a wealthy pagan father who shut her in a tower to keep her from the outside world. Unknown to her father, she had three windows placed in the tower to symbolize the Trinity. When Barbara chose to be baptized, her father had her killed. After her martyrdom, he was struck by lightning and killed. Barbara's legend extolls a wealthy, beautiful, and courageous young woman who valued membership in the Church and the consolation of the sacraments more than her father's wishes, and even more than her life.

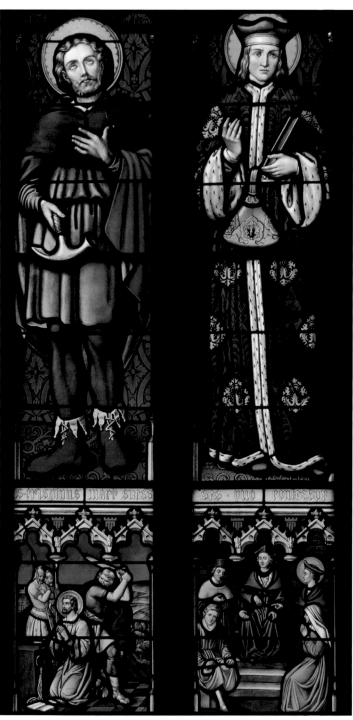

Saint Crispin *Saint Ivo*
Window 40, installed 1876

SAINT CRISPIN OF SOISSONS, MARTYR

Rome, Italy, and Soissons, France, d. 285/86

Feast: October 25

Patron: shoemakers, leatherworkers, saddlers, tanners

Attributes: leather strips, shoemakers' and leatherworkers' tools, working man's clothing

Saint Crispin, a shoemaker, stands ready to work. He and his brother Crispinian made shoes together at night to support their true vocation, preaching the gospel during the day. Crispin wears third-century craftsman clothes: basic brown leggings and a green, knee-length tunic with sleeves fitted to the lower arms so as not to obstruct his work. He wears a blue cloak with a shorter red cape. The red and yellow trimmed leather ankle boots are laced with leather strips and proclaim his skill as a shoemaker. He holds a French shoemaker's hammer in his right hand, extending it in a gesture of address. His left hand covers his heart and he looks heavenward. The medallion presents Crispin's martyrdom. He is well dressed in a mantle with gold-embroidered trim on the sleeves and hem. As soldiers watch, Crispin readies himself for death with a prayer book at his knees. His faith has prepared him for martyrdom, and he kneels, unbound, at the executioner's block.

The brothers were sent together from Rome to convert the Gauls in Soissons, northeast of Paris. Acting in imitation of Saint Paul, who made tents, they made shoes to support their preaching and to aid the poor. A new persecution brought their arrest and torture for openly teaching the faith.

The many vocations seen in the basilica windows tell that holiness is possible in every walk of life. Fr. Sorin noted, in 1883, "Whether in the class-room, or in the kitchen, or in the field, we spend ourselves and are spent for the same glorious end."[10] Brother John of the Cross, CSC (James King, 1815–1855), held the important job of Notre Dame's shoemaker. He came from Ireland and was, according to Fr. Sorin, "the head of the [apprentice's] workshop and a boot maker, one of the most able, most exemplary and best known [religious] in the area."[11]

SAINT IVO, CONFESSOR
Kermartin, France, 1253–1303

Feast: May 19

Patron: lawyers, abandoned children, the French province of Brittany

Attributes: purse, fur-trimmed dark cloak, jurist hat, breviary

Ivo of Kermartin, the patron saint of lawyers, was called the "Advocate of the Poor" in his lifetime. He is recognized by his jurist clothing, purse, and breviary. The hat, a *bonnet caress*, is a banded black toque with a top of three soft points. He wears an ankle-length cloak trimmed in fur. An important attribute is the green purse attached to his belt, as he carried money every day to give to the poor and orphans. He carried a prayer book, also known as a breviary. Though he became an ordained priest with a parish, he is never shown as a priest.

Over the centuries, attributes of saints can become mixed, and that is true with this depiction of Ivo of Kermartin. The elegant fur-trimmed red velvet cloak with an embroidered design of gold, silver, and silk threads, called *opus angelicanum,* indicates a different Saint Ivo. Saint Ivo of Chartres (1040–1115) was a bishop, a canon lawyer, a famous scholar and writer, and an advisor to kings. The cloak was a gift to Ivo of Chartres from an English queen. The breviary, books, and jurist hat are attributes of both saints.

The medallion helps to distinguish which Ivo is actually portrayed. A haloed Saint Ivo in a dark cloak stands with his client, a poor elderly widow, pleading her case to the judge. Two men tried to defraud the widow, who ran an inn. Saint Ivo took her case without charge. The judge in the background found in favor of the widow. The man on the left looks away from the judge in dismay. Saint Ivo of Kermartin was an outstanding defender of the poor and helped them to seek and receive justice.

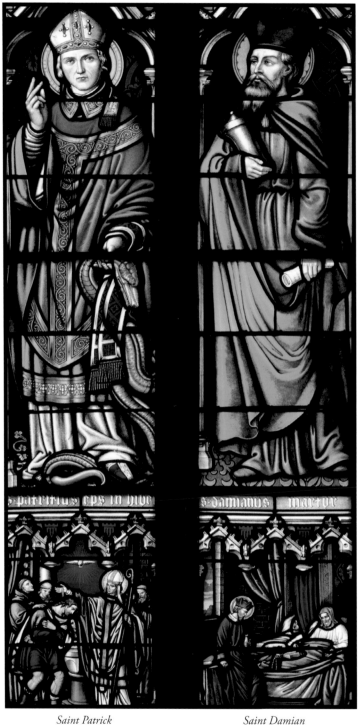

Saint Patrick *Saint Damian*

Window 40, installed 1876

SAINT PATRICK, MISSIONARY AND BISHOP, "APOSTLE OF IRELAND"
Roman Britain, 387–460/64

Feast: March 17

Patron: Engineers, Ireland

Attributes: bishop's miter, vestments, crosier, a snake, the color green, three-leaf clover

Saint Patrick, with a luminous green halo, is depicted as a clean-shaven, middle-aged man giving an episcopal blessing. He wears a bishop's elaborately ornamented miter and green vestments. Patrick has subdued a snake, standing on its body and holding its head in his left hand. The red and gold shoes and the stole wrapped about his forearm highlight this action. There are several three-leaf clovers on the floor. In the medallion Saint Patrick, holding his crosier, baptizes a nobleman of Tara. The Holy Spirit descends upon the catechumen. This scene illustrates an account of a Sunday assembly ordered to refute Patrick's faith and to keep Ireland's druids in power. On the eve of Easter in 433, Patrick started a forbidden fire on the hill opposite the druid religious site. The druid priests could neither extinguish Patrick's fire nor clear the darkened sky. Patrick convinced all concerning the Christian faith and converted and baptized the nobles. He was given permission to preach throughout the country.

Saint Patrick helped to convert Ireland to the Catholic faith over a long period of time. Many myths grew quickly about him after his death. Two of the most common myths are that he drove snakes out of Ireland and that he used the three-leaf clover to explain the Trinity.

Like Saint Patrick, Notre Dame's founders saw themselves as missionaries who evangelized in a new land. The Irish were well represented among Notre Dame's original founders. Four of the six brothers were Irish. Notre Dame's second president was Patrick Dillon, CSC, and the feast of Saint Patrick, March 17, was especially celebrated in his honor while he was president. The celebrations were a cause of concern because they seemed to eclipse the celebration of Saint Joseph on March 19, a major feast day for the Congregation of Holy Cross.[12]

Saint Damian, Martyr
Arabia, present day Syria, d. 287

Feast: September 26 (changed from September 27 in 1969)

Patron: doctors, surgeons, dentists, pharmacists, midwives, barbers, veterinarians

Attributes: medicine jars, surgical instruments, medical text, with his brother Cosmas

Saint Damian appears to be in contemplation. His parted beard indicates he is from the East. He is clothed in a long tunic with a long mantle and a black felted hat. He was a physician and is often shown with his brother Cosmas. He cradles an ointment jar and carries a scroll of medical texts. In the medallion Damian's concern for his two bedridden patients goes beyond the ointment jar he holds. An open book of prayer sits on the bed between Damian and his patients. The physician brothers not only healed the sick, they also gave them spiritual comfort and guidance, converting many to the faith.

Damian and his twin brother Cosmas were physicians and pharmacists from Arabia. They attained great reputations as excellent doctors and surgeons and were called "the Silverless" because they never took any form of payment. It was said they cured men and women due to the grace they received from the Holy Spirit. The brothers were even known to treat and cure animals.

In a late third-century persecution the brothers were martyred by beheading, an indication that they were Roman citizens. They are both mentioned in the Roman Canon of the Mass. The sixth-century Emperor Justinian believed their relics cured him of a deadly illness and spread their cult throughout his empire. He built a church in Constantinople that became a pilgrimage site. The great basilica of Cosmas and Damian in Rome was dedicated in the sixth century. The modest chapel of San Damiano in Assisi is named after Saint Damian. Returning twelfth-century French crusaders brought their relics to France and helped to make them popular saints throughout the country.

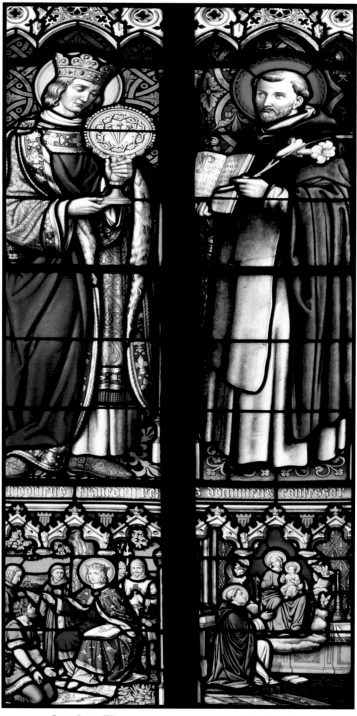

Saint Louis IX *Saint Dominic*

Window 39, installed 1876

Saint Louis IX, King of France
France, 1214–1270

Feast: August 25

Patron: France, French monarchy, Third Order Franciscans

Attributes: crown of thorns, three nails of the crucifixion, fleur-de-lis, holding a model of the Sainte-Chapelle

Saint Louis wears a red chalmys, or royal mantle, bordered with blue and gold fleurs-de-lis trim. This stylized flower was used by Louis VII as an emblem of the French king and of his sovereignty. It continued to be used through the succession of Louis' on the French throne. The Crown of Thorns in the reliquary he holds makes his own royal crown relative. Louis obtained the Crown of Thorns and other relics of Christ's Passion from Baldwin II, the Latin emperor of Constantinople. He built the Sainte-Chapelle in his castle in the heart of Paris to house the relics. Louis' dedication to justice and to impartial, centralized laws is portrayed in his medallion, where he personally delivers judgment under the oak trees near Vincennes, as was his custom. A man with shackled hands kneels before him. Crusaders and monks stand behind Louis. He was considered a just king who made impartial decisions regardless of social status.

Louis' education was very important to his mother, Queen Blanche of Castile, who educated him in the faith. The French people proclaimed him a saint upon his burial in Paris. Louis, a favorite saint of Fr. Sorin, is the only French monarch named a saint by the Church. "To his mother, next to God," Fr. Sorin wrote, "the Church owes this great Saint, the model of all kings."[13] Saint Louis IX is found in other basilica windows. The Passion of Christ, the importance of relics, and the close relation of French royalty and Catholicism are central themes found throughout the stained glass windows.

SAINT DOMINIC, FOUNDER
Spain, 1170–1221

Feast: August 8 (formerly August 4)

Patron: astronomers, Dominican Republic, falsely accused people

Attributes: lily, rosary, book, tonsure, black and white Dominican habit, barefoot

Saint Dominic holds a lily, the symbol of purity. As the founder of the Order of Preachers, or Dominicans, he wears the Dominican habit and holds a book opened to the viewer, a reminder that he always carried the Gospel of Matthew and the Epistles of Paul. He stands barefoot in poverty. His medallion illustrates a popular legend from the fifteenth century: the Virgin Mary and the child Jesus revealing the rosary to Dominic. Dominic kneels between the altar and the pulpit at prayer. Before him is a heavenly vision of Our Lady of the Rosary with the Christ Child. Mary offers Dominic a rosary. Jesus holds an orb with a cross, a symbol since the Middle Ages of his authority. They are surrounded with cherubim, who indicate the divine presence.

Dominic was born in Spain, where he was educated and ordained a priest. While traveling through southern France, he encountered a religious movement called Albigensianism, which taught that matter, including the human body, was evil. This heresy had established a stronghold in France. Dominic began to preach eloquently of the goodness of creation and of the human body. He exemplified his preaching by living in apostolic simplicity. The Order of Preachers stressed the importance of education, preaching the gospel, and fighting heresy.

Dominic is closely associated with the rosary, an immensely popular devotion in the nineteenth century. Such devotion was practiced locally, even before the basilica was completed. Beginning in 1875, St. Joseph's parish in neighboring Mishawaka made an annual pilgrimage to Notre Dame on Rosary Sunday. In 1879, four hundred parishioners processed the six miles with their pastor, carrying their parish societies' banners and reciting the rosary as they walked. At Notre Dame they attended Mass, had picnics in the campus groves, and visited the various shrines at Notre Dame. The day concluded with Benediction and a second rosary and the pilgrims processed home.[14] The rosary is also celebrated in the Our Lady of Victory Chapel and in the transept window of Our Lady of Lourdes.

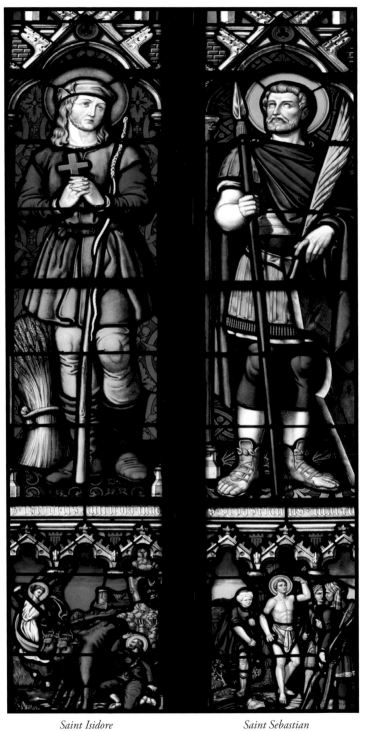

Saint Isidore *Saint Sebastian*

Window 39, installed 1876

SAINT ISIDORE, CONFESSOR, FARMER
Madrid, Spain, 1070–1130

Feast: May 15

Patron: farmers, day laborers, agriculture, Madrid and many other cities

Attributes: sickle, spade or plough, wheat, angels, oxen

Saint Isidore stands in an attitude of prayer, glancing upward, his hands folded around a small wooden cross. He is clothed as a farm laborer with a ploughman's whip resting against his body. A bundle of wheat beside him is a symbol of the wheat fields he ploughed daily on the estate of Juan de Vergas near Madrid. The scene in the medallion tells how angels helped Isidore plow the fields while he was at prayer. Despite the early hours required of a plowman, Isidore began the day at Mass. He would then go to the wheat fields, indicated as brown wheat behind the angel. While at prayer, he is surprised by an angel who takes over the oxen. His *Acta Sancta* tells the predictable outcome: fellow plowmen reported Isidore's late start to the wealthy squire, whose castle is in the background. When the squire investigated, he found that Isidore was helped by two others to plow that day's portion. They disappeared, leaving the furrows as evidence.

This scene presents Notre Dame's students, as well as the many farmers who were parishioners, with Isidore's very reverent, profound faith in addition to the toil and hardships of his life. He was known to feed the hungry with reckless generosity, even giving away what he needed for his own sustenance. His wife was Saint Maria Torribia. Isidore was canonized on March 12, 1622, with Saints Teresa of Avila, Philip Neri, Francis Xavier, and Ignatius of Loyola.

From its very beginning in 1842, farming was crucial for Notre Dame's survival. Brother Lawrence, CSC, was selected as one of the original founders of Notre Dame because he was a farmer. By 1844, he had 120 acres of cleared land under cultivation.

Saint Sebastian, Soldier Martyr
Milan and Rome, Italy, d. ca. 288

Feast: January 20

Patron: athletes, archers, soldiers, physicians, against the plague

Attributes: arrows, young man tied to a post or tree, armor on ground

Saint Sebastian is presented as a soldier saint: strong, athletic, bearded, and dressed as a member of the Imperial Praetorian Guard, the emperor's handpicked personal guards, with spear and shield. Carrying the martyr's palm he looks heavenward. Sebastian became a Christian and chose to help those imprisoned during the Diocletian persecution. When he was found out, he was sentenced to death. The medallion portrays the initial attempt to martyr him. Mauretanian archers in exotic dress, earrings, and turbans have stripped Sebastian of his uniform, tied him to a tree, and prepare to execute him with arrows. Left for dead, he was discovered and nursed back to health. Sebastian confronted the Roman emperor Diocletian and again revealed his faith. He was immediately condemned and was clubbed to death on the street, finally suffering martyrdom.

Sebastian is preeminent among the martyrs of the early Church. The historically reliable *Depositio Martyrum* of 354 tells what is known of Sebastian: he was martyred during Diocletian's reign and buried on the Via Appia. One of the earliest churches in Rome, Saint Sebastian Outside the Walls, was built over his grave in 367. Saint Ambrose tells of his veneration in Milan as far back as the fourth century. The earliest image of Sebastian, a very ancient mosaic in Rome in the church of Saint Peter in Chains, dates from 683 and depicts him as a dignified, bearded mature man carrying the crown of martyrdom. During the Italian Renaissance his image became that of a man stripped of clothes, tied to a tree, with arrows in his body. Such representation gave artists the opportunity to depict the nude human body.

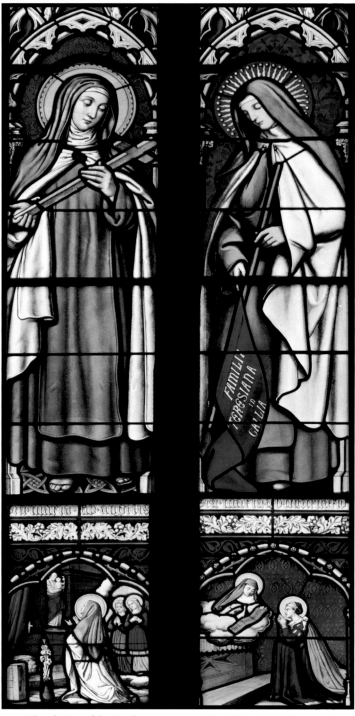

Blessed Mary of the Angels *Blessed Marie of the Incarnation*
Window 38, installed 1874

BLESSED MARY OF THE ANGELS,
CARMELITE FOUNDER
Turin, Italy, 1661–1717

Memorial: December 16

Patron: Carmelites; Turin, Italy

Attributes: small young woman dressed as a Discalced Carmelite,
a cross, statue of Saint Joseph

This window is the first of several that feature female Carmelite saints, reflecting the importance of religious orders and especially honoring the Carmelite neighbors of the Congregation of Holy Cross in Le Mans, France, who founded the Carmel du Mans Glassworks.

Blessed Mary of the Angels, beatified by Pope Pius IX in 1865, is dressed in the brown habit of the Carmelites. She wears a white cloak with a black veil over a wimple and the traditional *alpargatas*, or rope sandals, of the Discalced Carmelites. Blessed Mary holds a large wooden cross colored green to contrast with her brown habit. Her medallion presents Mary in her daily devotions to Saint Joseph. She is kneeling on a tile floor with open arms before a statue of Saint Joseph holding the young Jesus with a white lily, an attribute of Saint Joseph. A vase of white lilies on the floor beside Blessed Mary is a symbol of her purity. Two angels hover in clouds watching over her.

At a young age, Mary Fontanella entered the Carmelite monastery in Turin, Italy. She sought a life of prayer and did penance for the souls in Purgatory. She is often paired with Saint Rose of Lima, who is found across the nave from Blessed Mary of the Angels. Named prioress at the young age of thirty-three, she founded a new Carmel dedicated to Saint Joseph. Royalty, civic leaders, and the people of Turin sought her advice. The citizens of Turin refused to let her leave Turin to go to other Carmelite monasteries. She convinced the people of Turin not to flee invading French forces and to pray to Saint Joseph for deliverance. Turin and its people were saved from destruction twice. Through her efforts the city of Turin was dedicated to Saint Joseph, a saint who was greatly honored in the nineteenth century. The Congregation of Holy Cross was especially devoted to Saint Joseph, as can be seen, for instance, in Fr. Sorin's failed 1860 "campaign among South Bend's leading citizens to change the city's official name to St. Joseph."[15]

Blessed Marie of the Incarnation, Founder of Carmelite Convents in France

Paris, France, 1566–1618

Memorial: April 18, in Paris and in the Carmelite Order

Patron: widows, the poor, parents separated from children

Attributes: Carmelite habit, well-dressed woman of nobility

One of several windows featuring female Carmelite saints, Barbara Acarie is depicted as she lived the last four years of her life, as a Discalced Carmelite named Marie of the Incarnation. Beatified by Pope Pius VI in 1791, she is portrayed with a halo. She carries a banner bearing the words "The Carmelite Family of St. Teresa of Avila in France," which announces her importance as the woman who established the Carmelites in France. Her medallion tells of her experience of Saint Teresa of Avila in 1601. Barbara, a well-educated wife and mother, is dressed as a member of the wealthy French high society and is at prayer in her chapel. Saint Teresa (d. 1582), whose recently translated writings and biography Barbara had read, appears to her in a heavenly vision. Saint Teresa told Barbara that God wished her to found Reformed Carmels in France.

As a young girl, Barbara was educated by the Poor Clares and desired convent life. Her family, however, married her into wealth and status. She bore six children in her happy marriage to Pierre Acarie. Her husband's exile for his Catholic faith kept her in Paris to fight for their children's patrimony. Women usually did not argue in French courts. Barbara, however, argued in court and won her husband's legal battles, which allowed him to return to Paris. She was famous as a wise and charitable woman and was visited by distinguished scholars, as well as by religious and civic leaders. Although an invalid, she traveled and was able to found fourteen Carmelite convents in France. She also brought the Ursulines to Paris to help young girls find a vocation. After the death of her husband, she was finally admitted as a lay Carmelite sister in 1614 and took the name Marie of the Incarnation.

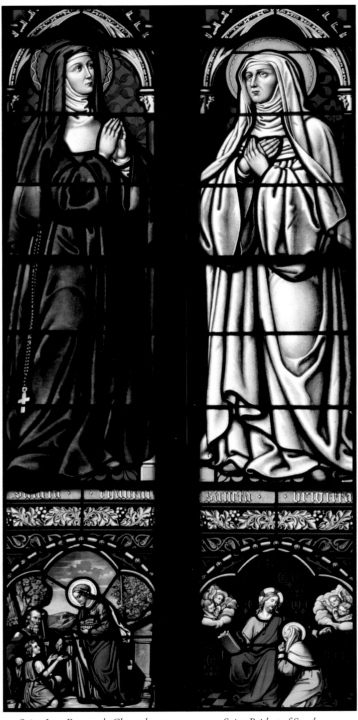

Saint Jane Frances de Chantal *Saint Bridget of Sweden*
Window 38, installed 1874

Saint Jane Frances de Chantal, Founder
Dijon, France, 1572–1641

Feast: August 12

Patron: forgotten people, loss of parents, parents separated from children, in-law problems, widows

Attributes: mature woman, Order of the Visitation habit

Jane Frances de Chantal is clothed in the habit of the Order of the Visitation, a full black habit tied with a girdle. She wears a black veil with a black bandeau and a white guimpe. A cross hangs from the belt. The medallion portrays a widowed Jane outside her father-in-law's home, showing charity to everyone, young or old, healthy or infirm. Jane had moved into her father-in-law's house when her husband died to ensure her children's patrimony. They suffered a harsh life as he, his staff, and his entourage treated her and the children very badly.

Wealthy before and after her happy marriage, Jane managed her uncle's estates with great business and management skills. Charity was the great virtue of her life. She practiced devotions to the Sacred Heart of Jesus and the Immaculate Heart of Mary. She met Saint Francis de Sales, who became her confessor, spiritual director, and friend. Together they founded the Institute of the Visitation of the Blessed Virgin Mary in Annecy, France, in 1607. The institute was unique in that it was not strictly cloistered, providing public outreach to administer to the sick and poor. Admission to the institute was granted without regard to age, health, wealth, or even if a woman had been refused entry to another religious order. By 1616, however, the Visitation had become a cloistered convent for elderly women, widows, and young girls, allowing them to pursue a spiritual life without the austerities of the monasteries of that time. Jane's sanctity and fame helped to spread the Order in France. Wherever she went to establish a house she was greeted and applauded by throngs of people. By her death in 1641, there were eighty-four established houses of the Visitation. Saint Margaret Mary Alacoque, a crucial figure in Sacred Heart spirituality and found in several basilica windows, was a Visitation nun.

SAINT BRIDGET OF SWEDEN, FOUNDER
Sweden, 1303–1373

Feast: July 23

Patron: widows, Sweden, Europe

Attributes: middle-aged woman, crown of thorns, writing book and tools, white habit, black or dark blue cloak, pen and ink bottle, pilgrim's clothes, bag, staff

Dressed in a white habit, Saint Bridget was never a nun in the Order of the Holy Savior, or Bridgetines, which she founded. One of the first Swedish writers, she wrote about the revelations she received, beginning in her childhood, from Christ and the Virgin Mary. The medallion presents a vision of Christ giving her the Rule. The cherubim indicate his heavenly presence. Bridget kneels at his side, listening intently. Her writings were published in both Swedish and Latin.

Bridget was born into a royal, pious, educated, and wealthy family. Married at thirteen to a young price, they had eight children. When Ulfo died, Bridget became a Third Order Franciscan. She built an abbey in 1346 at Valstena, Sweden, which housed both monks and nuns. Each religious could have as many books for study as he or she pleased. In the Jubilee Year 1350, Bridget traveled to Rome to obtain papal confirmation of her order, granted in 1370. Bridget went on many pilgrimages and lived in Rome until her death in 1373. She was universally loved in Rome for her charity and good works.

In 1855, Pope Pius IX gave Bridget's residence to the Congregation of Holy Cross. In 1870, when Rome became part of a unified Italy, the grill that separated the convent from the church at St. Bridget's was removed to Notre Dame for safekeeping, and was placed on the wall above the door of the east entrance to Sacred Heart church. It is currently displayed in the basilica's Bishops' Museum. While at St. Bridget's in 1876, Fr. Sorin wrote, "today I am entering my sixty-third year, and I must acknowledge that the anniversary of my birth and baptism could not be accompanied with more consolation and happiness. I have celebrated Mass in the very room in which St. Bridget died, attended by her daughter St. Catherine."[16]

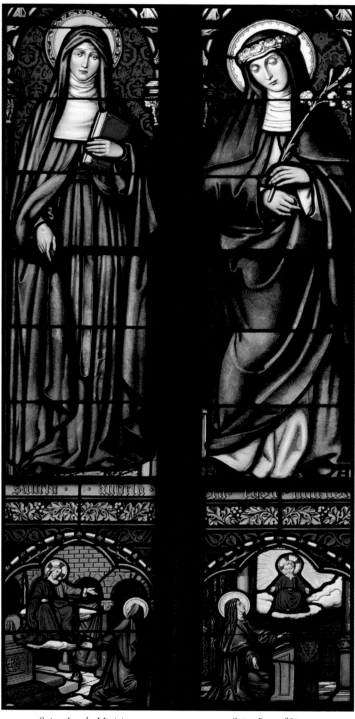

Saint Angela Merici　　　　*Saint Rose of Lima*

Window 37, installed 1874

Saint Angela Merici, Virgin and Founder
Italy, 1474–1540

Feast: January 27

Patron: handicapped persons, loss of parents, the sick

Attributes: Ursuline habit, book, ladder

Saint Angela Merici, founder of the Ursulines, is clothed in the habit eventually worn by French Ursulines. She holds a red book indicating her writings. Angela's medallion depicts her praying in the Church of St. Afra in Brescia, Italy, as was her daily custom. It was there that Jesus, in a vision, instructed her to found the first teaching congregation of women in the Church.

By the time she was an adult, Angela had suffered the loss of her parents and her sister and became a Third Order Franciscan. While practicing corporal and spiritual works of mercy, she instructed young girls who were neither wealthy nor members of a religious house in the basics of Christianity, which both strengthened their families and renewed society. Her fame grew and other cities asked her to help their citizens. Angela instructed the consecrated virgins to live in evangelical poverty in their own homes. Five years before her death, Angela, inspired by Saint Ursula's legion of wise virgins, formed the Company of Saint Ursula. Her Rule, originally without religious habit, canonical vows, or enclosure in a convent, was too forward-thinking for the sixteenth century. The company was obliged within thirty years of Angela's death to adapt to the canonical structures of sixteenth-century religious life.

The feast of Saint Angela was a festive occasion at St. Mary's College, in honor of Mother Mary of St. Angela, CSC (Mother Provincial of St. Mary's College from 1850 until her death in 1887; born Eliza Maria Gillespie). In 1868, after a "sumptuous supper," "the day was duly celebrated with addresses, music, plays and tableaux." Fr. Sorin, in Sr. Angela's name, gave permission for the St. Mary's students "to sleep an hour longer [the next day], and also to enjoy recreation for the entire day."[17] Sr. Angela's brother was Fr. Neal Gillespie, CSC (1831–1874), one of the first graduates of Notre Dame and editor of the *Ave Maria*. Her mother donated the nave window of the Eastern Church fathers.

Saint Rose of Lima, Virgin, Penitent, First Saint of the Americas
Peru, 1586–1617

Feast: August 23 (formerly August 30)

Patron: florists, embroiderers, people ridiculed for their piety, Latin America, against vanity

Attributes: cross, crown of thorns or of roses, anchor, lily, habit of Dominican religious, with the infant Jesus

Saint Rose of Lima, clothed in the habit of the Dominicans, wears a crown of roses and holds the lily of purity. Her large window is especially beautiful in the graceful "S" curve of her body. Her medallion shows Rose with the child Jesus. In the bull of canonization for Rose, Pope Clement X related the story of how when Rose was very ill, the infant Jesus appeared and deigned to play with her, for "Eternal Wisdom has, from the beginning, delighted to play in the world" (Prov. 8:30–31).

Rose of Lima was of Spanish and Inca descent. She lived in the violent and difficult times of the early European settlement in what is now Peru. Known for her beauty, she was dedicated to prayer and penance. She wore a crown of roses that hid a crown of thorns. She valued above all else the final beauty and truth of redemptive suffering for others. She was well known for her active care of the sick in the city of Lima. Her admiration of Saint Catherine of Siena led her to join the Third Order Dominicans. At her death, her burial was delayed because of the large crowds who wished to honor her. The first saint born in the New World, she is buried at Santa Domingo in Lima, near her friend, Saint Martin de Porres. She was canonized in 1671.

The original plans for Notre Dame's side chapels reveal that one chapel was to be dedicated to the story of Saint Rose of Lima, and would have proposed Rose of Lima as a role model to Americans. Saints as role models were of particular interest to nineteenth-century Catholics, and especially to Fr. Sorin.

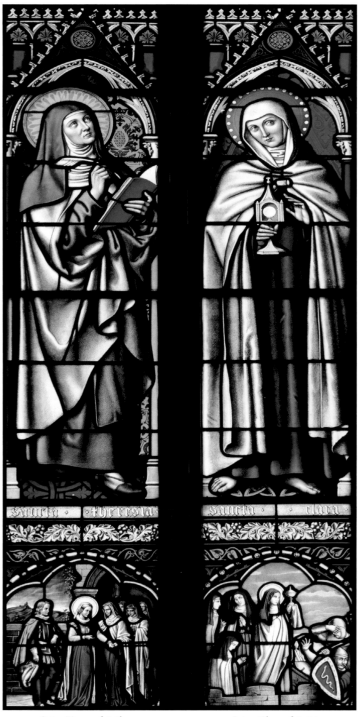

Saint Teresa of Avila *Saint Clare of Assisi*
Window 37, installed 1874

Saint Teresa of Avila, Virgin and Reformer
Spain, 1515–1582

Feast: October 15

Patron: bodily ills, headaches, lace makers, loss of parent, people in need of grace, people ridiculed for their piety, Spain, Avila, Carmelite order

Attributes: habit of Discalced Carmelites, book and quill, arrow-pierced heart, dove

Saint Teresa wears the rough garb of the reformed Carmelites and the distinctive sandals of her discalced (or unshod) Rule. She gazes heavenward and holds open a blue book and a quill, ready to write. In her medallion, an eighteen-year-old Teresa, in worldly clothes, gives her hand to the abbess of the relaxed Carmel of the Incarnation outside the walls of Avila. Because her father refused her permission to join the convent, she had slipped away from home accompanied by her brother Antonio early one November morning in 1535. The abbess greeted her, but informed her father, who came immediately and gave his consent.

It took Teresa many years before she stilled her restless mind and prayed. At prayer, her heart was pierced by the love of God. In an age of decadence and decline, Teresa forged a return to the pristine and primitive Carmelite rule of the twelfth century. She was undaunted by heavy opposition, unending difficulties, constant travel, and a frail constitution. She founded thirty-two reformed monasteries for nuns and (with her younger friend Saint John of the Cross) convents for monks. Ordered to write by her confessor, Teresa wrote with clarity, humor, and honesty. Her mystical teaching, found in *The Interior Castle*, is unrivaled even today. Pope Paul VI named her a Doctor of the Church.

In October, 1604, approximately twenty years after Teresa's death, Pierre de Bérulle, a founding figure of the French School of Spirituality, and his cousin Barbara Acarie (Blessed Marie of the Incarnation) brought seven of Teresa's reformed Carmelite nuns to France in order to establish a presence there. Teresa's reform influenced the French School of Spirituality, out of which emerged, in 1837, the Congregation of Holy Cross.

Saint Clare of Assisi, Virgin and Founder
Assisi, Italy, 1194–1253

Feast: August 11

Patron: embroiderers, sore eyes, telephones and television

Attributes: monstrance, bare feet, Poor Clare habit

Saint Clare stands barefoot, clothed in the rough brown Franciscan habit and a white travel robe. She reverently holds the monstrance with the eucharistic Lord, as she is usually portrayed. It is her most important attribute. Her left hand indicates the monstrance, and tells of her complete reliance on the Savior. In a story ascribed to Thomas of Celano, the army of Emperor Frederick II attacked San Damiano in 1234. Clare brought the monstrance with the Eucharist to the parapet, as seen in her medallion. The army, Thomas related, was overthrown by Clare's prayers and quietly descended the walls.

When Clare was only eighteen she heard Saint Francis of Assisi preach. Desiring to live a life of gospel simplicity, she professed vows to God. Clare lived with other holy women, mirroring Christ's "blessed poverty, holy humility, and ineffable love."[18] She founded the Order of Poor Ladies, or the Poor Clares. They led a life of prayer and works of mercy for the poor, especially the sick.

During the annual Franciscan Feast of Our Lady of the Angels (celebrated August 2), Fr. Sorin would carry the eucharistic monstrance donated by Napoleon II in procession around the lakes at Notre Dame, ending at a replica of the renowned Portiuncula, where Saint Francis had received Clare and accepted her vows. The replica stood between the lakes at Notre Dame. "A great concourse of people" came yearly to Notre Dame to gain the extraordinary indulgence of the Portiuncula, usually reserved for Franciscan churches, but granted to Notre Dame's pilgrims.[19]

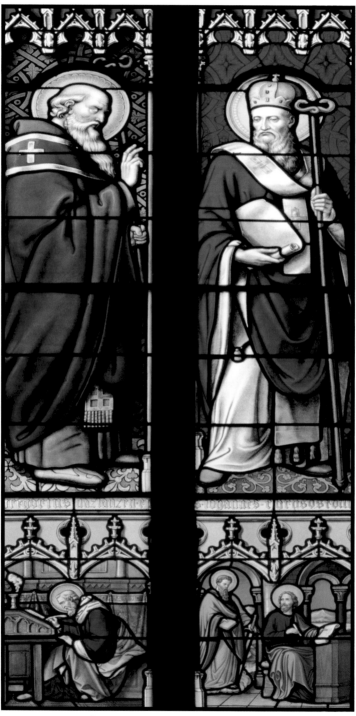

Saint Gregory of Nazianzus *Saint John Chrysostom*
Window 36, installed 1877

SAINT GREGORY OF NAZIANZUS, BISHOP AND DOCTOR OF THE CHURCH, "THE THEOLOGIAN"

Nazianzus, Cappadocia, 325–389

Feast: January 2 (changed from May 9 in 1969)

Patron: poets, for the harvest

Attributes: balding with white hair and beard, omophorion, bishop's crocia, giving blessing, book, scroll

Saint Gregory, a distinguished theologian, scholar, orator, writer, and poet, wears the liturgical vestments of an Eastern archbishop. The distinctive omophorion, a scarf with large gold crosses that is placed across the shoulders, symbolizes Christ as the Good Shepherd. It represents the bishop's pastoral and ecclesiastical authority. Gregory stands in profile to add variety and visual interest to the four figures found in this window. The drawing for Gregory's figure, also called a cartoon, is employed for two other figures in the basilica windows, Jerome and Joachim. In the medallion, Gregory is at work in his library with pen and parchment. The burning oil lamp suggests evening. Gregory, a poet, wrote his sermons and orations in verse.

As is true for the other three Eastern Doctors of the Church, Gregory was sent to all the finest schools of Caesarea, Athens, and Alexandria and received an excellent education. Saint Basil, who is celebrated in the scene above Gregory, was his friend. They studied together and both became monks. Basil greatly influenced him and appointed him bishop. Gregory, a fourth-century champion of orthodoxy, fought Arianism, a heresy that denied the divinity of Christ. After Basil's death, the emperor Theodosius, hoping to defeat Arianism, named Gregory archbishop of Constantinople and called the Ecumenical Council of Constantinople in 381. The patriarchs of Athens and Alexandria did not accept Gregory. Gregory, hoping to promote unity and peace, resigned as archbishop, a decision that ultimately brought him support. His efforts to describe the relations within the Trinity were crucial to the resolution of the Arian crisis.

Saint John Chrysostom, Bishop and Doctor of the Church
Antioch, Asia Minor, 347–407

Feast: September 13

Patron: preachers, orators, lecturers, speakers, Constantinople (Istanbul)

Attributes: crown, omophorium, scroll

Saint John, called "chrysostomos," or golden-mouthed, preached eloquently. Depicted as the archbishop of Constantinople, he wears a crown and the omophorion. He holds a scroll, partially unrolled and tucked under his arm, representing his more than three hundred and fifty extant homilies, commentaries on scripture, letters, and his beautiful Divine Liturgy, still used today. In the medallion, Saint John has paused in his writing and turned to Saint Paul, identified by his receding dark hair, beard, and the sword of his martyrdom. Paul is portrayed on clouds, indicating that he is a vision. He offers John a copy of his Epistles. In his commentary *On the Epistle of St. Paul the Apostle to the Romans,* John wrote of "recognizing the voice [of Saint Paul] so dear to me, and seem to fancy him all but present to my sight, and behold him conversing with me."[20]

John, classically educated, became a desert monk. Forced to return to Antioch because of poor health, he was ordained a priest. His preaching, his chief task, was so well received that his sermons were often interrupted by applause. His brilliant preaching made scripture easily understood and helpful for everyday life. In 398, he was summoned to Constantinople and consecrated archbishop. He preached against the excesses of royalty, the wealthy, and even the clergy and made many enemies because of his fiery sermons.

John Chrysostom's fame spread over the Byzantine Empire. Saint Jerome, found in the window opposite him, gave him a place in his *Viris illustres.* He brought reform and renewal and addressed the excesses of the clergy and the court. The empress Euxodia had him exiled twice. While in exile he continued to write and influence the faithful, who demanded his return. The emperor allowed him to return the first time, only to become fearful of him again. During the second exile John died from the harshness imposed on him during a forced march.

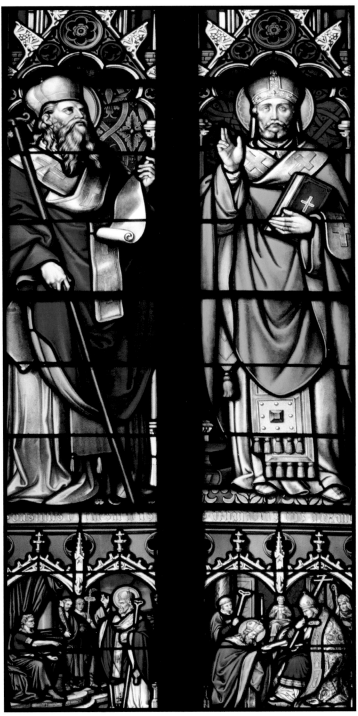

Saint Basil of Caesarea *Saint Athanasius*
Window 36, installed 1877

SAINT BASIL OF CAESAREA, BISHOP AND DOCTOR OF THE CHURCH
Caesarea, Cappadocia, ca. 330–379

Feast: January 2

Patron: schools, children, hospital administrators

Attributes: dressed as bishop wearing the omophorion and crown, crocia ending in a Greek "T," book or scroll

Saint Basil wears Eastern-style church vestments and a crown, symbolic of the kingship of Christ. The omophorion in red with gold crosses is the symbol of his spiritual and ecclesiastical authority. He holds his staff and a scroll of his writings, and his hair and beard are parted in the Eastern style. Emperor Valens, an Arian, summoned Basil to his court to submit to Arianism. History records that Basil never answered the summons of Valens, but the medallion illustrates a fictional confrontation between Basil and Valens. The emperor, his soldiers, and the symbols of the authority and jurisdiction of Rome take up sixty-five percent of the visual space in the medallion, but they are dwarfed by the dominant presence of Basil on the right. He was a champion of defending the divinity of Christ. Basil was a protector of individual liberties from political power. He was eloquent, brilliant, a practical genius, and earned the title of "Great" during his lifetime.

A monk, a teacher of literature and oration, a well-known theologian, and orator, he was appointed bishop of Caesarea. He was a close friend and colleague of Saint Gregory of Nazianzus. Saint Basil shortened the Divine Liturgy to keep people interested and prayerful and created a proper balance in his community between work and prayer. In times of famine he started a soup kitchen and passed out food and clothing. Using his own wealth and properties he created the "Basileiad," a complex of institutions offering services to the poor, underprivileged, the excommunicated, and those without skills. He started job training and counseling for reformed thieves and prostitutes, a hospice for strangers, and a hospital. Basil gave his personal inheritance to the poor and needy of his diocese.

SAINT ATHANASIUS, BISHOP AND DOCTOR OF THE CHURCH, FATHER OF ORTHODOXY
Alexandria, Egypt, 298–373

Feast: May 2

Patron: theologians, invoked against headaches

Attributes: dressed as bishop with omophorion and crown, giving Eastern sign of blessing, books, dark hair, beard

Saint Athanasius, depicted in a Western representation, is an Eastern father. He is portrayed as an older man with an episcopal crown and an omophorion. He holds a red book, representing his many writings. His *Life of Saint Anthony*, considered a masterpiece, has served as a model for eremitical life for centuries. The medallion is of Athanasius's meeting with Pope Julius I at the Vatican, indicated by the statue of Saint Peter on the far wall. In this Western view of the meeting in 340, Athanasius kneels before Pope Julius. Athanasius had fled to Rome to meet Pope Julius I after he was exiled to Gaul. Pope Julius overturned his exile and restored Athanasius as the archbishop of Alexandria.

Athanasius was well educated, led an eremitical life as a young man, and was ordained a deacon by the age of twenty-two. Acting as secretary and theological advisor for the archbishop of Alexandria, Athanasius participated in the Council of Nicea. He was called "the Father of Orthodoxy," because he defended the divinity of Christ against Arianism. Just five years later, upon the archbishop's death, he was consecrated archbishop. Four different Roman emperors exiled him five times for more than seventeen years. He was sent as far as Germany and France. When he returned to Egypt he faced accusations, dangers, and suffering. However, he lived a virtuous life and died a peaceful death. He has been venerated in France since the twelfth century.

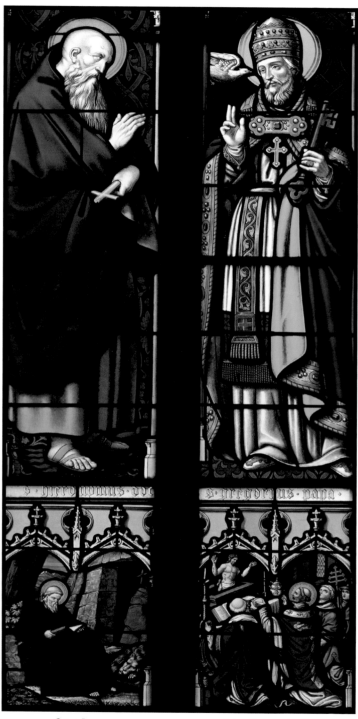

Saint Jerome *Saint Gregory the Great*
Window 35, installed 1877

Feast: September 30

Patron: biblical scholars, librarians, students, translators, archeologists, those with eye problems

Attributes: lion, cross, skull, rock, book or scroll, cardinal's clothing

Saint Jerome, clad in the rustic robe of a hermit, stands in profile. He holds a simple cross, which he has momentarily lowered as he raises his other hand to make an uncompromising point. "He watched constantly, with undaunted courage, over the sacred deposit of faith," an article in the 1865 *Ave Maria* recounts.[21] He stands on a cardinal's red *galero*, a tasseled, broad-rimmed hat. Once secretary to Pope Damasus, Jerome is often depicted as a cardinal, though cardinals did not exist until many centuries later. Jerome's medallion portrays him studying in his cave in Bethlehem, his apocryphal lion resting nearby. The tale of the lion, which had a thorn in his paw, is an endearing one. All the monks ran away from the lion, except Jerome, who removed the thorn and treated the paw. The lion never left Jerome's side.

Jerome knew Latin, Greek, and Hebrew. Pope Damasus, aware of the problems caused by imperfect translations of scripture, gave Jerome the task of writing an authentic translation. Jerome's work became the basis for the Vulgate, the official Latin translation of the Bible, written in the common, or vulgar, Latin of that day. In 386, Jerome, the greatest biblical scholar, left Rome. He found peace in the cave in Bethlehem traditionally considered the birthplace of Jesus. There he continued his scriptural studies, fought heresy, and defended the virginity of Mary. A community formed around him, including many holy and educated women who followed him from Rome. He was known for his charity and hospitality.

SAINT GREGORY THE GREAT, POPE AND DOCTOR OF THE CHURCH
Rome, ca. 540–604

Feast: September 3

Patron: musicians, singers, students, teachers, choirs, the papacy, the West Indies

Attributes: dove, keys, dressed as a pope

Saint Gregory the Great is the only pope found in the large nave windows. Gregory, dressed in papal robes, a stole about his neck, a ceremonial cope fastened across his chest, and the papal tiara, carries the keys of Saint Peter. The earliest representations of Gregory included the dove of the Holy Spirit dictating to Gregory as he wrote. The medallion, designed after a fifteenth-century drawing, depicts an immensely popular story first recorded in the eighth century and entitled *The Mass of Saint Gregory*. It presents Gregory's vision of Christ as the Man of Sorrows while he celebrated mass. The vision occurred in response to the doubts of a nearby believer about the true presence of Jesus in the Eucharist.

Gregory was a monk who reluctantly accepted the papacy. His remarkable fifteen years as pope ordered the Catholic world for centuries. He fashioned a legacy of liturgical reform in Gregorian chant and the Latin mass, care for the poor and refugees, organization and discipline of the church, and missionary work. Gregory was a favorite saint of Fr. Sorin. Nineteenth-century Catholics especially loved Gregory the Great as an exemplary model of the papacy, which, from 1870 on, as the papacy's temporal powers declined, was seen more and more in the role of the principal theological teacher for the Universal Church. He is the only pope who was also named a Doctor of the Church.

The Saint Gregory Society was formed at Notre Dame on January 30, 1871, "to take part in the offices and form the choir of the Church."[22] Fr. Alexis Granger, CSC, President of the Society, wrote in his *Book of Church Services*, Easter Sunday, 1881, "10 [a.m.]. Solemn Mass. . . . Collection $35.60.—A Caecilian Mass was sung, but not a success. Every one seems prefering common Greg. chant. There is more life in it, as every one here amongst the students can join in it."[23]

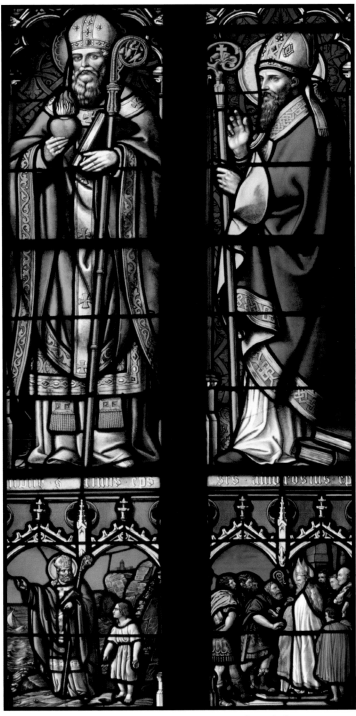

Saint Augustine　　　　　　*Saint Ambrose*

Window 35, installed 1877

Saint Augustine,
Bishop and Doctor of the Church
Africa, 354–430

Feast: August 28

Patron: theologians, learned men, printers, brewers, those with sore eyes

Attributes: flaming heart, pen, books, as a bishop, child, dove, in his study

The restlessness of his youth behind him, Saint Augustine looks peacefully and directly forward. Dressed in his bishop's robe, his left hand holds his writings and supports his bishop's crosier. His right hand presents his flaming heart, burning with love of God's truth and beauty. An Augustinian legend is depicted in his medallion. Augustine is walking on the seashore, wearing liturgical robes and carrying a book. He is pondering the Trinity. He finds a child using a shell to empty the sea into a hole in the ground. Augustine explains to the child that this is an impossible task, and the child replies that he will finish before Augustine understands the Trinity.

Augustine was trained as a philosopher and a rhetor, or public speaker. His wide-ranging mind and honest zeal for truth and beauty drove him on a long search from Platonism to Christianity. His mother, Saint Monica, prayed that he would be baptized. In 387 he was baptized in Milan, in the presence of his mother. Saint Ambrose, who baptized him, is in the neighboring window. After his return to Africa he was consecrated bishop of Hippo. He founded monastic communities and defended the Catholic faith against many heresies. He died as the Roman Empire was crumbling around him, with the Vandals sacking North Africa and the penitential psalms written on the wall by his bed. His piercing intellect and his desire to present the faith in all its fullness made his life and work of lasting importance. Among his writings are *Confessions*, *City of God*, *On Christian Doctrine*, and *On the Trinity*.

Saint Ambrose,
Bishop and Doctor of the Church
Germany and Italy, ca. 340–397

Feast: December 7

Patron: Milan, bishops, bees, learning, students, stonemasons

Attributes: pen, scourge (for penance he imposed on the emperor), beehive, dove

Saint Ambrose stands robed in his episcopal garb, holding his pastoral staff and turning to bless his people. The books at his feet contain transcripts of his many homilies. Remembered especially for his insistence that the emperor is within the church and not above it, his medallion depicts a legendary scene of Ambrose forbidding Theodosius I entrance to the basilica of Milan. While this confrontation never occurred, Ambrose did admonish Theodosius after the emperor's brutal massacre of seven thousand men, women, and children in Thessaloniki in 390. Theodosius repented, did public penance, and, two years later, died in Ambrose's arms. Ambrose preached at his funeral.

In 374, Ambrose, just thirty-four, was an unbaptized Christian and governor of Milan. When the bishop died, street fighting broke out over whether the next bishop should be an Arian or a Catholic. Ambrose begged the crowd for peace, and they unanimously acclaimed him the new bishop. Within eight days he was baptized, ordained, and consecrated bishop. He began his life as bishop by giving away his possessions and reading the Bible and early church writers. His door was always open to any visitor. With a bishop's love, he once taught his congregation beautiful antiphonal hymns as they were barricaded in their church against Arian violence. Ambrose preached eloquently, abhorred war, ransomed captives, and cared for the poor.

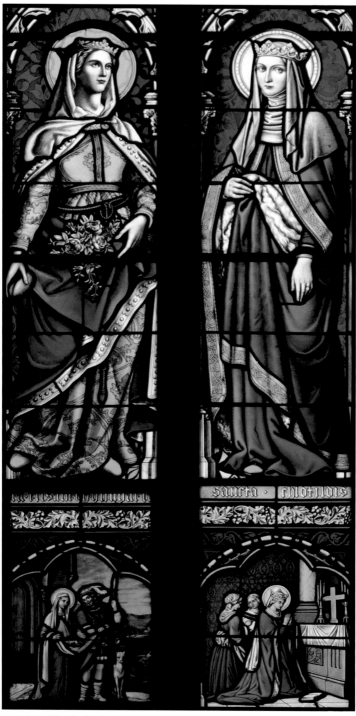

Saint Elizabeth of Hungary

Saint Clotilde

Window 34, installed 1874

SAINT ELIZABETH OF HUNGARY, QUEEN AND THIRD ORDER FRANCISCAN
Hungary, Thuringia (Bavaria), 1207–1231

Feast: November 17

Patron: Catholic charities, young brides, widows, bakers, Secular Franciscan Order

Attributes: queen, red and white roses, bread

Saint Elizabeth, queen of Ludwig of Thuringia, was born in Hungary, the daughter of a king. Dressed as a thirteenth-century queen, she wears a dress with fitted garment reaching from neck to hips with a full skirt. Fabrics at that time were richly brocaded, adorned with gold, silver, and precious stones, and lined with fur. She wears a knotted rope at her waist, signifying her membership in the Franciscans. She discretely carries a single roll of bread and carries roses in her mantle. The medallion explains the bread and roses. Daily Elizabeth brought food hidden in her mantle to the poor below the castle. On one occasion, King Ludwig had returned from hunting, as a dog and his elaborate hunting clothes and staff indicate. He questioned Elizabeth about the heavy burden she carried in her cloak. When the cloak was opened, he found red and white roses that could not have been in bloom. He loved the roses and sent her on her way. When she reached the village the roses had been turned back into food.

Giving of her own wealth and food, Elizabeth was famous as far away as Italy. She corresponded with Saint Francis of Assisi, who sent her one of his cloaks, which she wore in daily prayer. She joined the Third Order Franciscans. When Ludwig died on a crusade, Elizabeth was forced to leave the palace and beg for herself and their three children. Ludwig's returning knights forced the royal family to allow their return to the castle as the oldest son was the rightful king. With her children safe, she left courtly life and, using the dowry money that had been returned to her, she built a hospital. She lived among the poor and served at the hospital until her death. Elizabeth died at age twenty-four and was canonized within twenty years.

Saint Clotilde, Queen
France, 475–544

Feast: June 3; June 4 in France

Patron: queens, brides, wives of abusive husbands, adopted children, parents, exiles, widows, the lame

Attributes: crown, at prayer, the baptism of Clovis

Saint Clotilde, a queen of the sixth century, is dressed as royalty with various bright colors, gold-embroidered trim, and a fur-lined mantle. A color scheme of pale pink, warm flesh, white wimple, and pale grey veil accentuate her face. She wears a gold crown and a wedding band. The medallion presents Saint Clotilde kneeling before an altar with a prayer book open before her. The chapel contains an ornate altar with cloth, cross, and candelabra. This scene of the saintly queen at prayer before an altar was the most popular medieval image of her. The relief on the altar contains the Greek alpha and omega plus the Chi Rho of Christ. Two kneeling handmaids seem more interested in each other than in their prayer.

Queen Clotilde was known for her sanctity, charity, and generosity to the Church. She had a deep devotion to the Virgin Mary. She worked with her friend Saint Genevieve to convert her husband King Clovis, who was an Arian. In the Battle of Tolbiac, Clovis, outnumbered, vowed to accept Christian baptism if he won. Clovis won and credited his victory to the intercession of Saint Martin of Tours. He and his army were baptized at Reims on Christmas day, 496. As a result of his baptism all of France was baptized into the Catholic faith. After Clovis's death and the tragic infighting of their sons, Clotilde withdrew to Tours and lived near the shrine of Saint Martin. She dedicated herself to a life of prayer, to charity for the poor and sick, and to the founding of churches and monasteries. She was named a saint only five years after her death.

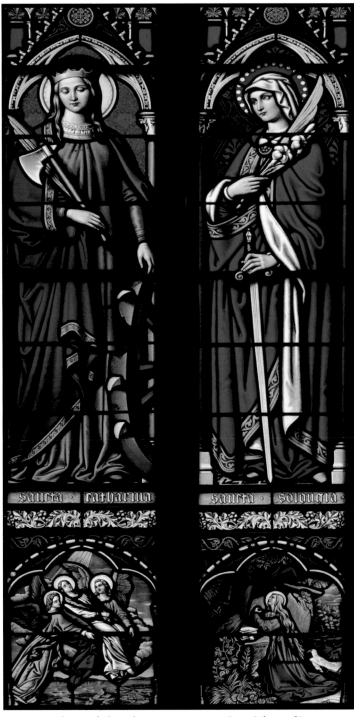

Saint Catherine of Alexandria *Saint Solange of Berry*
Window 34, installed 1874

Saint Catherine of Alexandria, Virgin Martyr
Egypt, d. 310

Feast: November 25 (removed from the calendar in 1969, restored in 2002)

Patron: learning, students, philosophers, educators, preachers, young girls, University of Paris, wheelwrights, knife grinders

Attributes: broken wheel with knives, sword, palm branch, crown, book

Catherine, with a virgin's loose and flowing hair, looks squarely at the viewer. She wears a modest princess's crown, and her left hand rests on the cruel wheel built to torture her. It broke, tradition says, at the touch of her hand. She cradles the palm and axe of her martyrdom. In the medallion, two angels in flight bear Catherine's lifeless body to the Sinai desert, where they will hide it. Their robes and wings of complementary colors intensify each other: gold with purple, green with red. These colors draw attention to Catherine's lifeless, colorless body. A palm branch is laid across her chest and a divine light shines the way. Tradition says milk, a symbol of grace, flowed from the wounds on her neck.

Catherine was known for her education, intelligence, eloquence, and courage. Her legend tells how, of her own accord, she approached the Roman magistrate to argue against the persecution of Christians. She had not been arrested, but gave arguments against the terrible treatment. The magistrate assembled all the known philosophers and scholars of Alexandria to refute her arguments. Instead, she converted them all and they were then martyred. Catherine suffered many tortures and was finally beheaded. Because of her legend as learned, eloquent, and courageous, Catherine was named the patron saint of many European universities, and was a role model for Notre Dame students, who studied philosophy and rhetoric.

Her relics have been at Saint Catherine's Monastery at Mount Sinai in Egypt since the fourth century. An eleventh-century monk brought a relic of Saint Catherine to Rouen, France. A monastery built there to house her relic helped to establish her cult. In the twelfth and thirteenth centuries returning Crusaders brought back a devotion to Saint Catherine. Her church in Rouen became a pilgrimage site before being destroyed during the French Revolution.

Saint Solange of Berry, Virgin Martyr

France, d. 880

Feast: May 10, in Sainte-Solange, France

Patron: drought relief, rain, rape victims, shepherds, Bourges and the province of Berry in France

Attributes: lily, palm branch, sword, a star shining over her

This young woman wears a rather elaborate mantle that is gold-trimmed with a metal clasp, as royalty would wear. Her kerchief-like headdress betrays that she was a working shepherdess. She holds the martyr's palm and the lily of purity across her chest. Her left hand steadies the hilt of the sword of her martyrdom. In the medallion, she is kneeling at prayer in a natural oratory with her prayer book. A wattle fence separates the oratory from the sheepfold. One tradition concerning Solange told that God gave her a star of divine light to guide her steps and to indicate the hours for prayer as she worked in the pasture. The light from the unseen star shines brilliantly upon her and makes the rock faces look snow covered in the dark oratory.

Solange, a local saint of the province of Berry in France, is one of the few virgin martyrs of the ninth century. From a poor and devout family, she watched over her father's sheep. When she was young, Solange had vowed to live as a virgin dedicated to Christ. God gave her gifts that were for healing others: the ill, the poor, the possessed, and even animals. Just being in her presence cured the ill. One day the Count of Poitiers' son saw her pasturing the sheep. He desired her and proposed marriage. She refused as she had devoted her life to the Savior. He tried to take her away by force, but Solange resisted and he killed her in anger. Even today, pilgrimages are held yearly for Solange on her feast day, beginning at her field of prayer and ending at the local church where her remains rest.

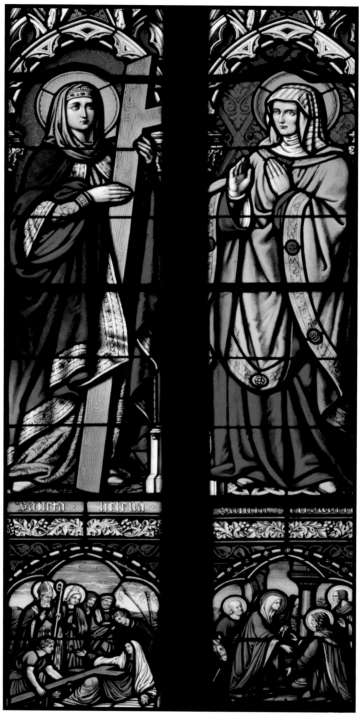

Saint Helena *Saint Elizabeth*

Window 33, installed 1874

Saint Helena, Empress
Turkey, ca. 250–ca. 330

Feast: August 18

Feast of the Exaltation of the Holy Cross: September 14, the titular feast day for the Sisters of the Congregation of the Holy Cross (St. Mary's College, Notre Dame, Indiana)

Patron: empresses, converts, difficult marriages, the divorced, archeologists

Attributes: cross, crown

Saint Helena, the mother of the Roman Emperor Constantine the Great, is credited with the finding of the True Cross. She wears a crown of jewels and a royal purple mantle with gold trim and pearls. She holds a large wooden cross against her body and her purple mantle drapes over it and claims it as a part of her identity. Together they dominate the niche. Her medallion details the legend of Helena's discovery of the True Cross. The episcopal robes and halo identify Saint Macarius, Bishop of Jerusalem. Helena is at his side, wearing a modest traveler's crown. Having unearthed three crosses, they discovered which was the True Cross when its touch healed a woman who was ill.

Saint Helena was of humble origin. Constantine honored her with the title "Augusta." Helena and Constantine's conversion to Christianity and his legalization of the Christian religion had a profound impact on the history of Christianity. She cared for the poor and constructed many important churches. The bishop and historian Eusebius recounts the eighty-year-old Helena's pilgrimage to Palestine from 326 to 328. Reliable accounts of the veneration of the cross in Jerusalem date from 380.

In 569, a piece of the cross was brought to the holy Queen Radegund in Tours, France. Venantius Fortunatus composed one of the greatest hymns of the Latin liturgy, "Vexilla Regis," to mark the occasion. A line from this hymn became the motto of the Congregation of Holy Cross: *O Crux, ave, spes unica*: "Hail, O Cross! our only hope." The basilica's Relic Chapel houses a relic of the True Cross.

SAINT ELIZABETH, COUSIN OF THE VIRGIN MARY, MOTHER OF JOHN THE BAPTIST
Palestine, first century

Feast: November 5

Feast of the Visitation: May 31 (formerly July 2)

Patron: pregnant women

Saint Elizabeth's striped headscarf declares her Hebrew heritage. Her hands are raised in prayer and she is garbed in a mantle that is simply pulled over the head, a style used in first-century Rome. Her medallion presents the Visitation (Luke 1:39–57). Mary and Joseph have just arrived, each with a walking stick. Joseph brings along their donkey. A kneeling Elizabeth greets Mary, who is pregnant with Jesus and has come to assist Elizabeth in her old-age pregnancy. The still mute Zechariah gestures with his hand. The inclusion of Joseph and Zechariah, not found in the biblical narrative, reflects the nineteenth-century emphasis on the family. John the Baptist, the gospel tells us, leapt in Elizabeth's womb, acknowledging the presence of the Incarnation. Mary's reply to Elizabeth's greeting is a canticle, the "Magnificat," which has become a regular part of Vespers, the Church's evening prayer. Fr. Sorin described the Visitation as "the ineffable embrace of two hearts such as the world had never seen. What an unspeakable scene of heavenly peace!"[24]

Elizabeth's wondrous pregnancy marked the beginning of the unmistakable intervention of God in history, the revelation of God's saving plan from all eternity. Fr. Sorin wrote of the Visitation: "Oh! the beautiful feast! . . . No mystery of our holy Faith has filled my mind and my heart with greater admiration and veneration of our Blessed Mother."[25]

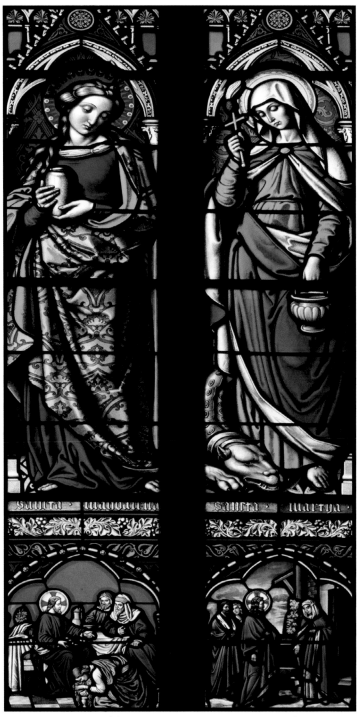

Saint Mary Magdalene *Saint Martha*
Window 33, installed 1874

SAINT MARY MAGDALENE, CONFESSOR AND PENITENT
Palestine, first century

Feast: July 22

Patron: the contemplative life, repentant sinners, perfumers, hairdressers, against sexual temptation

Attributes: alabaster jar, long light hair, sumptuous clothing

Mary Magdalene wears a richly embroidered gown. She is barefoot with the long, unbound hair of a penitent, as tradition has portrayed her. Her face is peaceful, and she holds her alabaster jar of aromatic ointment. Her medallion presents her as the woman who came to the house of Simon the Pharisee, washed Jesus's feet with her tears, kissed them, wiped them dry with her hair, and then anointed them.

Magdalene was present at Jesus's death and burial and at his tomb on Sunday morning, where she encountered the risen Lord (John 20: 11–18). Rabanus Maurus (d. 856) called her the Apostle of the Apostles. Beginning with Pope Gregory I, Western thought conflated several Marys who followed Jesus: Mary Magdalene, Mary of Bethany (Luke 10:38–42; John 11:1–42), and the unnamed "sinful woman" (Luke 7:36–50; Matt 26:6–7; Mark 14:3–9).

Her placement in the window next to Martha draws on the biblical narratives of siblings Mary and Martha (Luke 10:38–42). In France, her relics are claimed at Vézelay and at Sainte-Baume. An attractive model of repentance, she was a crucial saint in nineteenth-century French spirituality. She is also found in a window of the Lady Chapel in her richly embroidered gown, weeping at the foot of the cross. An article in the *Ave Maria* in 1868 tells of Magdalene's importance: "The saintly repenting souls . . . shine in the brilliancy of their tears. . . . At their head is Mary Magdalen."[26]

SAINT MARTHA, CONFESSOR
Palestine, first century

Feast: July 29

Patron: hotelkeepers, housewives, restaurant workers

Attributes: dragon, holy water vessel and cross

Though Saint Martha is renowned as a woman from Bethany near Jerusalem who was privileged to offer hospitality to Jesus in her home, she is presented in the large figure holding a container of holy water and a cross-shaped aspergillium, a tool for sprinkling holy water. At her feet is a unique animal that seems to be part dragon and part dog. It is the Tarasque, who lived at Tarascon, a place in southern France, and terrified the citizens. According to *The Golden Legend*, Martha, with her sister Mary and her brother Lazarus, were set adrift from the Holy Land during a persecution.[27] They landed in Sainte-Marie-de-la-Mer, France, thus establishing a biblical foundation for French faith. Martha tamed the Tarasque by holding up to it a cross and blessing it with holy water, as she is presented in her window. As seen in the medallion, Saint Martha offers hospitality to Christ at her home in Bethany with her siblings, Mary and Lazarus.

In the Gospel accounts, Martha, direct and practical, remarked that all should help out with household chores (Luke 10:40), and, when the stone was rolled away from Lazarus's tomb, observed that there would be a stench (John 11:38). But her practical observations helped her to answer Jesus's words "I am the Resurrection," with her affirmation, "Yes, Lord, I believe that you are the Christ, the Son of God" (John 11:27).

From early Christian times, the active life of Martha and the contemplative life of her sister Mary have come to represent the two forms of Christian life. Martha and Mary are set side by side in the basilica windows.

Each window opening in the nave consists of twin lancets. At the top, nested between the pointed arches, is a stylized lozenge. The Carmel du Mans called these lozenges "tympanum." The tympanum windows in the nave are to be read as a group, and are not directly related to the windows of the saints in the lancets below them. They present "the history of the Old Testament" in ten scenes.[28]

The tympanum windows are read beginning on the western wall with *Adam and Eve* and alternating west and east, starting at the entrance to the nave and ending at the transept.

In *Adam and Eve*, the first parents cover themselves in shame. The lush garden surrounds them and Adam struggles to understand. A snake crawls on its belly on the ground. God the Father leans out of a cloud, pointing to an image of the Virgin Mary, whose whole being is wrapped in a mandorla. Her foot is on the snake's head. God's words of consolation in Genesis 3:15 provide the key to reading this particular biblical narrative. Addressing the snake, God says, "I will put enmity between you and the woman, and between your seed and her seed; he shall bruise your head, and you shall bruise his heel." These words of promise are called the protoevangelium, or the first proclamation of the gospel. This "prophecy of old," Fr. Sorin says, is the promise of delivery from sin and death, and is the first revelation of God's eternal plan of redemption.[29]

In *Cain Kills His Brother Abel* (Gen. 4:8), Cain's jealousy and anger reveal the contagion of sin begun with his parents, Adam and Eve, and result in Cain's unjust murder of his brother Abel.[30] In the background are Abel's sheep and the sacrificial fire. Fr. Sorin wrote that "Abel [the just], slain by his brother Cain, represented Jesus Christ who was to be killed by . . . His brothers."[31]

The third tympanum, *Noah*, presents the patriarch as he emerges on a ladder from the ark. His dove has returned with an olive branch (Gen. 9:13), and Noah sees the rainbow in the sky, a token of God's covenant (Gen. 8:11).

The window *Abraham and Isaac* is set on a mountaintop (Gen. 22:9–14). Isaac is bound on the altar with his hands folded in prayer. Incense rises. An elderly Abraham, his clothing fluid with the movement of his knife, looks away to an angel with fluttering robes who

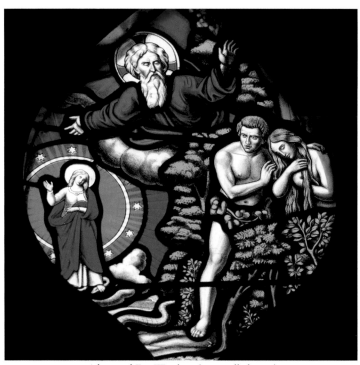

Adam and Eve, Window 41, installed 1874

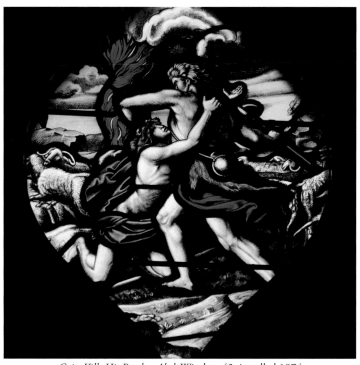

Cain Kills His Brother Abel, Window 42, installed 1874

Noah, Window 39, installed 1876

Abraham and Isaac, Window 40, installed 1876

stops Abraham's hand. A ram that will be sacrificed in place of Isaac is seen in the thicket.

Jacob's Ladder presents Jacob asleep with his head on a rock below a ladder of glory (Gen. 28:12). Angels ascend and descend the steps. At the head of the ladder, God the Father looks down on Jacob and promises him descendants.

The sixth tympanum is titled *Joseph and His Brothers* (Gen. 45:1–15). Joseph, unrecognized by his brothers, stands before them wearing both the ring and the chain about his neck that tell of the authority given him by the Pharaoh of Egypt. Brought back by Egyptian soldiers, Judah, the eldest, holds a bag of coins and argues in defense of the young Benjamin, who holds open his sack of grain. Joseph is about to dismiss the Egyptian workers and reveal his identity.

In the next tympanum, *The Passover Lamb*, an Israelite family is gathered in prayer around the Passover Lamb (Exod. 12:1–20). On the table are the lamb, a cup of wine, bitter herbs, and unleavened bread. The Passover lamb, without blemish, has been slaughtered and its blood put on the doorposts and the lintel of the house so that the Angel of Death will pass over the houses of the Israelites in Egypt. Dressed for flight, each man holds his walking staff.

In the next scene, *Moses Strikes the Rock*, the patriarch gives drink to the thirsty Israelites who surround him in the desert at Zin (Exod. 17:1–7). A man holds up a bowl to catch the flowing water. The water appears as a turquoise-colored waterfall. Moses appears larger than anyone else, with rays of light emanating from his head.

The penultimate tympanum presents the scene *Gathering Manna in the Desert* (Exod. 16:4). "Then the Lord said to Moses, 'I am going to rain bread from heaven for you, and each day the people shall go out and gather enough for that day.'" One basket of manna is labeled *panis angelicum*, "the bread of angels." In John's gospel, Jesus takes up the story of the manna in speaking of himself: "I am the bread of life. Your fathers ate the manna in the wilderness, and they died . . . I am the living bread which comes down from heaven; if any one eats of this bread, he will live for ever; and the bread which I shall give for the life of the world is my flesh" (John 6:48–51).

Finally, the window *Tobit and Raphael* presents the wonderful story found in the book of Tobit. Tobit's dog is nearby and the angel Raphael, whose name means "God heals," tells Tobit to pull out the red fish that has attacked him in the Tigris River (Tob. 6:3–4). The fish

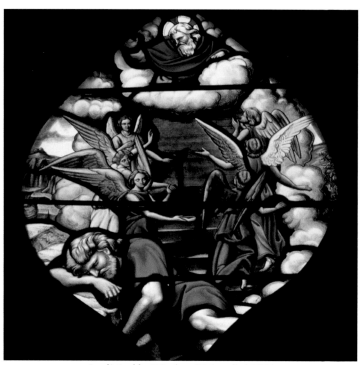

Jacob's Ladder, Window 37, installed 1874

Joseph and His Brothers, Window 38, installed 1874

The Passover Lamb, Window 35, installed 1877

Moses Strikes the Rock, Window 36, installed 1877

Gathering Manna in the Desert, Window 33, installed 1874

Tobit and Raphael, Window 34, installed 1874

represents "that ancient serpent" (Rev. 12:9, 20:2) seen first in the Adam and Eve tympanum of Genesis 3:15, the serpent whose head the Virgin Mary will bruise through the redemption brought by her son, Jesus. The tympanum windows conclude with this final scene of Tobit's victory over the monstrous fish, which tells of Jesus's victory over sin and death.

CHAPTER FOUR

The Transept

The transept arms, set at right angles to the nave, make the basilica cruciform, or cross-shaped. The transept windows are to be read following the advance of light throughout the day, beginning at the east end with the large *Pentecost* window and then proceeding to the four windows that line the transept. They conclude at the west end with the large *Dormition of the Virgin* window.

Notre Dame's basilica, called Our Lady of the Sacred Heart of Jesus by Fr. Sorin, is dedicated to the Virgin Mary. The largest windows in the basilica, located at the east and west ends of the transept, feature her. By long Catholic tradition, the Virgin Mary is also an image of the Church, and so these two large windows are about both the Virgin Mary and the Church. The windows that line the transept reinforce the focus on the Church. They, in fact, flow out of the Pentecost window because all that the Church possesses are gifts of the Holy Spirit. The transept presents a particular vision of history—a history that begins with the birth of the visible church at Pentecost and concludes with the Dormition of the Virgin and the promise of the believer's final victory over sin and death.

THE PENTECOST WINDOW

The *Pentecost* window illustrates the manifestation of the Holy Spirit that began the age of the visible Church in the world: "When the day of Pentecost had come, they were all together in one place. And suddenly a sound came from heaven like the rush of a mighty wind, and it filled all the house where they were sitting. And there appeared to them tongues as of fire, distributed and resting on each one of them.

And they were all filled with the Holy Spirit and began to speak in other tongues, as the Spirit gave them utterance" (Acts 2:1–3).

In this window the "upper room" of Pentecost (Acts 1:13) is presented as a portico open to the sky. The multiple bays make a canopy over the large group and convey the vastness of the space. The figures, grouped informally, interact with each other by glance and gesture and create between them a shared space. The linear perspective and the realistically proportioned groupings of figures construct a room that the viewer can inhabit. Saint Peter, in the bottom left, turns and looks out, inviting the viewer into the scene. Above him, another saint gestures with his left hand, directing the viewer to the central figure in the room, the Virgin Mary. This window is a particular type of composition known as a *sacra conversazione*.[1]

Mary sits on a low dais and is clothed in blue. Her stillness accentuates the lively activity evident around her. Behind her, the red cloth of honor confirms her importance and draws the viewer up to the active dove of the Holy Spirit, illustrated with outstretched wings and radiating light. Tongues of fire stand above all. A loop of animated cloth arches above one figure and gives visual testimony to the sound "like the rush of a mighty wind."

The Virgin inclines her head to her left. She looks at the apostle John, who is clean-shaven and young, and who holds the book of his Gospel. He, in his turn, looks up to Mary. This unspoken dialogue reminds the viewer of the words of Jesus on the cross to his mother, "Woman, behold your son," and to John, "Behold, your mother" (John 19:26–27). The figures around Mary represent the one hundred and twenty—apostles, disciples, men, and women—present in the upper room on the day of Pentecost (Acts 1:14–15, 2:1).

The element of color, here the use of red, becomes the directional force and unites the action in the window. The red column behind Peter directs the viewers' eyes upward through the curtains, columns, and capitals and into the stone tracery in the upper portion of the window. There, in a heart-shaped window, denoting that God is love, Christ with his cross sits enthroned at the right hand of the Father, who rests a jeweled cross-bearing orb on his knee. Both bestow a blessing. Six angels, scattered in the tracery, adore God. In the topmost window an angel holds a scroll inscribed with Gabriel's words of greeting, *Ave Maria*, "Hail, Mary," addressed to the Virgin Mary at the Annunciation, before the Holy Spirit overshadowed her.

Pentecost, Window 30, installed 1877

The circular movement of the window is completed in a return back to the Pentecost scene by way of the red column at the right of the Pentecost scene. The red garments of the kneeling saints in the foreground as well as their own shapes direct the viewers' eyes to the Virgin in front of the red cloth of honor. In this way she is in a direct line to the dove of the Holy Spirit, and to the Father and the Son.

THE TRANSEPT TYMPANA

The four tympana of the transept illustrate prayer, which is the work of the Holy Spirit. Fr. Sorin left no doubt as to the central and indispensable place of prayer at Notre Dame: "God has blessed among ourselves nothing but what has by prayer been made His own work. . . . Prayer will be the first, the indispensable means to secure success. We believe in no other, nor do we look for any such result as success among us without prayer."[2]

In the first tympanum, *Jean Baptiste de La Salle* (1651–1719), La Salle is clad in the distinctive garb of the Institute of the Brothers of the Christian Schools (also known as the Christian Brothers) that he founded. His ideas about Christian education permeated the Congregation of Holy Cross. He gazes upon an angel who holds a sword and shield because he associated teachers with the work of the guardian angels, as did Holy Cross. He holds up a parchment to a group of children and adults who proclaims the angelic liturgical hymn *Gloria in excelsis*, "Glory to God in the highest" (Luke 2:14). Correctly portrayed without a halo, Jean Baptiste was not beatified until 1888, after these windows were installed. Today he is known as the Father of Catholic schools.

The second tympanum is *Eucharistic Adoration*. The Eucharist, the most blessed sacrament, is inscribed with a crucifix and presented in a Gothic chapel monstrance around which a red sun burns with golden flames. Situated in the clouds, it is the *panis angelicum*, the "bread of angels." One of the four worshiping angels swings a thurible from which incense curls. The smoke of incense symbolizes prayer, as in Psalm 141: "My prayer rises up like incense." The monstrance depicted in this window is used for public adoration. Perpetual Adoration, regularly scheduled in the Lady Chapel after the basilica was complete, was, Fr. Sorin declared, "our great consolation."[3]

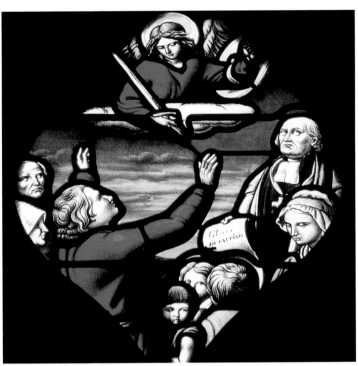

Jean Baptiste de La Salle, Window 32, installed 1874

Eucharistic Adoration, Window 28, installed 1874

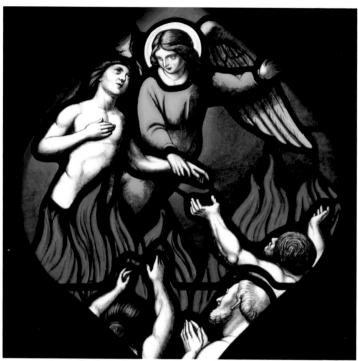

Prayer for the Souls in Purgatory, Window 31, installed 1874

The Song of Praise in Heaven, Window 27, installed 1874

The third tympanum presents *Prayer for the Souls in Purgatory*. An angel, gesturing heavenward, has taken hold of the wrist of a soul in Purgatory. The released soul, his hand on his heart, looks to Heaven. Three souls remain in the purifying flames, each in a pose of prayer. In 1890, Fr. Sorin wrote of "one of the chief objects for which generous souls love so much to pray, namely, the eternal rest of those we have lost, and who now from the excruciating flames of purgatory continually cry to us: 'Have mercy on me, at least you, my friends.' This, indeed, is a touching sight for generous hearts. For my part, I may say, it is making upon me day by day an ever-growing impression."[4] Fr. Sorin died of Bright's disease just three years later.

The fourth tympanum illustrates *The Song of Praise in Heaven*. Saints gathered in Heaven participate in the heavenly liturgy of praise of God. Among the saints is Saint Sebastian with his military clothing and his arrows, Saint Lawrence with the top of his gridiron visible, and Saint Stephen, the proto-martyr, with a stone perched on his head. Above the saints is a symbol for God the Father, the All-seeing Eye within an equilateral triangle, from which glory emanates. Below this symbol but above the saints are the words of angelic praise of God— *Sanctus, Sanctus, Sanctus,* "Holy, Holy, Holy." The triple Sanctus is the echoing song of praise sung by six-winged angels that Isaiah heard in a vision of God in Heaven (Isa. 6:3).

THE FOUR EVANGELISTS

Matthew, Mark, Luke, and John are presented in their role of evangelists. Each holds the scroll of his Gospel and is barefoot. Each has as an attribute a winged creature derived from a vision of the prophet Ezekiel. Ezekiel's four winged creatures carried the throne of mercy, indicating the divine presence of God among his people (Ezek. 1:5–10). Like the four winged creatures, the four evangelists' Gospels bear witness to the presence of God in Jesus.

The Evangelist Mark window portrays Mark as he intently writes his Gospel. His bearded lion stands with great dignity next to him. The lion is as a voice crying out in the wilderness, with which Mark begins his gospel (Mark 1:3).

Mark's companion in the lower window is *The Evangelist Luke*. His hand is poised on his Gospel scroll. He is seen with his symbol, the

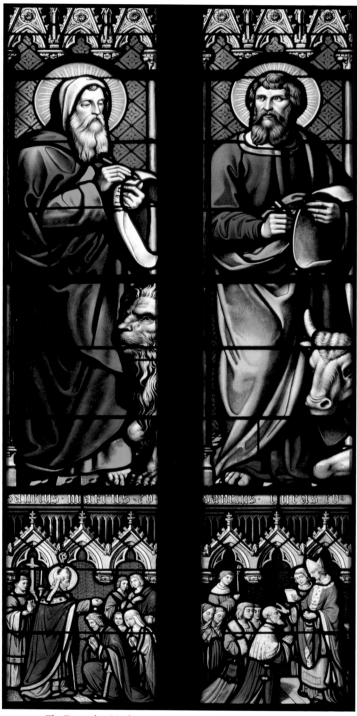

The Evangelist Mark *The Evangelist Luke*
Window 32, installed 1874

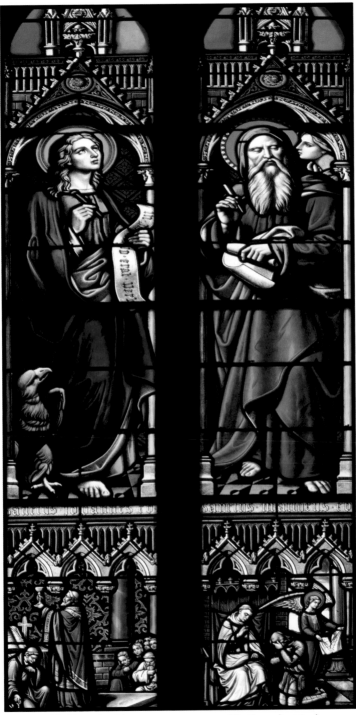

The Evangelist John *The Evangelist Matthew*

Window 32, installed 1874

ox, a sacrificial animal, for he begins his Gospel telling of the priest Zechariah, the father of John the Baptist and a priest in the Temple. Luke also wrote the Acts of the Apostles. He was from Antioch and was well educated. He is portrayed in his window with his beard parted in the style of the East.

The third window, *The Evangelist John*, presents John, always portrayed as young, looking toward heaven. His eagle stands at his feet and also looks heavenward. Because the eagle soars the highest of all birds according to medieval bestiaries, John is assigned the eagle in honor of his profound theology. He was "the disciple whom Jesus loved" (John 13:23; 19:26; 20:2). John is the author of the Gospel of John, the three Letters of John, and the Book of Revelation. He holds the scroll of his Gospel, inscribed with its beginning words: *In principio erat Verbum*, "In the beginning was the Word" (John 1:1).

The fourth evangelist is bearded. In his window, titled *The Evangelist Matthew*, he has paused in his writing and raised his quill. He is listening to the voice of a figure portrayed as a human, but often in art depicted as an angel. Matthew is assigned this attribute because he begins his Gospel enumerating the ancestors of Jesus.

THE SEVEN SACRAMENTS

The medallions of the seven sacraments begin below the four evangelists in the east transept and finish in the west transept below the four major prophets. The location of the sacrament windows below the evangelists and prophets reflects the close relationship of word and sacrament. The sacred number of the sacraments—seven—leaves one window available, and this remaining window is employed in an imagined scene of Fr. Sorin presenting the church of Our Lady of the Sacred Heart of Jesus as a votive offering to the Virgin Mary.

The first sacrament window, *Baptism*, illustrates the saving water of baptism washing away sin and making the baptized children of God and members of Christ and his Church. The baptism scene emphasizes the long association of the French monarchy and the Catholic faith. It portrays the baptism of King Clovis on Christmas day in 496 by the holy Bishop Remigius at Reims. Clovis's victory at the Battle of Tolbiac consolidated the territory that would become France. He attributed his decisive victory to Christ, through the intercession of Saint

Baptism *Confirmation*

Window 32, installed 1874

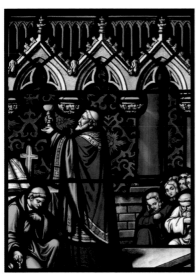
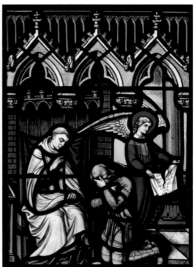

Eucharist *Reconciliation*

Window 32, installed 1874

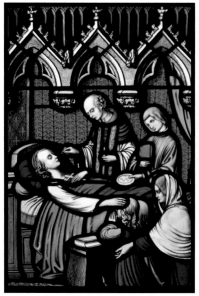

Anointing of the Sick *Holy Orders*

Window 31, installed 1874

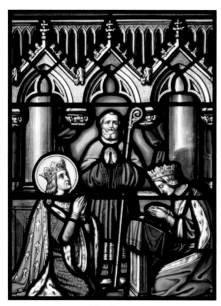

Matrimony

Window 31, installed 1874

Martin of Tours. This scene represents one of the most important events in the history of France, because the baptism of Clovis meant that all of France would be baptized in the Catholic faith. Behind Clovis kneels his queen, Saint Clotilde, who had prayed for his conversion from Arianism.

Confirmation, the second window, illustrates how this sacrament strengthens the baptized in holiness. The bishop holds the ampule of chrism and anoints the forehead of an older man who wears a short ermine cape. Others kneel behind the confirmandi. An acolyte holds the bishop's crosier.

The window *Eucharist* emphasizes the moment of elevation of the sacred host that immediately follows upon the words of consecration. The kneeling acolyte rings the bell, and the congregation makes the sign of the cross. A reflection by Fr. Sorin focuses on the reception of the Eucharist: "I, every day, or every other day, I, poor sinner, receive Him . . . in my own bosom, in my very heart, so truly that I may say with St. Paul: 'I live: no, not I, but Christ lives in me!' O wonder! The very angels adore Him in my heart."[5]

The fourth sacrament window, *Reconciliation*, explains how baptismal grace is restored. The scene presents the moment of absolution. The priest, who represents Christ, raises his hand to absolve, "in the name of the Father, and of the Son, and of the Holy Spirit." The sacramental stole is draped on the priest's shoulders. The penitent, an equestrian knight in chain mail, kneels before the priest. His guardian angel tears a paper in half. The paper lists the seven capital sins, *superbia* (pride), *avaritia* (greed), *luxuria* (lust), *ira* (wrath or anger), *gula* (gluttony), *invidia* (envy), and *acedia* (sloth).

The *Anointing of the Sick* window illustrates how this sacrament strengthens the dying and fortifies them for their final combat with sin and evil. In this sacrament sins overlooked by a good conscience as well as the lingering remnants of sin are forgiven. It can also restore bodily health. The scene portrays a critically ill young mother in her bed holding a cross to her chest. A prayer book is on the kneeler and the shawl-clad governess presents the children to their mother. The mother's right hand rests in blessing on one of them. The priest, in the sacramental stole, offers the mother the Eucharist.

The scene for the sacrament of *Holy Orders* presents a part of the ordination rite. A bishop sits in his episcopal chair, and an acolyte holds his crosier. The tonsured candidates for priesthood gather around

the bishop, who holds out the chalice and paten. One candidate has placed his hands on the sacred vessels of the Eucharist. A liturgical book of the rite of ordination, held open to the bishop, reads, *Accipe potestate offere sacrifice deo missamque celebrare tam pro vivis quam pro defunctis in nomine domini.* "Receive the power to offer sacrifice to God, and to celebrate masses for the living and the dead, in the name of the Lord."

Finally, the window *Matrimony* portrays the sacred link uniting a man and a woman. The small scene presents the marriage of Saint Louis IX, King of France, to Marguerite of Provence. He is the only sainted monarch in French history and wears a robe appointed with fleur-de-lis. Gauthier Le Cornu, the Archbishop of Sens, who witnessed their marriage at the Cathedral of Sens in 1234, stands between them with his bishop's crosier.

FATHER SORIN'S VOTIVE WINDOW

An example of a traditional donor or founder scene, *Father Sorin's Votive Window* presents Fr. Sorin, robed in an elaborate cope, kneeling before an altar, and offering the Virgin Mary a votive replica of the Basilica of Our Lady of the Sacred Heart of Jesus. Fr. Sorin, accurately portrayed as clean-shaven in this 1874 window, had not yet grown his famous beard. A scroll draped on the altar before the tabernacle declares, *b. Mariae virg. E. Sorin dicavit. a.d. mdccclxxiv,* "E. Sorin dedicates this church to the Blessed Virgin Mary, 1874." This scene expresses Fr. Sorin's gratitude for the Virgin Mary's continued intercession for Notre Dame. "Has she not taken care of us? To her we owe everything. She never forgot us in any need."[6]

The year given on the scroll, 1874, refers to the year the window was made. At that time the church building was still a work in progress. Monies were being sought and the actual year of dedication was not yet known. Finally finished and formally dedicated on August 15, 1888, its dedication extended, as Fr. Sorin wrote, to the "general dedication of the whole Institution of Notre Dame," to the buildings of the university, the statue on the dome, and "the ground on which we move."[7]

When the Holy Cross missionaries first arrived at Notre Dame on November 26, 1842, Fr. Sorin noted that the Virgin "seemed already to

Father Sorin's Votive Window, Window 31, installed 1874

have taken possession" of the land and water.[8] The snow "made upon all an indelible impression," and "could in no way be misunderstood."[9] The "deep and unspotted covering of snow was spread over the land and water, and forcibly brought to their mind the Unspotted Virgin."[10]

They had departed Le Mans for the New World on the feast then known as of Our Lady of the Snows (August 5), a feast that celebrated the legend that the Virgin Mary herself had outlined the site for a church, today known as St. Mary Major, on the Esquiline Hill in Rome with a miraculous August snowfall. Discovering that their new land was a spotless domain marked out with snow, Fr. Sorin says, "made on the new-comers an impression which time will never obliterate."[11] "I

shall tell you now what I have never said before. At that moment, one most memorable to me, a special consecration was made to the Blessed Mother of Jesus, not only to the land that was to be called by Her very name, but also of the institution that was to be founded there."[12] The Unspotted Virgin "claimed the homage, not alone of the site itself, but also of every human soul that should ever breathe upon it."[13] Wearied and intensely cold, they did not retire until they had contemplated, "again and again, and from every point around the lakes, the new scenery now before them."[14] Providence, he said, brought them there, to this land and water, which he understood in biblical imagery: "The Lord is my shepherd . . . by still waters he leads me!" (Ps. 23:1–2).[15]

THE THEOLOGICAL VIRTUES

This window presents personfications of the three theological virtues, Faith, Hope, and Charity. These virtues are not acquired by human effort but are the gifts of the Holy Spirit given in baptism. They are, typically, depicted as beautiful maidens. The remaining window presents a personification of Religion, making a group of four that was popular in nineteenth-century Catholic art.[16]

In the first figure, *Charity*, perfect Love is personified with strings of pearls in her hair. Her right hand supports her outer robe, filled with loaves of bread for the hungry and with a purse, its coins available to any in need. She holds the Agnus Dei disc near her heart, proclaiming that all she does is in the name of Christ, the Lamb of God, who loved us first and freed us from sin, which keeps us from perfect love. Below, in the medallion, the Good Shepherd is crowned with thorns.[17] The thorns are a reference to the ancient curse of thorns and thistles as punishment for sin found in Genesis 3:18.[18] Having found the lost sheep among the brambles of sin, the shepherd will lay it on his shoulders, just as Jesus took up the cross out of love for sinful mankind. The Good Shepherd, as the evangelist John said, "loved us first" (1 John 4:19), and by his redemptive suffering, freed us to love as God loves.

In the second window, *Religion*, the figure wears a regal crown and wimple. Her left hand lightly supports an ornate processional cross. Her right hand is raised in blessing for all who look to her. All the virtues tend toward the perfect love of God. Such perfect love is offered unequivocally in the liturgy of the Church, especially in the Mass, the

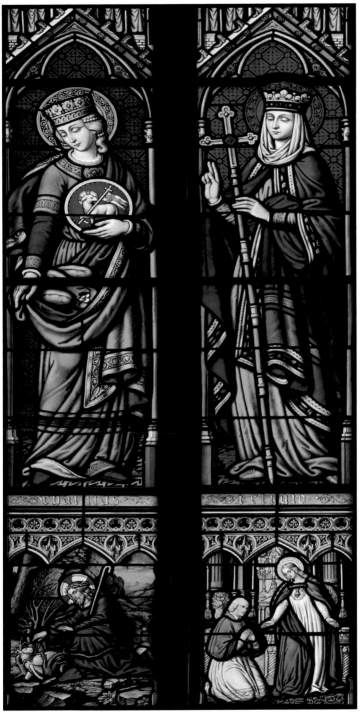

Charity　　　　　　　　　　　*Religion*

Window 28, installed 1874

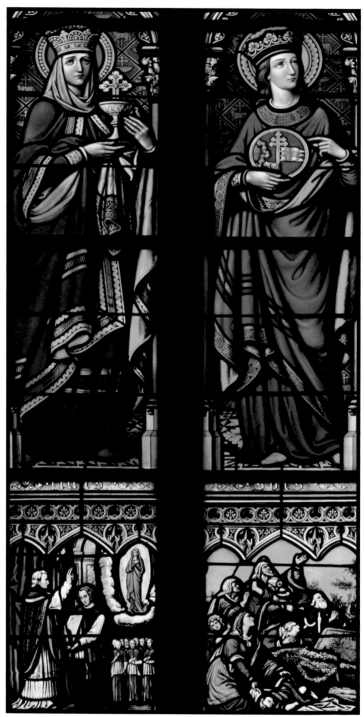

Faith *Hope*

Window 28, installed 1874

sacrament of love, which gives infinite glory to God in this world. In the medallion is Fr. Charles Dufriche-Desgenettes (1778–1860), a contemporary and favorite of Fr. Sorin. Fr. Desgenettes kneels in prayer at his failing parish, Our Lady of Victories, which had been decimated by the French Revolution and its aftermath. Instructed by the Virgin Mary, here portrayed as the Immaculate Heart of Mary, he founded a confraternity to the Holy and Immaculate Heart of Mary, which drew citizens back to the parish. The text for the confraternity sold over twenty million copies. Fr. Desgenettes is also featured in the windows of the basilica's Our Lady of Victories radiating chapel.

In the *Faith* window, the figure looks heavenward. She holds up, for all to see, the cross of Christ and the eucharistic chalice. "Faith is the assurance of things hoped for, the conviction of things not seen" (Heb. 11:1). Natural happiness is guided by evidence provided by unaided, natural reason; final, supernatural happiness, Catholics hold, is guided by the illumination of the intellect by revealed truths beyond the understanding of natural reason. Faith perfects the intellect by its firm assent to revelation. In Faith's medallion Saint John Eudes solemnly celebrates the first Office and Mass in honor of the Sacred Heart of Jesus in the Grand Seminary of Rennes, France, on August 31, 1670. Devotion to the Sacred Heart, with its close association with the Eucharist, perfectly illustrates faith. The Blessed Virgin Mary as the Immaculate Heart of Mary is symbolically present in a glowing mandorla.

Finally, the window *Hope* portrays a maiden who looks heavenward and directs the viewer's attention to the disc she holds. Here is Hope: a hand emerges from the clouds of Heaven and presents the cross with the banner of the resurrection, often depicted in art held by the resurrected Lord. Because we do not possess the happiness of Heaven in this life, the virtue of hope perfects our will, allowing us to trust in God's grace with unshakable confidence. Below, the medallion shows where Hope is at work in this world. There are garlands of funereal flowers and an open grave. A mother, as she begins to shroud her dead child, weeps as she looks toward heaven in hope of the resurrection. Grief is palpable in the agitated prayers of those around her. Here is death at its worst—the death of a innocent child. "When the perishable puts on the imperishable, and the mortal puts on immortality, then shall come to pass the saying that is written: 'Death is swallowed up in victory.' 'O death, where is your victory? O death, where is your sting?'" (1 Cor. 15:54–55).

This window presents Jeremiah, Isaiah, Ezekiel, and Daniel. They pair with the evangelists in the east transept, a long-standing tradition in stained glass windows. Each prophet holds a scroll. Their words seem to adorn their person, like clothing.

All the scrolls prophesy the virgin birth of the messiah. This window celebrates the 1854 declaration of the dogma of the Immaculate Conception. The dogma proclaimed Mary's singular freedom from the stain of original sin that allowed her to respond to the request of the Angel Gabriel at the Annunciation with total inner freedom. The simultaneous virginity and maternity of Mary is essential to the identity of Jesus as fully human and fully divine. It is enshrined in the words of the Apostles' Creed, "conceived by the Holy Spirit, born of the Virgin Mary."

In the first figure, *Jeremiah*, the covered head of the elderly prophet accentuates his pathos. He contemplates his scroll, which reads *femina circumdabit virum*. It is Jeremiah 31:22, "For the Lord has created a new thing on the earth: a woman shall encompass a man," which has been interpreted in Christian tradition as a prophecy of Mary's virginal conception of Jesus.

The second window, *Isaiah*, portrays the sublime prophet of the Incarnation. With a sidewise, heavenward glance, he listens to God. He reaches forward in a gesture of declaration. His scroll shows us *virgo concipiet et pariet filium*, "Behold, a virgin shall conceive, and bear a son, and shall call his name Immanuel" (Isa. 7:14).

Ezekiel, the third figure, is pensive. His hand holding the scroll is raised to his mouth and his words flow down. He holds *porta haec clausa erit*, the opening phrase of Ezekiel 44:2, "This gate shall remain shut; it shall not be opened, and no one shall enter by it: for the Lord, the God of Israel, has entered by it; therefore it shall remain shut." This passage is understood as a prophecy of the perpetual virginity of Mary.

Finally, the fourth figure, *Daniel*, presents the young and beardless contemporary of Ezekiel. Barefoot and clothed in a star-covered robe, he raises a declaratory hand. He displays his scroll, which includes the words *abscissus est lapis*, which refers to Daniel 2:34, "A stone was cut out by no human hand." This passage is understood as a reference to Jesus's virginal conception.

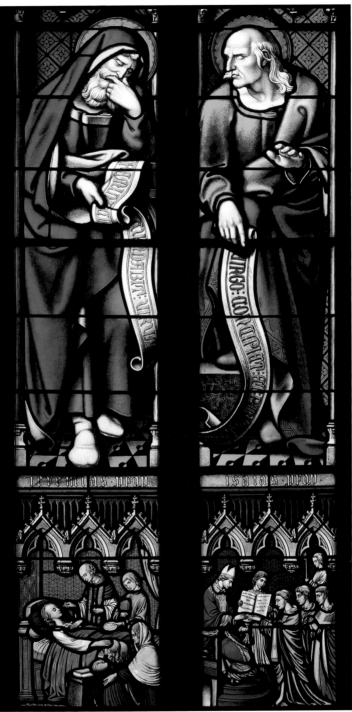

Jeremiah *Isaiah*

Window 31, installed 1874

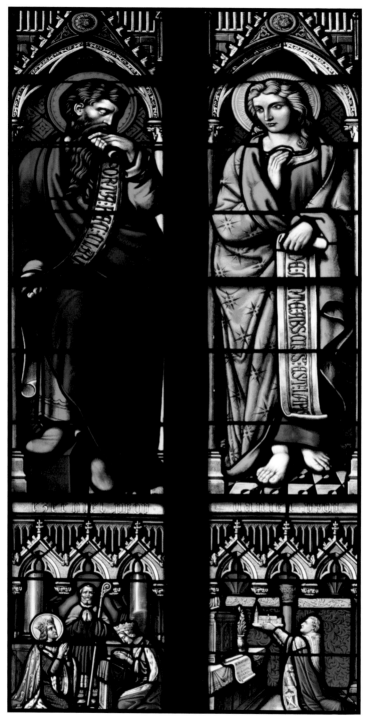

Ezekiel *Daniel*

Window 31, installed 1874

In the first window, *Guardian Angel*, the hand of the winged guardian angel hovers protectively over a young child, the open palm signaling guardianship. Complete trust is on the child's upturned face, and his hands folded in prayer tell of the angel's close and fruitful relationship. The medallion presents a little child, shoeless and asleep, who has become weary and lost picking a bouquet of flowers. The angel's fluttering robe conveys the immediacy of the angel's response to danger. The wand of authority, hastily placed on the ground, announces that the angel is from God.

The French nineteenth-century spirituality that formed the Congregation of Holy Cross especially honored guardian angels as models and patrons of teachers. "What a consolation for us all, members of a teaching Order! we are all," Fr. Sorin wrote, "the immediate, the visible assistants to the Guardian Angels."[19]

Portrayals of guardian angels in the nineteenth century emphasized the innocent vulnerability of those in their care. The Holy Cross religious were certainly "visible assistants to the angels" in their work with vulnerable orphans and destitute children, given a home and vocational training in Notre Dame's Manual Labor School, as well as with the celebrated Minims, aged twelve and under, who were the favorites of Fr. Sorin. He founded the Association of the Guardian Angels of the Sanctuary in 1874, the year this window was installed. Beside devotion to the guardian angels, the association cultivated Catholic piety and provided altar servers for the celebration of Mass. The association had a unique element, though, given Fr. Sorin's confidence in the special efficacy of children's prayer and his admiration for the pope: the association also prayed for the health and safety of the pope.

The second window is *Ecclesia*. The same word is written below this figure and is the Greek feminine noun meaning "Church." Traditionally personified as a woman, she is vested in liturgical garments, including the stole around her neck, a symbol of priestly ordination. The cope fastens across her chest with an ornate clasp. She wears the triregnum, or papal tiara. Its three gold crowns represent the pope's three offices of supreme pastor, teacher, and priest. The book of the Word of God, which she is charged to faithfully preserve, sits lightly in her left hand, which also casually holds Peter's keys of the kingdom.

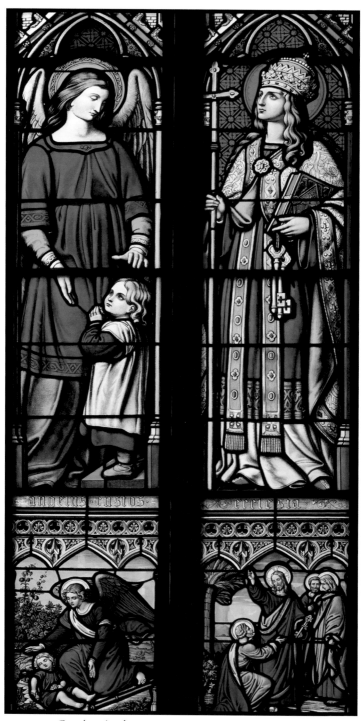

Guardian Angel *Ecclesia*

Window 27, installed 1874

Her right hand grasps the papal ferula, a staff with a crucifix at the top, and her red halo proclaims her holiness. Her gaze is not direct, but turned a bit to the side, emphasizing her focus on another place. She looks toward Jesus as the Sacred Heart in the upper window. Her strength comes from Christ, who will remain with his Church "even to the consummation of the world" (Matt. 28:20).

The medallion below the figure of the Church illustrates the story of Peter receiving the keys of the kingdom from Jesus (Matt. 16:13–20). Papal infallibility in matters of faith and morals was proclaimed in the document *Pastor Aeternus* promulgated by Vatican I in 1870, just a few years before this window was installed. Fr. Sorin was in Rome during part of the First Vatican Council and attended some of the sessions on papal infallibility. In 1881, Fr. Sorin extended an invitation to Pope Leo XIII to take up residence at Notre Dame, "the center of Catholicism in the New World."[20]

THE SACRED HEART OF JESUS
AND OUR LADY OF LOURDES

The next two windows depict visions that are immensely popular modern Catholic devotions, the Sacred Heart to Margaret Mary Alacoque, and the Immaculate Conception to Bernadette Soubirous.

The figure presented in *The Sacred Heart of Jesus* gazes directly at the viewer, inviting a response. His head is tilted slightly to his left, placing his gaze directly over his heart. His hands, bearing the marks of his crucifixion, indicate his symbolic flaming heart, placed over his chest, surrounded by a horizontal crown of thorns and radiating glory. *Miserere nobis* is inscribed below the figure of the Sacred Heart: "Have mercy on us." The medallion illustrates Margaret Mary Alacoque's vision of the Sacred Heart of Jesus in 1675 in the chapel of the Order of the Visitation at Paray-le-Monial, France. The monstrance holding the Eucharist can be seen through the light rays emanating from Jesus and reminds the viewer of the importance of the Eucharist in Sacred Heart spirituality. Margaret Mary was beatified by Pope Pius IX in 1864, and is here appropriately depicted with a halo.

In a circular letter of 1849, Fr. Sorin reflected on the original wooden church at Notre Dame consecrated to the Sacred Heart of Jesus, "our refuge" and "our model." It stood on the site of the present

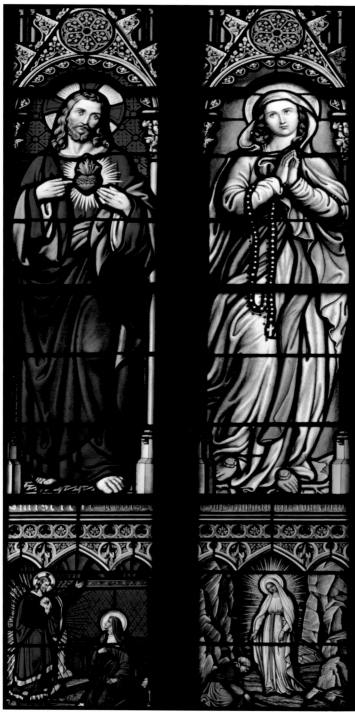

The Sacred Heart of Jesus *Our Lady of Lourdes*

Window 27, installed 1874

basilica. "As often as you enter the church, you enter, as it were, into the Heart of Jesus, there to learn how to pray, how to praise God, how to humble yourselves, and especially how to love and to sacrifice all the faculties of your being for His glory."[21]

Our Lady of Lourdes presents the beautiful woman who appeared in a grotto to young Bernadette Soubirous at Lourdes, France, in 1858. The Lady folds her hands in prayer and a rosary hangs from her arm. She is clothed in a white robe with a blue girdle and has golden roses on her feet, as Bernadette described her. She prayed the rosary with Bernadette, though the mysterious woman did not recite the Hail Mary. When Bernadette asked her name, the woman replied in Bernadette's Gascon Occitan language, but in words unknown to the simple Bernadette: *Que soy era immaculada concepciou,* "I am the Immaculate Conception." The window inscribes Mary's words below her figure in the French language, *Je suis l'immaculée conception.* The medallion illustrates Bernadette finding, at Mary's instruction, the miraculous spring. The rocks of the Massabielle Grotto surround Mary. Bernadette holds her rosary and wears a shawl and the striped headscarf of her region.

Fr. Basil Moreau, the founder of the Congregation of Holy Cross, "believed that in the designs of God the declaration of the Immaculate Conception was to be the crowning achievement of the devotion to Mary that had been growing in the Church for centuries."[22] Pope Pius IX proclaimed the dogma of the Immaculate Conception on December 8, 1854, just four years before the apparitions at Lourdes. News of the December 8, 1854, proclamation reached Notre Dame at the beginning of 1855 by way of the French Catholic newspaper *l'Univers* and was immediately celebrated. Notre Dame's church was spectacular in its decorations. The Mass was celebrated with several sermons in German, French, and English. Fr. Sorin gave the sermon in English. "Outside," Sorin's biographer Marvin O'Connell says, "joyful pandemonium reigned. . . . all the bells in the compound, big and small, rang out together, and the college band played with a zest and a volume unprecedented."[23] The residents of Notre Dame marched in procession twice around the lakes with the Eucharist. Fr. Sorin seemed to think that those in town were wondering what Notre Dame was up to again: "We have over a radius of four or five leagues no doubt stirred up a veritable panic. Tomorrow our neighbors will be demanding explanations from us."[24]

Fr. Sorin took many trips to Lourdes on pilgrimage. In 1874, the Confraternity of Our Lady of Lourdes was established at Notre Dame with the same indulgences and privileges as at Lourdes. The confraternity obtained the sole distribution of Lourdes water for the United States, and donations for the water helped raise funds for the construction of the basilica. It is still available on campus through the Holy Cross Association. Notre Dame's celebrated Grotto, a replica of the Lourdes grotto, was built in 1898.

THE DORMITION OF THE VIRGIN

The Dormition of the Virgin is modeled on a 1540 stained glass window in the church L'Assomption de Notre-Dame, in Éve, France. The Éve window is based on the design of Francesco Primaticcio (1504–1570), a Renaissance painter and architect.[25] The Carmel du Mans restored the Primaticcio window and must have made a serviceable drawing of the window at that time. The figures in the Notre Dame execution have halos, which are absent in the French window, but which were thought necessary in the missionary territory of Indiana.[26]

In this large scene, many people crowd into a bedroom. The man in the lower left glances over his right shoulder and invites us into the *sacra conversazione*. The deep purplish blue of his garment grounds us, and the "V" of his green sleeve begins a blue circle, pulling us up to the authoritative man in the center of the window. His arm is mid-motion, the raised aspergillum casting holy water onto the woman lying on the canopied bed. Someone swings a censer toward her, incensing. A young man cradles her and holds a palm, its long green branch plunging us downward, as we consider her. She is the Virgin Mary. The energy and action stop at her. She is still and turned away from the activity of the room. Her flesh is grey and her eyes are open.

Gathered about the bed are the twelve apostles. The animated faces and gestures convey a momentous occasion. At the far right, the last apostle to arrive has just entered the room. His garments are still hitched up from his walk and he carries his staff in his right hand. All are occupied with the customs that accompany the dying, complete with prayer books. The authoritative figure giving priestly blessing is Peter. A young and clean-shaven John, who took the Virgin Mary into his home, is closest to her and holds the green palm branch from

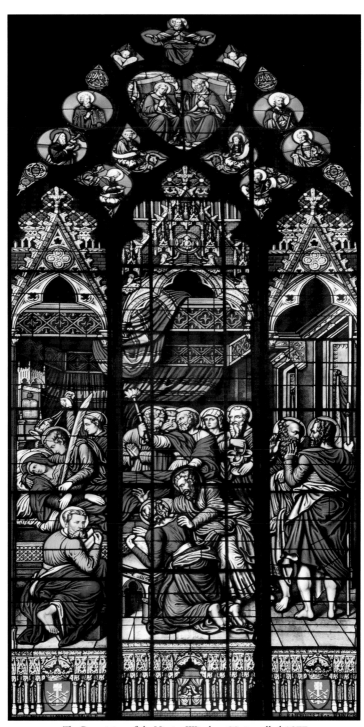

The Dormition of the Virgin, Window 29, installed 1877

Paradise. Western tradition says the archangel Gabriel gave the palm to the Virgin to announce her approaching death and that John would carry it before her funeral bier.[27]

The tablets of the ten commandments, surmounted by a red rose, are located at the head of the bed and above the Virgin's face. A miniature canopy creates a sacred space for the tablets and for the Virgin. This takes up the long Christian tradition of associating the Virgin Mary with the Temple in Jerusalem. It proclaims Mary the "container of the uncontainable." In Mary's "Yes" to God at the Annunciation, she became a dwelling for the divine, and so "her body remains holy forever thereafter as a result of housing the Holy One of Israel."[28]

The red columns and the red canopy drapery draw us upward, to the network of windows in the tracery above. There are Old Testament figures—Elijah being fed by the raven, Moses with the tablets of the law, King David with his harp, and Solomon with his censer. Prophets are seen in balconies wound round with foliage like a Jesse tree—Daniel, Micah, Zephaniah, and Joel.

In a heart-shaped window, two angels hold a blue and gold brocade cloth of honor before which Christ crowns his mother. Two cherubim occupy the small windows. Even higher, God the Father sits in a boundless sky, his hands outspread over all in blessing. Here is the final reality, perfectly depicted in Mary, the summation of the promises of God and the confirmation of Christ's final victory over sin and death.

The Sanctuary

Raised above the transept floor by steps, the sanctuary is the area that contains the altar and is the most sacred place in the church. There are two sets of windows in this area, one east and one west, each with four saints. As in the nave, these windows portray saints. Unlike the nave, the saints portrayed in the sanctuary all lived in the time of Christ, because the founders of Notre Dame "honored especially the holy personages of the Gospel who lived in the intimacy of Our Lord."[1]

The east tympanum declares the subject of the east window—Mary as *The Immaculate Conception*. Her foot rests on the moon as a golden mandorla surrounds her. Mary is depicted with her parents in the lower window and with Joseph and her child Jesus in the upper window. Pictorially, this presents the Immaculate Conception, the one who was conceived without original sin, in the context of family life.

The holy family, a central theme of nineteenth-century Catholic spirituality, was seen as the perfect model for both family life and religious life.[2] The Congregation of Holy Cross, originally structured with brothers, sisters, and priests, was modeled on the holy family.[3] According to Fr. Moreau, devotion to Jesus, Mary, and Joseph was "the distinctive characteristic of the piety" of the Congregation.[4]

Anne and Joachim, the parents of the Virgin Mary, occupy the lower east windows. Their story is found in apocryphal, or nonbiblical, narratives. The first figure, an elderly *Saint Anne*, the first teacher of Mary, wears a striped head cloth and gazes upon her daughter. Mary reads a scroll, traditionally said to be the Book of Wisdom. Her blue dress sweeps across the bottom of the window. Her long hair is crowned with a circlet, often seen in French depictions of the child Virgin. This scene is traditionally entitled "The Education of the Virgin." Notre Dame is a school dedicated to Mary and to Catholic education. Anne's medallion repeats the important theme of Mary's education,

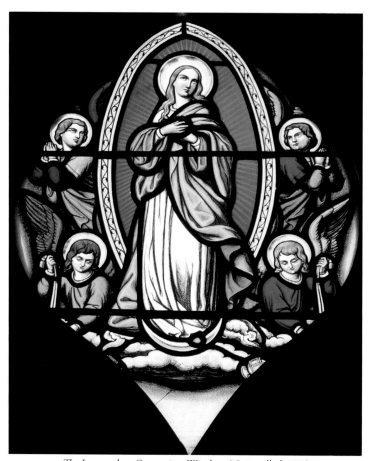

The Immaculate Conception, Window 26, installed 1874

which takes precedence over the basket of sewing and spinning chores placed in the corner.

The second figure, an elderly *Saint Joachim*, is barefoot and holds his shepherd's staff. He is turned toward the adjacent window and gazes on his daughter, who is intent on her reading. It is a window of great dignity and peace, because Joachim and Anne, tradition claims, were a family in which nature and grace were harmoniously intertwined. Their daughter Mary, born without original sin, was the beginning of redemption. Joachim's medallion presents him on his deathbed. Mary kneels at his bedside and prays. Anne stands to his left, also in prayer.

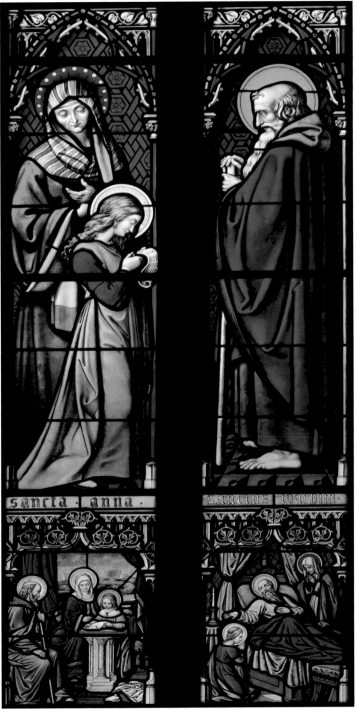

Saint Anne *Saint Joachim*

Window 26, installed 1874

Above Anne and Joachim are *The Virgin and Child* and *Saint Joseph*, the holy family. The Virgin Mary faces forward and wears a crown.[5] She is barefoot, and her long, unbound hair tells us she is a virgin. Her downward gaze directs us to her child, held between the golden edges of her robe. She supports Jesus effortlessly, and seems to be in the act of turning him forward. His gaze is upon the viewer, and his gold and red cruciform halo emphasizes his face, wise beyond his years. His left hand holds the blue orb of the world, surmounted with a cross. His right hand is raised in blessing. The Virgin's figure is not subscripted with her name but with the Latin phrase, *Ora pro nobis*, "Pray for us." In addition, her medallion is not a scene from her life, but illustrates Genesis 3:15, God's first promise of redemption, and its future fulfillment in the Virgin Mary, portrayed as the Immaculate Conception.[6]

Saint Joseph stands in the adjacent niche, at the Virgin's side. His left hand has gathered his full robes, and his drapery sweeps in the opposite direction of Mary's, creating between them a circular movement. His lily-flowered staff draws the viewer to his elderly face, framed in a red and yellow halo. His entire focus is on Mary and her child. Joseph's medallion depicts the holy family in Saint Joseph's carpenter shop, a favorite scene in nineteenth-century spirituality. The Virgin sits on a raised chair, a long green and gold brocade cloth draped behind her. She holds her distaff and spindle in her hands as she spins thread. Joseph wears common clothes and a carpenter's leather apron and holds a wood plane. All about the workshop are the tools of his trade: chisels, a hammer, and a ruler. A vase filled with lilies, a flower associated with Saint Joseph, sits on the windowsill. A young and very determined Jesus is learning the carpenter's trade under the watchful eye of his foster father. Jesus is beginning to saw the small bench on which he is kneeling in half. Joseph has raised his hand as if to say, "Pay attention to what you are doing."

The family scene found in Joseph's medallion certainly evokes the family of Holy Cross. Fr. Sorin established a Confraternity of the Holy Family. Its members would "study and imitate the life of that earthly Trinity, and secure for themselves the protection of Jesus, Mary and Joseph. Evidently, it is adapted to none better than ourselves; in every way, it should be *our* Confraternity."[7]

On December 5, 1842, Fr. Sorin wrote in his first letter from Indiana to Fr. Moreau in France, "Truly, it is somewhat cold here; but,

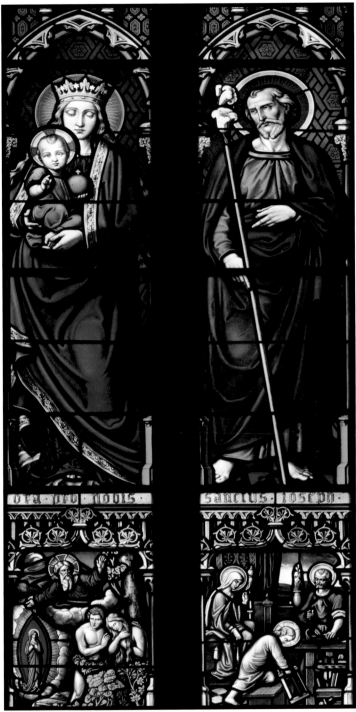

The Virgin and Child *Saint Joseph*

Window 26, installed 1874

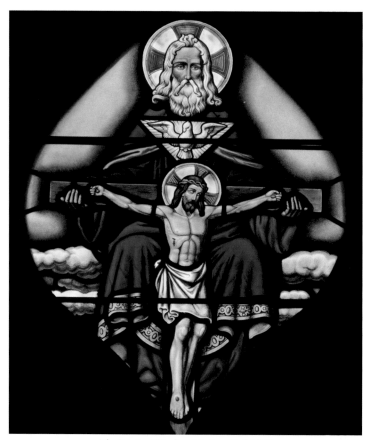

The Trinity, Window 25, installed 1874

though at times the blood does not circulate freely through one's members, provided the heart still beats with love for the work of Jesus, Mary and Joseph, what more is needed?"[8]

Across the sanctuary, the west tympanum presents *The Trinity* as the Throne of Mercy, an image popular from the twelfth to the seventeenth century. God the Father, seated in the heavens on a throne of clouds, holds the lifeless Jesus on the cross. The Holy Spirit in the form of a dove is between them.

In the west window, the two lower figures present Peter, the head of the apostles, and Paul, the apostle to the Gentiles. They are often shown together in sacred art because together they represent the Universal Church.

The *Saint Peter* window presents the apostle to whom Christ gave the role of first pope, raises the keys to the Kingdom of Heaven for the

Saint Peter *Saint Paul*

Window 25, installed 1874

viewer's consideration. The keys, usually, as here, presented one in silver and one in gold, represent the dual nature of the kingdom, of both earth and heaven (Matt. 16:13–20). Peter is an older man with short white hair and a short beard, as his iconography has depicted him throughout Christian history. Peter's medallion illustrates his martyrdom by crucifixion, upside down, outside the walls of Rome on Monte Montorio. Fr. Sorin especially loved Saint Peter, the first pope.

In the *Saint Paul* window, Paul stands dressed in a robe that envelopes a long and elaborate sword. Paul, a Roman citizen, was martyred by beheading. He glances downward as if deep in thought. His figure illustrates his well-known iconography—dark hair, a receding hairline, and a long dark beard. He is an apostle, a title bestowed by his conversion experience, as one "untimely born," of the resurrected Lord (1 Cor. 15:8), illustrated in his medallion (Acts 9:1–22). Presented in military clothing, the not-yet converted Saul is without a halo. Blinded by the sudden appearance of Christ as he was travelling to Damascus, he is on the ground. Christ leans out of a cloud in a light of glory, one hand indicating Saul and the other pointing toward the Christians in Damascus whom Saul intended to arrest, and asks him, "Saul, Saul, why are you persecuting me?" Saul's horse gallops away. Though there is no horse in the biblical account, Christian art has depicted one, adding to the narrative of the scene.

The two upper figures in the west window portray the last prophet, John the Baptist, and the last patriarch, Joseph.

John the Baptist had announced: "Behold the Lamb of God, who takes away the sins of the world" (John 1:29). In the window *Saint John the Baptist* the prophet fulfills his sacred role—his right hand indicates Jesus, held by Saint Joseph in the adjacent window. He is barefoot and bare chested, clad in a camel-skin tunic. He holds a cruciform staff. At his feet stands the Lamb of God, one of the most ancient symbols for Christ. In his medallion, Herodias's daughter, traditionally known as Salome, kneels before her mother, holding the tray displaying the haloed head of John the Baptist (Matt. 14:6–11). Herodias's drooping feather fan tells of the frivolous evening that ended with John's execution. Herod, crowned with laurel, looks out from the scene. He had promised Salome anything she wanted if she would dance. She claimed the head of John the Baptist.

Saint Joseph appears twice in the sanctuary's eight figures, once in the east window and here, in the west window, as *Saint Joseph, Patron*

Saint John the Baptist

*Saint Joseph, Patron
of the Universal Church*

Window 25, installed 1874

of the Universal Church. The upsweep of Joseph's blue cloak draws attention to the peaceful triangle that encloses Joseph and the child Jesus in his arms. Joseph's yellow halo focuses the viewer on his devotion to the child Jesus, evident in the inclination of his head. His richly embroidered robes tell of his importance, and he holds his lily-flowered staff. Jesus holds a rose, a reminder of his Virgin Mother, and reaches out in blessing, supported by Joseph's arms. Joseph's figure is singularly subscripted, not with his name but with the Latin phrase popularly applied to Joseph, *Ite ad Joseph*, "Go to Joseph" (Gen. 41:55). His medallion presents the death of Joseph. Mary, ever virgin, does not touch Joseph. Jesus cradles Joseph's head and raises his hand in a final blessing. Joseph's death can also be found in a window of the Saint Joseph Chapel.

Pope Pius IX had declared Joseph the Patron of the Universal Church on the Feast of the Immaculate Conception in 1870, just four years before this window was installed. In 1872, we find in *Ave Maria*: "How deeply in keeping with the propriety of things is it that the Protector of our Saviour-God should also be the Protector of His Mystical Body, which is the Church."[9] A Saint Joseph holy card in Fr. Sorin's final prayer book, with a prayer to Saint Joseph as the Patron of the Universal Church, bears witness to this popular and widespread nineteenth-century devotion.

CHAPTER SIX

The Radiating Chapels

A radiating chapel is a small, semi-circular chapel that projects out, or radiates, from the area behind the altar. Radiating chapels appeared in the Romanesque period and provided further, discreet space to accommodate an additional altar for the celebration of Mass. Twelfth-century structural innovations marking the emergence of the Gothic period allowed for thinner and taller walls and resulted in the great development and multiplication of stained glass. Radiating chapels are commonly found in French Gothic churches.

Although constant financial shortfalls marked the construction of the church at Notre Dame, it boasts seven radiating chapels, an unusual attraction in America that elevated the status of Notre Dame's church. Notre Dame's Thomas Stritch noted that even as late as the 1930s the radiating chapels were "the first such many of us [students] had ever seen."[1]

The chapel windows date from the Eugène Hucher era of the Carmel du Mans Glassworks. Hucher judged the carmin technique more proper to porcelain and not a technique to be used in authentic, classical stained glass, and so brought an end to the use of carmin. By 1881, Frédérick Küchelbecker had left the Carmel du Mans and was established at the St. Joseph Glassworks in Le Mans.

The scenes in the chapel windows flow across the wall openings in the pictorial style of the Renaissance, as if a window had been opened upon a particular scene. The light pours through them more freely, and some of the glass even reveals the scenery outside the basilica.

Until about the seventeenth century Saint Joseph was relatively ne-
glected in Western spirituality, portrayed as an aged and marginal fig-
ure that attended to the needs of the Virgin Mary and the child Jesus.
The now universal image of Joseph as a young and active member of
the holy family first emerged, though not without some ancient prece-
dent, in the late Middle Ages (1300–1500), when family structures
were threatened by plagues, famines, war, and economic hardships.[2]
The development of Joseph as an admired and significant saint made
possible the flowering of the cult of the holy family, for "a strong, posi-
tive image of St. Joseph is a prerequisite for regarding Jesus, Mary, and
Joseph as a credible family unit."[3]

Devotion to Joseph was an outstanding feature of nineteenth-
century French spirituality. Saint Joseph's important place in the Con-
gregation of Holy Cross's devotions is evident in Fr. Sorin's striking
account of Notre Dame's recovery from the devastating fire of 1879
that destroyed the Main Building and "threatened a complete ruin
on Notre Dame."[4] Two weeks after the fire, "when the ruins were yet
smoking and not a step had been taken to repair the immense fatality,"
Fr. Sorin entreated Saint Joseph "to take the matter in his own hand."[5]
"The following morning all was changed, and in six months the loss
was repaired, even to advantage."[6] Fr. Sorin attributed the recovery to
the intercession of Saint Joseph.

According to the apocryphal *Protoevangelium of James*, Mary
was raised in the Temple in Jerusalem from the age of three. When the
time came to select a husband for her, all eligible male descendants of
the tribe of Judah were asked to bring their staff to the Temple. In the
first window scene, *The Selection of Joseph as Mary's Husband*, stand the
eligible descendants. Clean-shaven young men wearing short tunics
and holding their staves are gathered in the Temple. Joseph, bearded
and wearing long dignified robes, stands alone before them. Incense
rises, and the high priest, at the altar, wears the breastplate of Aaron.
He has taken up Joseph's staff. It has budded forth, indicating that
God himself had selected Joseph to be Mary's husband. Joseph's hand
is placed on his chest and his head is bowed.

The second scene, also from apocryphal literature, presents *The
Wedding of Joseph and Mary*. Set before the altar in the Temple, Joseph
is placing a ring on Mary's right hand. A maid stands behind the
modest Virgin and the high priest officiates. His hand is raised in bless-

The Selection of Joseph as Mary's Husband, Window 20, installed 1884

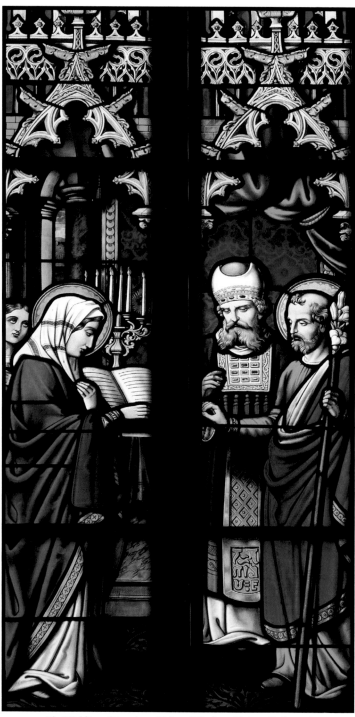

The Wedding of Joseph and Mary, Window 20, installed 1884

ing over the ring. Joseph is older and balding and holds his budded staff. When Joseph found that Mary was with child after they were betrothed but before they had married, he, "being a just man," had "resolved to send her away quietly. But as he considered this, behold, an angel of the Lord appeared to him in a dream" instructing him to take Mary into his home "for that which is conceived in her is of the Holy Spirit . . . for he will save his people from their sins" (Matt. 1:19–21).

Jewish law required that all firstborn males should be consecrated to the Lord and then redeemed by a sacrificial offering. In the third scene, *The Presentation of Jesus*, Joseph and Mary are in the Temple in Jerusalem to fulfill the requirements of the Law. Joseph presents two turtledoves, the sacrificial offering prescribed for the poor. Mary holds the swaddled Jesus within the folds of her robe. His head radiates cruciform rays. An incense burner emits curling smoke. Joseph shares the scene with the prophet Simeon, who was "righteous and devout, [and] looking for the consolation of Israel," for "it had been revealed to him by the Holy Spirit that he should not see death before he had seen the Lord's Christ" (Luke 2:25–26). Simeon's hand is on Jesus's head. He is proclaiming his famous canticle (Luke 2:29–32), which begins "Lord, now you let your servant go in peace." Simeon also prophesied to Mary, "a sword will pierce through your own soul" (Luke 2:29). Simeon's prophecy is, tradition says, the first of Mary's seven sorrows. Directly across the basilica, in the Holy Cross Chapel, is Mary's fourth sorrow, the Virgin meeting her son as he carries his cross. Fr. Basil Moreau, founder of the Congregation of Holy Cross, placed the entire congregation under the patronage of Our Lady of Sorrows whose feast on September 15 is the main feast day of the Congregation of Holy Cross.

In the fourth scene, *Joseph Is Warned by an Angel to Flee to Egypt*, a sleeping Joseph holds his carpenter's saw. A book is on the table before him, and his sandals are on his feet. Behind him, the sleeping Virgin, before a canopy, holds the child Jesus close. A red-winged angel has arrived. Its garments are still fluttering. The angel looks to Joseph, telling him in his dream: "Rise, take the child and his mother, and flee to Egypt" (Matt. 2:13). An oil lamp illuminates the scene. Its highlights help us see out the window and reveal the night. The angel's hands frame the tragic outdoor scene. Soldiers with drawn swords knock at a door. The angel's order, Fr. Sorin wrote, "admits of no delay; the next moment Mary and Jesus, under the protection and guidance of Joseph, are on their journey, directing their steps towards Egypt."[7]

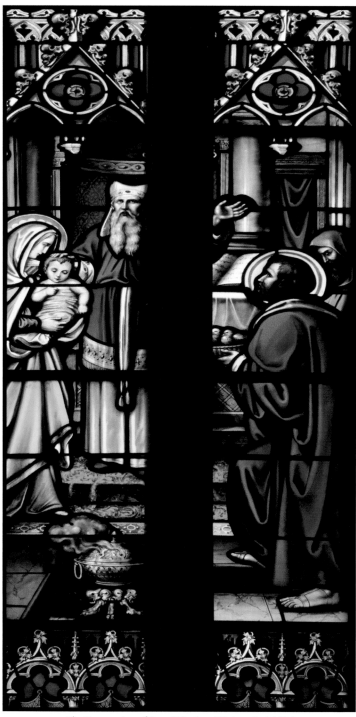

The Presentation of Jesus, Window 22, installed 1884

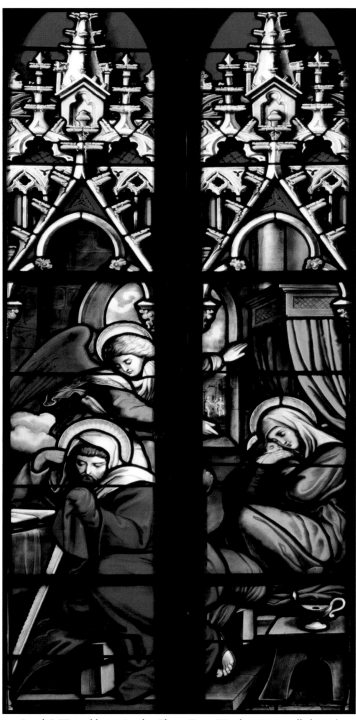

Joseph Is Warned by an Angel to Flee to Egypt, Window 22, installed 1884

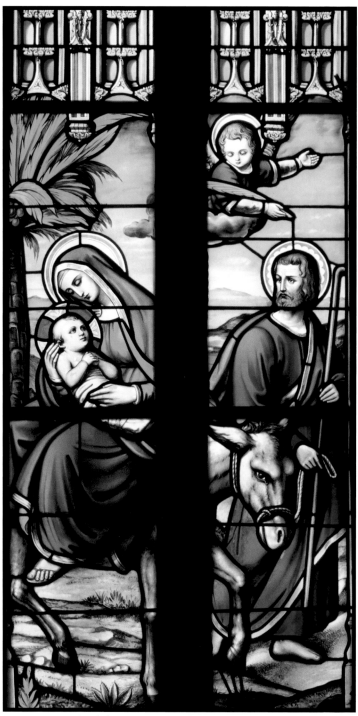

The Flight into Egypt, Window 24, installed 1884

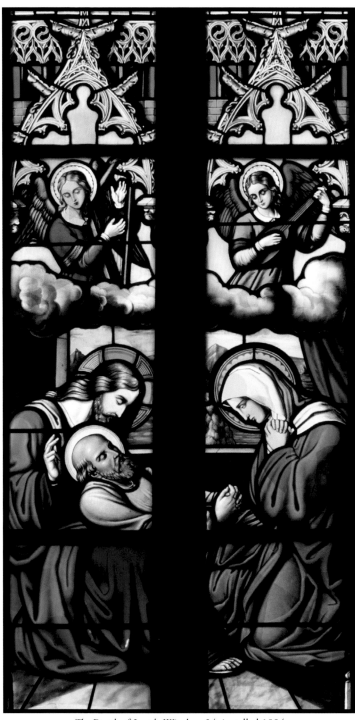

The Death of Joseph, Window 24, installed 1884

The fifth scene presents *The Flight into Egypt*. A barefoot Joseph with a walking stick leads the way. He looks behind at the Virgin and Child on the haltered donkey. Mary sits astride the donkey with her back to Joseph, cradling the infant Jesus. The palm tree frames the scene and mountains are in the distance. A young angel, holding a palm branch and guiding the way forward, glances behind to the Virgin and Child. Again, Fr. Sorin's words describe the scene: "Strange and unlooked-for as the flight may appear, the young Mother, with her precious Burden in her arms, follows in silence her dear guide and protector; not a word of complaint or of apprehension escapes her lips; she trusts in him and fears no evil."[8]

In the final scene, *The Death of Joseph*, the elderly Joseph, between Jesus and Mary, dies in the lap of Jesus. Joseph's hands are folded in prayer. Jesus looks down into his face and blesses him. A young Mary kneels at his feet and clasps her hands in sorrow. The large window opens onto distant mountains. In a golden light, two angels playing the harp and the lute attend the death on darkened clouds. This final scene is not biblical, but Joseph is traditionally believed to have died in Nazareth, with Jesus and Mary. The tympanum above this scene reminds us that Joseph is the patron of a happy death—an angel holds up the words of Revelation 14:13, *Beati [mortui] qui in domino moriun[tur].* "Blessed are the dead who from now on die in the Lord."

THE VIRGIN MARY CHAPEL

Church fresco cycles of the life of the Virgin, found as early as the ninth century in Eastern Europe, presented various narratives of Mary's life. Of the six scenes in this chapel, the first four are selections from traditional narratives and come from apocryphal literature. The final two scenes extend the Virgin's narrative to include the modern proclamation of the dogma of the Immaculate Conception.

The tympana honor Mary as *Sancta Virgo Virginum*, "Holy Virgin of Virgins," and *Regina Virginum*, "Queen of Virgins." In 1880, on the Feast of the Purity of the Blessed Virgin, Fr. Sorin wrote to the members of the Congregation of Holy Cross: "May the glorious Queen we all love with our whole soul, and whose purity permeates our hearts today with such a veneration, purify more and more our mutual feelings, and thus make us more worthy of each other, and, above all, more worthy of our Divine Brother's Virgin Mother!"[9]

Mary's nativity scene is typical of fourteenth- or fifteenth-century presentations of *The Birth of the Virgin*. A red bed curtain is drawn back to reveal Anne, the mother of the Virgin Mary, sitting in her bed. A handmaid offers Anne nourishment. An elderly Joachim, Mary's father, looks over the scene. Anne and Joachim's advanced age is a reminder of the intervention of God in the barren Anne's old age pregnancy. A washbowl and towel are near the second handmaid, who presents the bathed and loosely swaddled Virgin Mary. Newly born, Mary has a halo because she was conceived without the stain of original sin. A window reveals an outdoor scene. Above, angels celebrate the birth and bear a scroll that reads *et egredie(t)vr virga v radice jesse*. "There shall come forth a shoot from the stump of Jesse" (Isa. 11:1).

In the second scene, *The Presentation of the Virgin Mary*, Anne and Joachim have taken their daughter to the Temple in Jerusalem. Unaided, the three-year-old Virgin Mary holds a candle and climbs the Temple steps. Anne remains behind her and holds a book, indicating that she has already begun Mary's education. An elderly Joachim leans on his walking stick. Rejected from the Temple because he was without children, Joachim now returns with his daughter and offers her to God. She will remain in the Temple, continuing her education, until she reaches maturity. A maidservant looks on, and the high priest spreads his hands in welcome. Apocryphal accounts say the Virgin danced on the Temple steps and took a vow of virginity.

The third scene depicts *The Assumption of the Virgin Mary*, body and soul, into Heaven. Mary ascends in a burst of golden light. She wears a white gown and a purple-lined blue mantle with her name embroidered around its golden edge. Her hair, unbound as a virgin's, descends her shoulders. With hands crossed on her breast, Mary looks upward. Two cherubim are in the gothic arches above her. Below, an angel is turned toward the Virgin and drops roses into her sepulchre, reflecting a fourth- or fifth-century tradition that when Mary's sepulchre was opened it contained only lilies and roses. Pilgrims who visited Notre Dame in the nineteenth century not only admired this window but also visited a "tomb of Our Lady," constructed to faithfully represent the tradition of her empty tomb.[10] It was located in the woods north of St. Mary's Lake.

In the fourth scene, *The Coronation of the Virgin Mary in Heaven*, yellow rays within a golden sky descend from the dove of the Holy Spirit. Jesus, seated on a cloud, holds the crown over the Virgin's head. God the Father holds a scepter and raises his hand in blessing above

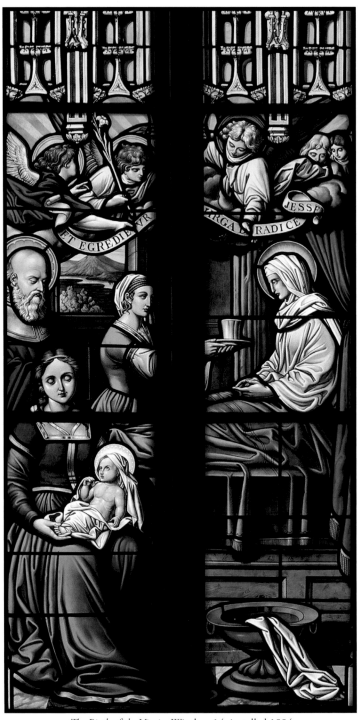

The Birth of the Virgin, Window 14, installed 1884

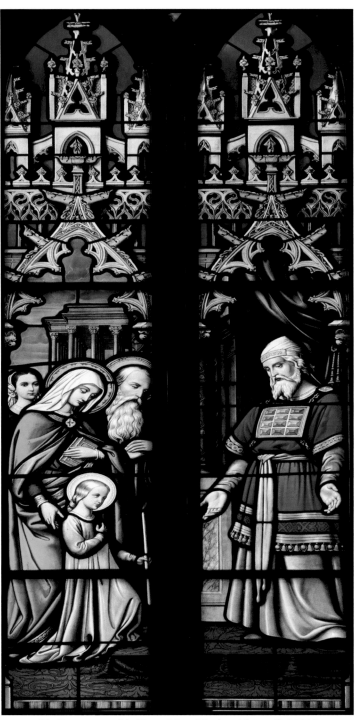

The Presentation of the Virgin Mary, Window 14, installed 1884

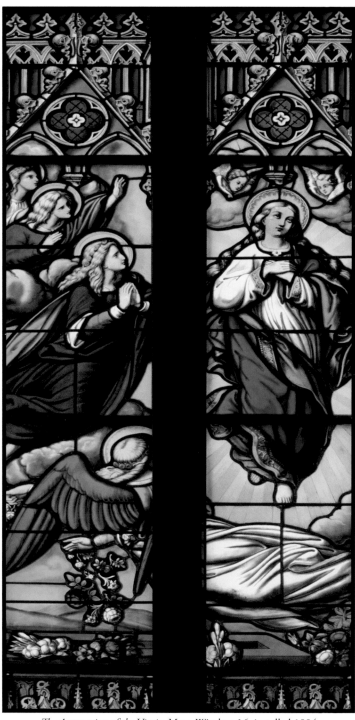

The Assumption of the Virgin Mary, Window 16, installed 1884

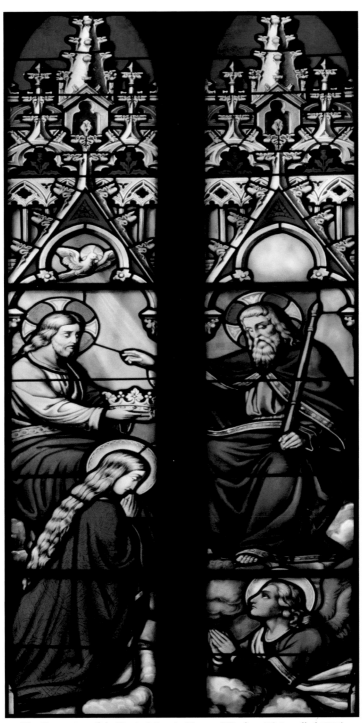

The Coronation of the Virgin Mary in Heaven, Window 16, installed 1884

The Proclamation of the Immaculate Conception, Window 18, installed 1884

Mary's crown. It is the moment of the coronation. She is the Queen of Heaven. The Trinity wears a cruciform halo. The Virgin does not look upon the Trinity, but is bowed in prayer. A red-winged angel, with unfurled wings, looks up to her, because she is also the Queen of the Angels.

The fifth scene, *The Proclamation of the Immaculate Conception*, portrays Pope Pius IX wearing the papal triregnum crown and a robe elaborately embroidered with images of the apostles. The pope indicates an angel who holds the proclamation, complete with the seal affixed by a ribbon at the bottom edge and dated December 8, 1854. Five cardinals and bishops represent the one hundred and seventy present in St. Peter's that day, as well as innumerable pilgrims. The city of Rome appears behind the assembled hierarchy. There is an arch and a church in the background. The angel holding the proclamation points higher, to the window above.

Above, the sixth scene portrays *The Blessed Virgin Mary as the Immaculate Conception*. A sunburst presents the Virgin "clothed with the sun" (Rev. 12:1). Her graceful curved figure is robed in white with a blue mantle edged in gold. She is beautiful and young and holds her hands in a gesture of prayer. The moon is under her feet (Rev. 12:1), and she treads the ancient serpent (Gen. 3:15) and stands upon the world. Set in the clouds, the Virgin is the "great sign [that] appeared in heaven" (Rev. 12:1). Three angels accompany her. One carries a lily, a symbol of Mary's virginity, and another a crown of white flowers because she is the Queen of Virgins. The third angel, with covered hands, carries the Crown of Thorns, because Mary as the Mother of God shared in Christ's passion.

THE HOLY CROSS CHAPEL

In the plans for the chapels, Fr. Sorin did not identify this chapel as the Stations of the Cross chapel, as it has come to be known, but as *la santé croce*, the chapel of the Holy Cross. Fr. Moreau, the founder of the Congregation of Holy Cross, instilled a love for the cross of Christ in members of the Congregation.[11] This love of the cross, characteristic of nineteenth-century spirituality and especially of the Congregation, sprang from devotion to the Eucharist and the Sacred Heart, as well as the frequent practice of the Stations of the Cross.

The Blessed Virgin Mary as the Immaculate Conception,
Window 18, installed 1884

The Stations of the Cross, one of the most popular Catholic devotions, consists of fourteen stations or halting places that are placed at intervals in the nave of a church or on an outdoor path. Each station commemorates a significant event as Jesus was condemned to death in Jerusalem, carried his cross outside the city, and then was crucified, died, and was buried. Outdoor stations were erected at Notre Dame in the woods north of St. Mary's Lake and drew pilgrims in the nineteenth century.

The chapel windows, limited to six scenes, required a careful selection from among the fourteen stations. Their distillation reveals the focus of this chapel. There is no presentation of the crucifixion. The crucifixion scene is reserved for the Lady Chapel, whose windows are dedicated to the Sacred Heart.

The three lower scenes focus on Jesus taking up his cross and carrying it along the way. The background of each scene follows Jesus's movement, beginning with the walls inside Jerusalem and moving out and away from the city. Jesus is never alone with just soldiers. In every scene sympathetic figures invite the viewer to join the movement. Simon the Cyrene, who was pressed into service, helps Jesus to carry the cross. Jesus is accompanied, as well, by some of his followers. The viewer is to hear the words of Jesus, "If any man would come after me, let him deny himself and take up his cross and follow me" (Matt. 16:24).

The three upper scenes depict Jesus's three falls beneath the cross. This repeated focus reminds the Christian viewer that Jesus, in his solidarity with fallen humanity, took up the weight of human sin when he took up the cross. The viewers are encouraged to examine their conscience and repent of their sins. A pilgrimage, an act of penance, is, as Fr. Sorin once wrote, "no pleasure party; it is essentially a praying movement, an earnest search after Divine assistance and protection."[12]

In 1887, the elderly Fr. Sorin made a pilgrimage to the Holy Land. On his return voyage he wrote "a little new Way of the Cross, as I have long wished to do."[13] Excerpts from Fr. Sorin's *Via Crucis: The Way of the Cross*, published in 1888, are included below to help illustrate this chapel's windows.[14]

In the first scene, *Jesus Takes Up the Cross*, a barefoot Jesus wears the crown of thorns. His robe is purple, a color that is both royal and penitential. His red mantel is symbolic of suffering. Already condemned to death by crucifixion, he looks at the cross as it weighs into

Jesus Takes Up the Cross, Window 23, installed 1884

his hands. "Jesus," Fr. Sorin wrote in his *Via Crucis*, "beholds the instrument of His death!"[15] Simon the Cyrene helps Jesus bear the cross. An armed soldier stands nearby.

The second scene, *Jesus Falls the First Time*, presents the first of the three times Jesus fell under the weight of the cross. The rock that marks this station in Jerusalem is seen beneath Jesus's hand. As Simon the Cyrene steadies the cross, soldiers raise their hands against Jesus. Of this scene, Fr. Sorin wrote, "Fill my heart with Thy holy love, that I may never fall again into mortal sin; that I may make some return for Thy infinite charity!"[16]

The third scene is that of *Jesus Meets His Afflicted Mother*. Her hands are raised in sorrow, and another woman stands behind her. Jesus has lowered his hand and opened it toward Mary. The mounted soldier has paused and glances over his shoulder. The dramatic unfurled cloth on his lance gives a sense of urgency and of pressing forward. Simon the Cyrene has faded to the background, giving this central scene a Marian focus. Fr. Sorin speaks of the stations as "a religious practice so directly and so admirably instituted to honor our dying Redeemer and His sorrowful Mother."[17] He writes, "Here, in overwhelming affliction, met the two tenderest hearts that ever lived! . . . O Merciful Jesus, by the merits of this sorrowful meeting teach me how to meet adversity, pains of mind and body, with patience and humble resignation."[18]

The fourth scene, *Jesus Falls the Second Time*, presents Jesus on one knee, bowing his head. His hand rests upon the rock in Jerusalem that traditionally marks his second fall. A sorrowing Simon helps Jesus with the cross. An armed soldier leans forward, pointing, and driving Jesus and Simon on. "He falls again, exhausted, to the ground," Fr. Sorin wrote of this station. "Sweet Jesus, shall I require any new proof of the sad consequences of my sins? By the merits of this second fall grant me, O merciful Redeemer, never to resist again Thy holy grace."[19]

Jesus is still fallen in the fifth scene, *Veronica Wipes the Face of Jesus*. Simon looks ahead, grasping the cross, but Jesus looks behind. Veronica, a nonbiblical woman traditionally found in the stations, has lowered herself to Jesus's gaze and holds out a cloth to wipe his face. The image of Jesus's face, tradition claims, remained upon the cloth. Two distraught women behind Veronica portray the women who accompanied Jesus on his way. "O Divine Redeemer," wrote Fr. Sorin in his *Via Crucis*, "grant me the grace to serve Thee to the end of my life

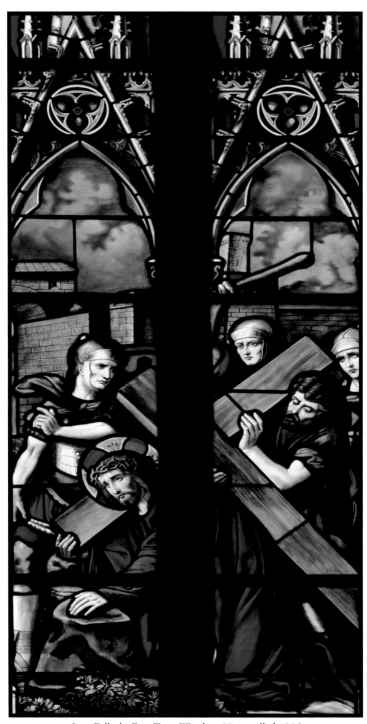

Jesus Falls the First Time, Window 23, installed 1884

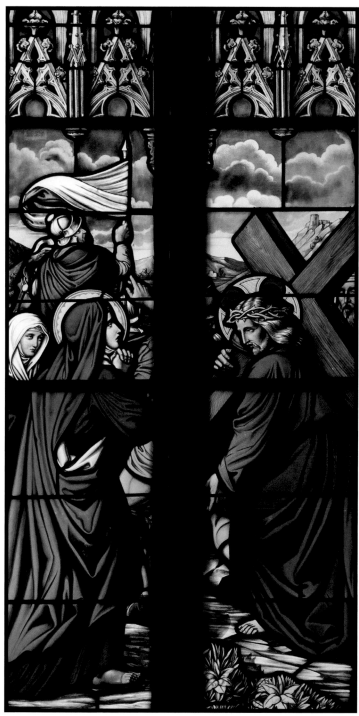

Jesus Meets His Afflicted Mother, Window 21, installed 1884

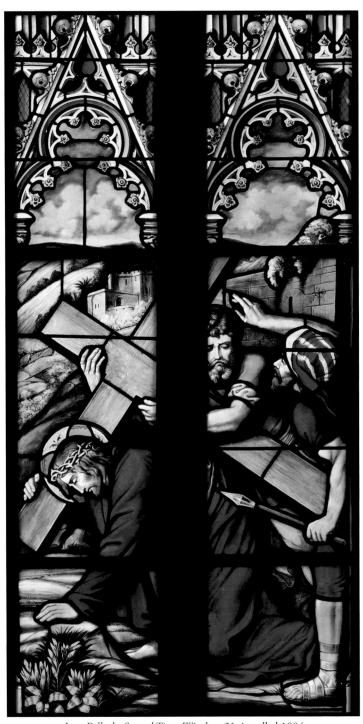

Jesus Falls the Second Time, Window 21, installed 1884

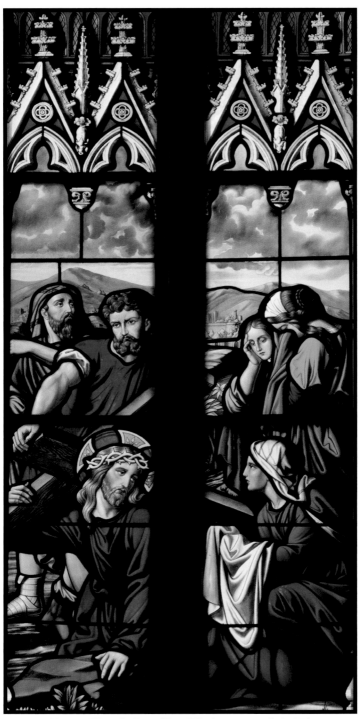

Veronica Wipes the Face of Jesus, Window 19, installed 1884

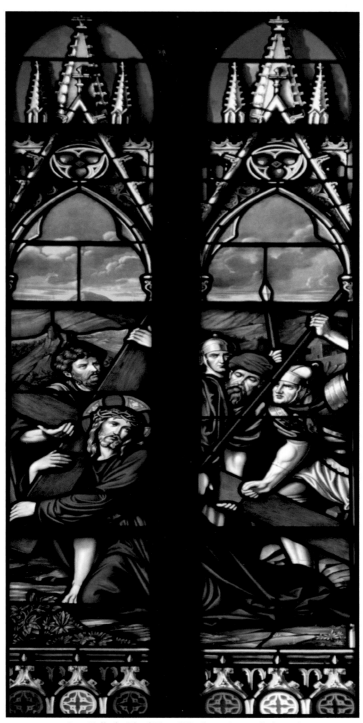

Jesus Falls the Third Time, Window 19, installed 1884

with a like energy and constant fidelity...especially rejoicing in acts of charity."[20]

Devotion to the Holy Face, usually portrayed as seen in the tympanum above the Veronica window, was prominent in the nineteenth century. The wooden church that preceded the present one had only three windows, all by the Carmel du Mans. One window was of the Holy Face, probably with this tympanum's image of Veronica's veil. It was a gift to Fr. Sorin from the Le Mans Carmelites.

The sixth scene presents *Jesus Falls the Third Time*. A second man joins Simon the Cyrene, and both help Jesus to carry the cross. Jesus's purple robe spreads across the scene and he turns his sorrowing face to the viewer. One of the two soldiers, with a clenched fist, urges him forward with the butt of his lance. "O good Jesus, have mercy on my poor, blinded soul!" Fr. Sorin wrote. "I wish to be converted, never to offend Thee again, but to love Thee for ever. Help me, O Jesus! otherwise I shall fall again and again into sin."[21]

THE OUR LADY OF VICTORIES CHAPEL

The church of Our Lady of Victories in Paris is a place of pilgrimage. Thirty-seven thousand *ex votos*, objects left by grateful pilgrims for spiritual and physical healing, are a testament to the many miracles attributed to Our Lady of Victories. Though the Congregation of Holy Cross encouraged devotion to her and Fr. Sorin made pilgrimages to the church in Paris, the original plan for the chapels did not include one dedicated to Our Lady of Victories.[22] In November 1875, however, Fr. Sorin was lost at sea and the providential rescue of the disabled, drifting ship was credited to the intercession of Our Lady of Victories. Fr. Sorin's revised list of chapels, dated September 1876, added this chapel dedicated to Our Lady of Victories.

Fr. Sorin departed New York aboard the steamship *Amérique* on November 13, 1875. On November 21, the steamship became disabled, floated off its course, and was lost at sea. Using their rosaries, Fr. Sorin and other passengers prayed the devotion of a Thousand Hail Mary's every morning, hoping for a rescue.

Because Our Lady of Victories was "so famous for the miracles of mercy wrought at its shrines," the Holy Cross community at Neuilly in France "had secured the celebration of special masses, and the public

The Battle of Lepanto, Window 17, installed 1884

recitation of prayers for those in danger [aboard the *Amérique*], at the altars of this church."[23] On December 5, the day of the special masses and prayers at Our Lady of Victories, the disabled *Amérique* was found. The captain of the *Ville de Brest*, who found the drifting *Amérique*, said: "It was by a miracle; and do you never call it any thing else!"[24] Fr. Sorin and others aboard the ship visited Our Lady of Victories in Paris to offer thanksgiving for their deliverance and to celebrate Christmas mass.[25]

This chapel celebrates the history of the Virgin Mary as she has provided aid to those in difficult situations when invoked through praying the rosary. The first two scenes are composed as *ex voto* art, with the Virgin and Child in the upper left and the scene of struggle illustrated below.

The first scene, *The Battle of Lepanto*, depicts the famous sea battle off the coast of Greece, in 1571. Two hundred and two galleys of the Holy League, organized by Pope Pius V, were dispatched to engage the larger and highly organized navy of the Ottoman Turks, who hoped to expand their empire. Despite illness, Pius led a rosary procession in Rome. The two oared navies met on Sunday, October 7, and the large sea battle, with rival ships locked together, lasted five hours. In the turbulent window scene, the green waves surge beneath the hulls and a mast and sail loom high. More sails and masts are in the distance, giving depth to the immediate scene. The Holy League, in morion helmets with brims and crests, is armed with spears and flintlock pistols. A heavy cannon sits on the deck. The Ottoman fighters wear conical helmets and carry scimitars. A white banner with an image of Mary with the Christ child is held aloft over the Holy League. It is embroidered with Mary and Jesus's monogram and with the words *Auxilium Christianorum.* "Our Lady, Help of Christians." Above and to the left, seated on a cloud, Mary reaches toward the fighting, and Jesus holds a victory palm. The Holy League was victorious and Pius credited the victory to Mary. He instituted the Feast of Our Lady of Victory to be celebrated annually on October 7.

While scholars disagree about the event depicted in the second scene, the coats of arms of Alfonso VIII of Castile and Peter II of Aragon suggest it is the battle of Las Navas de Tolosa in 1212. In the window *The Battle of Las Navas de Tolosa*, Alfonso's forces wear chain mail and the crusader helmet, also called the great helm. The army of Muhammad al-Nasir wears conical helmets and chain mail and carry

The Battle of Las Navas de Tolosa, Window 17, installed 1884

scimitars. A flag bearing an image of Mary with the child Jesus and inscribed with the words *Ave Maria* represents the Marian image carried into the battle. Mary is seen on a cloud directing Jesus's attention to the battle. This decisive victory occurred on the Feast of Our Lady of Mount Carmel, a rosary feast, and was credited to the Virgin Mary.

The next two scenes explain the origin of the famous church of Our Lady of Victories in Paris. In the third scene, *Louis XIII and the Siege of La Rochelle*, King Louis XIII (reigned 1610–43), with Cardinal Richelieu at his side, kneels and acknowledges the Virgin and Child following his victory at La Rochelle in 1628. Louis had prayed for Mary's assistance in his fight with the French Protestant Huguenots. He holds a scroll that depicts the façade of Our Lady of Victories. Across the harbor, the medieval walls and towers of the port city of La Rochelle are accurately portrayed. Louis' royal flag is seen between the cannon and some of the implements employed in the siege.

The fourth scene, *The Plan of Our Lady of Victories*, portrays Louis XIII seated on his throne and solemnly agreeing to finance the construction of a church already begun in Paris by the Augustinian "little friars." Cardinal Richelieu gestures toward the floor plan of Our Lady of Victories, held up by a friar for the king to examine.

When the Our Lady of Victories church was restored in 1809 following the French Revolution, there were almost no parishioners. Fr. Charles Dufriche-Desgenettes (1778–1860) was assigned to the dying parish in 1832. The fifth scene, *Fr. Desgenettes Establishes the Association of the Most Holy and Immaculate Heart of Mary*, presents a perfect likeness of Fr. Desgenettes. He kneels in prayer and asks the Virgin Mary for guidance. By an interior voice, Desgenettes was instructed to consecrate the struggling church to the Holy and Immaculate Heart of Mary, Refuge of Sinners. Mary, seated on a cloud and holding the child Jesus, indicates her Holy and Immaculate Heart. Fr. Desgenettes is writing the statutes for the confraternity, and has paused and raised his quill. He founded the Confraternity of the Most Holy and Immaculate Heart of Mary and began to speak about it to people on the streets and in the neighborhood offices. The response was immediate and transformed the parish. The confraternity spread and had 800,000 members by Desgenettes' death in 1860. Fr. Sorin joined the confraternity before his ordination in 1838, and later established it at Notre Dame. Fr. Sorin corresponded with and knew Fr. Desgenettes, and probably made certain that he appeared in the window of this chapel.

Louis XIII and the Siege of La Rochelle, Window 15, installed 1884

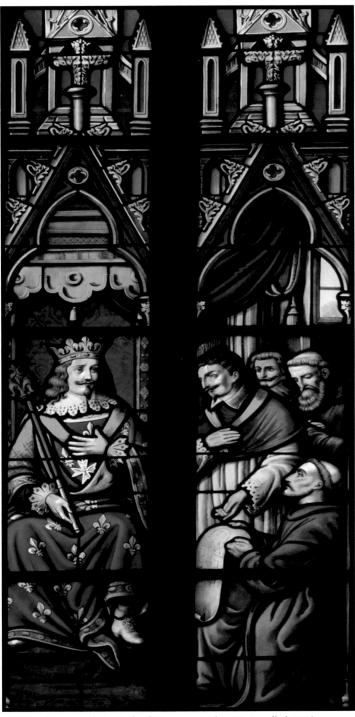

The Plan of Our Lady of Victories, Window 15, installed 1884

Fr. Desgenettes Establishes the Association of the Most Holy and Immaculate Heart of Mary, Window 13, installed 1884

Our Lady of Victories, Window 13, installed 1884

The final scene, *Our Lady of Victories*, honors the Virgin Mary as she is portrayed at Our Lady of Victories in Paris. Rays of bright yellow and orange light emanate from the Virgin and Child. Several figures are turned toward Our Lady and the Child Jesus. They are on clouds and accompanied by angels. Jesus stands on a starred orb. His arms are raised toward his mother and confirm her intercessory role. Both are honored with canonical crowns, bestowed in 1853 by Pope Pius IX. This is Our Lady who delivered Fr. Sorin from death on the Atlantic. Like Louis XIII, who dedicated the Augustinian Little Friars' church to Our Lady of Victories, Fr. Sorin dedicated this chapel to Our Lady, thankful for her deliverance.

The Apsidal Chapels

The apsidal chapels are radiating chapels located in the apse of the church, the semicircular end of a church located behind the altar. There are three apsidal chapels in Sacred Heart Basilica.

THE RELIC CHAPEL

This chapel focuses on the discovery of famous relics and on the solemn translation of relics to locations suitable for veneration. "The relics of the saints," Fr. Sorin said, "are more precious than silver and gold."[1] The veneration of relics is an ancient Catholic practice. In the year 156, the Christians of Smyrna, in Turkey, claimed that the bones of their martyred bishop Polycarp were "more precious than the most exquisite jewels and more purified than gold."[2]

Relics are deemed precious because they witness to Christ's saving and healing presence. When early Christians found that wonders occurred in the presence of the relics of saints, they did not attribute the healings to the saint, but to Christ. Veneration and honor (*dulia*) are proper to relics, Catholics believe, and distinct from the worship and adoration (*latria*) appropriate only to God. As Saint Jerome explained, "we honor the relics of the martyrs, that we may adore Him whose martyrs they are."[3]

Churches and shrines that house relics became pilgrimage sites, visited to venerate the saint and to request healing through the saint's intercession with Christ. Pilgrimage sites housing relics were also cultural and economic centers. Popular enthusiasm for the cult of relics easily led to error, fraud, and greed, evident as early as the fourth century. The Protestant Reformation rejected relics, and the Enlighten-

ment was critical of them. This chapel, which presents the ancient veneration of relics and argues for their important role in Catholic devotions, is certainly a response to the devaluation and destruction of relics that occurred during the French Wars of Religion and the French Revolution.

Notre Dame's *The Scholastic Year* reported that in 1869 "the Festival of St. Joseph was chosen as a fit day to expose them [the relics] for the first time to the veneration of the faithful."[4] The report goes on to add that "not less than six hundred relics were exposed, and some of them very remarkable and highly precious."[5] Fr. Alexis Granger, CSC, pastor of the basilica, wrote of that festival in his *Book of Church Services*, preserved in the university archives: "Nota. The Exposition of the H. Relics was beautiful and striking. They were visited by numerous people, but too many seemed to visit them as we do a museum. A proper instruction should be given previously, and people should not come too near the altar."[6]

The first relic apsidal chapel window, *The Translation of the Relics of Saint Martin of Tours*, depicts the translation of Saint Martin's relics from Candes, France, where Martin died in 397, to Tours, France. Bishop Perpetuus of Tours (d. 490) follows the sarcophagus that is elaborately decorated with seated figures of saints and inscribed *Scs. Martinvs*, or "Saint Martin." Kneeling believers honor Martin's relics along the procession route. Perpetuus built a basilica in Tours to accommodate the large number of pilgrims who came to venerate Martin's relics and to be healed. Martin is a patron saint of France. This window must have reminded Fr. Sorin of Leo Dupont (1797–1876), who encouraged and financed the 1860 excavations in Tours that located Saint Martin's tomb and a few relic fragments. Dupont travelled in the coach with Fr. Sorin and the Holy Cross Brothers when they departed Le Mans for their voyage to Indiana in 1841.[7] He was, Fr. Sorin wrote, "for years my best friend beyond the sea."[8]

The second scene, *The Finding of the Relics of Saint Stephen*, presents the discovery of the relics of the first Christian martyr by the priest Lucian. Lucian had been instructed in a dream where to find Stephen's tomb, and the scene accurately details Lucian's written testimony. He has paused, and, with a shovel in hand, gestures to the coffins, seeking permission from Bishop John of Jerusalem to open them. Bishop Eutonius of Sebaste and Bishop Eleutherius of Jericho are also present. The names *Nasuam* and *Abibas*, Syriac for Nicodemus

The Translation of the Relics of Saint Martin of Tours,
Window 8, installed 1884

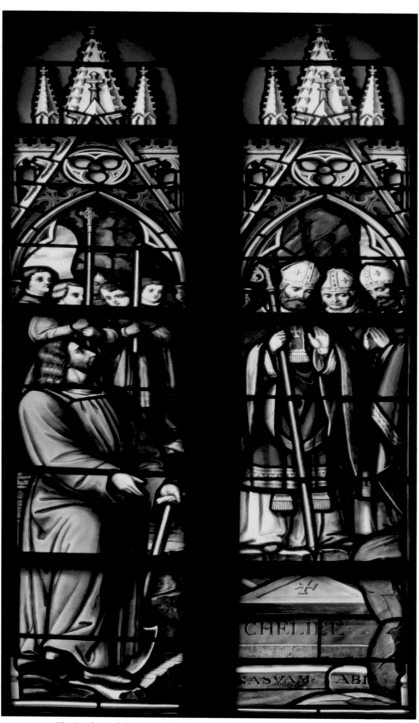

The Finding of the Relics of Saint Stephen, Window 8, installed 1884

and Abibas, are engraved on a tomb. The large coffin has *Cheliel* engraved on it, Syriac for "crown," the meaning of the name Stephen.[9] Lucian reported that at the opening of Stephen's tomb the earth shook, the sweet odor of sanctity was detected, and many gathered there were healed. The Roman Empire had fallen in 410, and the finding of Stephen's relics in 415 brought hope and healing in a collapsing world.[10] Portions of his relics were taken throughout the Christian world.

A scene from the extraordinary story of the theft of the relics of Saint Nicholas of Myra (270–343) is narrated in the third scene, *The Arrival of the Relics of Saint Nicholas at Bari, Italy.* In the eleventh century, when Nicholas's relics were thought to be in danger from the Seljuk Turks, the city of Bari in the Kingdom of Naples sent ships on the long voyage to southern Turkey to seize the relics, presumably to save them from destruction. The scene presents the successful return of the Bari sailors and merchants on May 9, 1087. The ship sits in the Bari harbor, and the casket made by the sailors during the return voyage has been brought to shore. Archbishop Ursus of Bari, who hoped to take custody of the relics, blesses them. However, the merchants, sailors, and people of Bari entrusted Nicholas's relics to Benedictine monks, seen kneeling opposite Archbishop Ursus. The daring voyage and the ensuing struggle in Bari for the custody of Nicholas's relics illustrate their religious as well as cultural and economic importance.

The fourth scene is titled *King Louis IX Carrying the Crown of Thorns in Paris.*[11] Saint Louis had acquired the Crown of Thorns and twenty-nine other relics from his cousin Baldwin, the Latin Emperor of Constantinople. Louis reverently carries the Crown of Thorns on a red cloth that he shares with bishops who carry elaborate reliquaries. Louis' toes peek out from the lower edge of his clothing because he carried the Crown of Thorns barefoot, an indication of the great holiness of the relic. The bishops are also barefoot. At Louis' right is certainly Archbishop Gautier Le Cornu of Sens, who helped Louis acquire and translate the Passion relics. The street scene is crowded with royalty and bareheaded Parisians, one of whom is on one knee. A baldachin, or liturgical canopy, honors the relics. Louis' acquisition of the Crown of Thorns in August of 1239 confirmed his leadership of the Christian world.

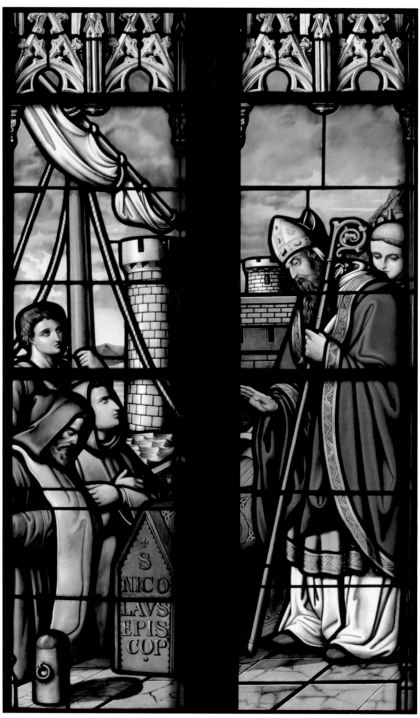

The Arrival of the Relics of Saint Nicholas at Bari, Italy,
Window 10, installed 1884

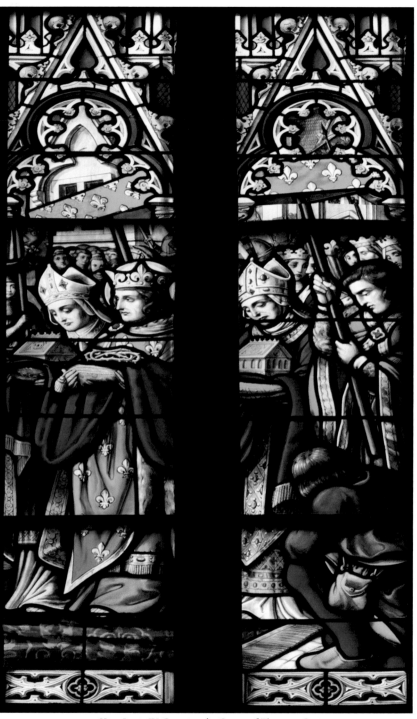

King Louis IX Carrying the Crown of Thorns in Paris,
Window 10, installed 1884

The fifth relic window has received varying interpretations. It has been named the "Reception of Relics," and one scholar described it as "a journey of the relics of some saint but the picture has left no clues as to its subject except for the letter 'A' on the casket. This could be the relics of Augustine."[12] The letter "A" inscribed on the gable of the small reliquary, however, is to be understood as the first letter of the Greek alphabet, the alpha. On its other side of the reliquary is certainly the last letter, the omega, in reference to "'I am the Alpha and the Omega,' says the Lord God, who is, and who was, and who is to come, the Almighty" (Rev. 1:8). As early as the third or fourth century, funerary use of the alpha and omega proclaimed the eternal nature of Christ and of a believer's afterlife in Him. If this were a reliquary of Saint Augustine, it would certainly be inscribed with his name—*Saint Augustine*—as are the other saint's reliquaries in the relic windows.

The final two scenes in the relic chapel narrate the interesting history of the relics of Saint Eutropius, the bishop of Saintes and an early Roman martyr in southwest France, as it is found in an 1877 book.[13] Eutropius's skull, which bore the ax mark of his martyrdom, had been sent from Saintes to Bordeaux for safekeeping during the French Wars of Religion. The precious relic was returned to Saintes in 1602, and the fifth scene, *The Return of Saint Eutropius's Relics from Bordeaux to Saintes, 1602*, depicts the conclusion of the magnificent seventy-five mile translation from Bordeaux to Saintes. The processional cross and candles have entered the church and the reliquary containing Eutropius's skull rests in the hands of Cardinal François de Sourdis of Bordeaux (1574–1628). A young acolyte incenses the reliquary, and deacons stand nearby with the cardinal's staff and prayer book.

The sixth scene, *The Translation of Saint Eutropius's Relics in 1843*, presents the widely celebrated 1843 translation of Eutropius's relics. The excavation of the Romanesque crypt of the church dedicated to Eutropius uncovered his tomb and a few small relics. This discovery was "one of the great archaeological events of the country."[14] The additional relics were placed, along with Eutropius's skull, in a large reliquary case. On October 14, Eutropius's relics were carried into the basilica in Saintes. The scene accurately details the large reliquary crowned with Eutropius's attributes: the ax of martyrdom, the palm branch of victory, and the bishop's miter. Bishop Clément Villecourt of La Rochelle (1787–1867) follows the martyr's relics into the church with a celebratory procession of acolytes and choristers. Holding a

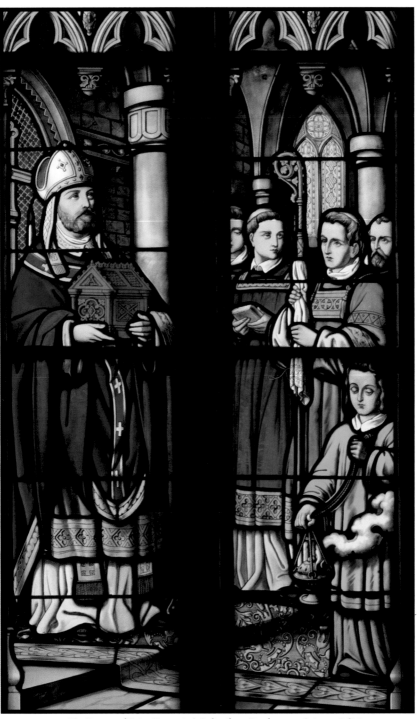

The Return of Saint Eutropius's Relics from Bordeaux to Saintes, 1602,
Window 12, installed 1884

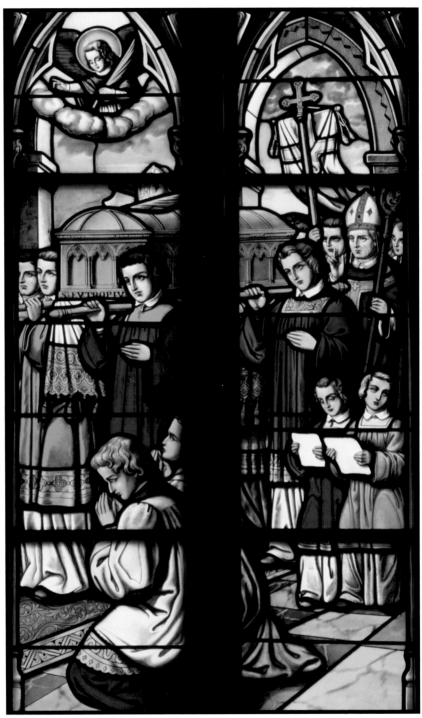

The Translation of Saint Eutropius's Relics in 1843,
Window 12, installed 1884

victory palm, an angel on a cloud shows the way. In 1850, Fr. Sorin received a relic of Eutropius from Bishop Clément Villecourt of La Rochelle. It can be found among the relics displayed in the Relic Chapel.

THE ANGELS CHAPEL

The Angels Chapel focuses on the three archangels: Michael, Raphael, and Gabriel. In these windows, the archangels are portrayed on clouds to indicate their arrival from incorporeal realms. They wear exquisite garments and sometimes a circlet crown with a cross in the front. Their idealized human forms, an artistic attempt to portray bodiless and therefore sexless spirits, are feminine, and illustrate the nineteenth-century conviction that the feminine is best able to convey the spiritual.[15]

The first scene, *Saint Michael the Archangel*, portrays Michael vanquishing evil. His wings are powerful and unfurled. Despite his armor, his fluttering clothes tell of the lightness of his being. Lucifer, in the form of a coiled serpent with red-webbed wings, screams as he is pierced by Michael's spear. Flames and smoke rise from a break in the earth. Michael's feminized face is peaceful and confident of the final victory of God. In vanquishing Lucifer (Rev. 12), Michael's influence extends even to the depths of hell. He holds scales in his left hand, indicating the office given to him by God to weigh human souls. Behind Michael and across the rippled tidal bay is an accurate depiction of Mont-Saint-Michel, an important pilgrimage site off the northern coast of France dedicated to Saint Michael the Archangel.

The second scene, *The Inspiration for Mont-Saint-Michel*, illustrates the origin of Mont-Saint-Michel. Saint Aubert, the eighth-century Bishop of Avranches, reported three dreams in which the archangel Michael commanded him to build a monastery on Mount Tomba, an impregnable rocky outcrop off the coast of Normandy. The winged Michael, clad in his armor and a voluminous robe, admonishes the bishop and holds out to him the floor plan of Mont-Saint-Michel. Kneeling, fully robed in liturgical dress, Aubert is attentive. The architecture and stained glass windows suggest a religious setting. Begun in 708, Mont-Saint-Michel was an important pilgrimage site. It housed a piece of the vermillion altar cloth said to be left by Saint Michael in 490 on Mount Gargano in Italy. Closed during the French Revolution,

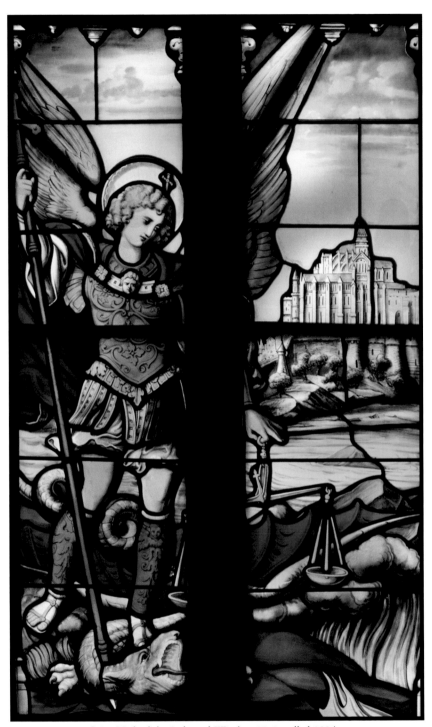

Saint Michael the Archangel, Window 11, installed 1884

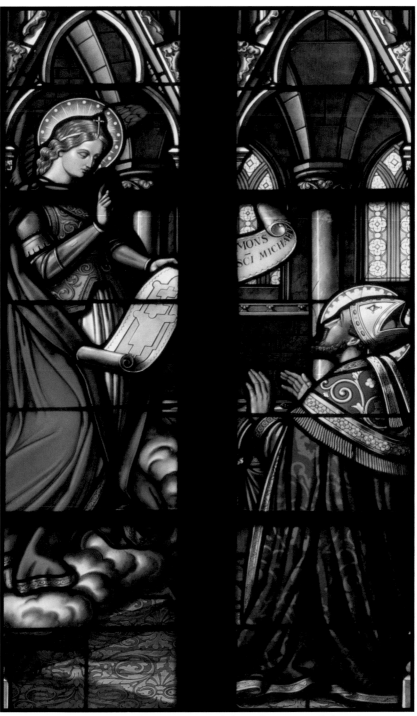

The Inspiration for Mont-Saint-Michel, Window 11, installed 1884

Mont-Saint-Michel was declared a French historical monument in 1874. Today, Mont-Saint-Michel is a UNESCO World Heritage Site.

Saint Peter Is Freed from Prison by an Angel features Saint Raphael. The beautiful night scene is illuminated by moonlight and narrates the biblical story of how Saint Peter, while imprisoned in Jerusalem by King Herod, was miraculously freed by an angel (Acts 12:5–10). Tradition credits Raphael with his rescue. Faithful to the biblical account, Peter has put on his cloak and his sandals. The door has opened and Raphael, clasping Peter's hand, leads him up and out. The guard sleeps and Peter's chains lie discarded by a red water pitcher.

The chains depicted in this window scene faithfully replicate those found in the reliquary at the minor basilica of Saint Peter in Chains in Rome. The single chain displayed in the reliquary there is traditionally believed to have been a miraculous fusion of the two different sets of chains that had held Peter when he was imprisoned, first in Jerusalem and later in Rome. When this window was installed in 1884, it must have reminded viewers of Pope Pius IX (reigned 1846–78), who was popularly referred to as "Saint Peter in Chains," because Pius had voluntarily confined himself to the Apostolic Palace after the loss of the Papal States to the Kingdom of Italy in 1870. Fr. Sorin actively sought prayers and donations through the *Ave Maria* journal "for the defense of the pope," as did many other papal sympathizers in the late nineteenth century.[16]

The archangel Raphael is head of the guardian angels, and the fourth scene, *An Angel Guards a Child*, is a typical nineteenth-century portrayal of a child with his guardian angel. The angel and his charge are clearly close companions and walk in unison through a barren and hazardous landscape. They are wearing traveling clothes. The angel's sheltering arm is laid on the child's shoulder and the child's hand is laid over his. The confident angel, sure and unafraid, guides the child as he shelters him with his body. He raises his hand in a gesture of warning to a horned presence with red, webbed wings. The evil cringes. The child points out the sinister presence and betrays no fear. Walking in step, the angel and child move together toward a wooden plank over a deep crevice.

In the fifth scene, *The Annunciation to Zechariah*, Gabriel the archangel announces to the priest Zechariah that, though his wife is barren and they are both elderly, his wife will bear him a son, who will be called John (Luke 1:5–25). This annunciation scene is faithful to

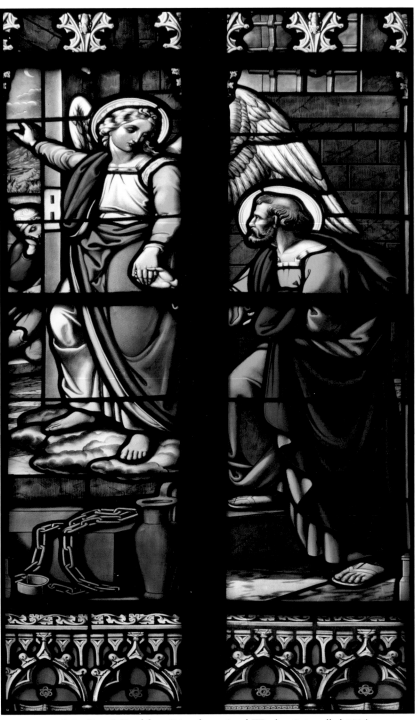

Saint Peter Is Freed from Prison by an Angel, Window 9, installed 1884

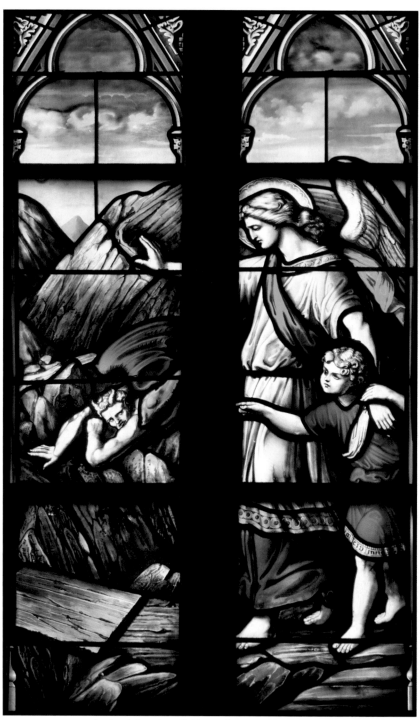

An Angel Guards a Child, Window 9, installed 1884

The Annunciation to Zechariah, Window 7, installed 1884

The Annunciation to the Virgin Mary, Window 7, installed 1884

the gospel's narrative. Zechariah, chosen by lot to enter the Temple sanctuary for the hour of incense, wears the breastplate of Aaron, identifying him as a high priest. Smoke billows from the incense burner on the altar. The curtain is drawn back and the book of prayer is open. The angel Gabriel has appeared at the right side of the altar, robed in luminous brocade and carrying lilies. Behind him, the world opens out to sky, while before him the kneeling Zechariah spreads his hands in disbelief. His incredulity resulted in his muteness, and stands in contrast to the Virgin Mary's perfect response.

The sixth and final scene, *The Annunciation to the Virgin Mary*, is a frequent subject found in Western Christian art (Luke 1:26–38). This is, Fr. Sorin wrote, "the solemn moment of the Incarnation of the Eternal Word."[17] Gabriel, sent from God, comes in grandeur on a cloud. His exquisite brocade robe is still moving and his words of greeting are wrapped around his lily standard: *Ave Maria gratia plena*, "Hail, Mary, full of grace." His left hand is raised and indicates the radiant dove of the Holy Spirit, behind and above him. In plain clothing, Mary kneels at an oratory with her hands folded, a prayer book open before her. She acknowledges Gabriel's presence by turning from her reading, revealing her face as she listens to the angel. A lily in an ornate vase alludes to Mary's virginity. A red brocaded tapestry hangs on the wall, suggesting an interior, private room and the window behind the Virgin opens onto lush growth and a distant mountain landscape.[18]

THE CHAPEL OF THE SACRED HEART OF JESUS (THE LADY CHAPEL)

The Lady Chapel is an architectural term for a chapel located behind the altar. It is usually the largest chapel and is typically dedicated to the Virgin Mary. And while Notre Dame's Lady Chapel holds a large statue of the Virgin Mary, its windows are dedicated to the Sacred Heart of Jesus, which was, Fr. Sorin said, "the spirituality of the day."[19]

The iconography of Sacred Heart devotion places outside Jesus's body and at the location of his human heart a visual symbol of divine love—Jesus's heart in flames encircled by the crown of thorns and surmounted by the cross, indicating Christ's love for humanity made evident in his death on the cross. Devotion to the Sacred Heart is centered on the Eucharist, the sacrament of love, in the form of frequent

Communion, Communion on the first Friday of each month, and the observance of a holy hour in prayer before the Eucharist. This eucharistic focus is found in the windows of this chapel.

Fr. Sorin envisioned this chapel as the heart of the university, a place for perpetual devotion to the blessed sacrament, where there would always be prayer. He described the Lady Chapel as "the center of all campus devotions and the source of all blessings" at Notre Dame.[20] The west windows present New Testament scenes and illustrate the biblical basis of the devotion to the Sacred Heart. The east windows present its historical development. The tympanum windows present angels holding the instruments of Jesus's passion, popularly contemplated as an aid to devotion: the lance and sponge, the crown of thorns, the ladder and hammer and pincers, the cross and nails, the chalice, and the whip and pillar.

In the first west window, *The Birth of Jesus*, youthful angels on darkened clouds float above the crib of the Incarnation and hold aloft the flaming Sacred Heart, the cross within its flames. The angelic banner proclaims *Verbum caro factum est*, "And the Word became flesh" (John 1:14). Mary leans over Jesus, cradling him, reminding all that he is flesh of her flesh. Joseph, the foster-father and guardian, has removed his hat and laid down his staff in worship. The ox and the ass represent the animals that tradition asserts were at the manger.

In the second scene, *The Last Supper*, the room is brilliant with light, though it is night in Jerusalem. Jesus and his apostles gather around the Passover table. Judas, with no halo, looks away from the scene, his bag of silver coins lowered from sight. A knife, laid on the table before him, points toward Jesus. Jesus must have just declared that one of them will betray him, because Peter, across the table from Jesus, points toward himself, as if asking "Is it I, Lord?" (Matt. 26:22). This dialogue of betrayal sets the stage for the institution of the Eucharist. The Passover lamb has been eaten and cleared away. It is "after supper" (Luke 22:20). On the table are three modest fish, to be eaten with the unleavened bread.[21] By pious artistic tradition they remind the viewer that the initials for "Jesus Christ, Son of God, Savior" spell out the Greek word for fish, *ichthus*. Jesus, seated before an elaborate gold and red canopy, picks up the chalice, and John, the beloved disciple, leans on Jesus's breast and listens to the Sacred Heart.

The third scene, *Gethsemane*, portrays Jesus's agony in the garden of Gethsemane (Luke 22: 39–46). In response to Jesus's request to be with him for a while, his closest disciples, Peter, James, and John, sleep

The Birth of Jesus, Window 5, installed 1884

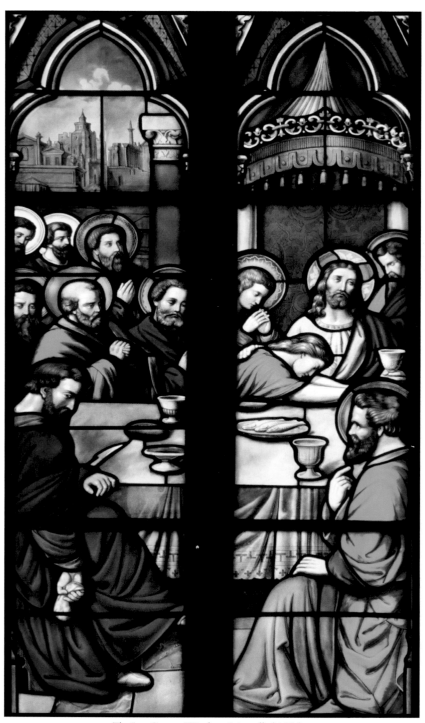

The Last Supper, Window 5, installed 1884

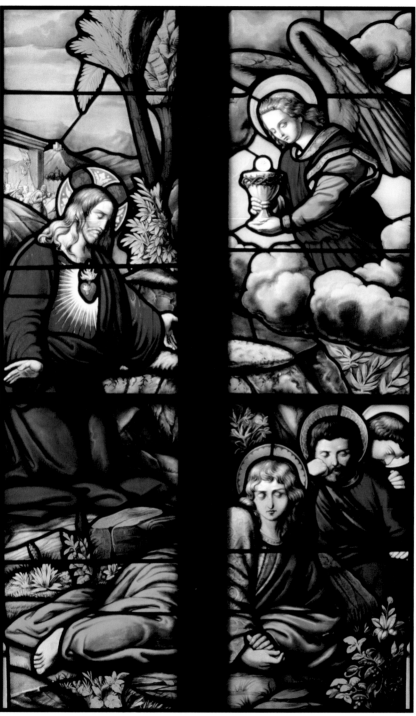

Gethsemane, Window 3, installed 1884

in the lush garden, their backs turned to him. A divine glow emanates from Jesus's heart. Another fire burns inside the Sacred Heart, already crowned with fire. On Jesus's face are sweat and tears, and he spreads his arms in prayer, almost embracing the sleeping disciples. Jesus's embrace includes the angel who, with lowered eyes, has come on a darkened cloud bearing a chalice bound about the rim with a crown of thorns and with a host inscribed with a cross. Behind Jesus, an excited crowd with cudgels, torches, and swords descends upon the still scene. Judas, in the lead, holds a moneybag.

In *The Crucifixion*, Mary Magdalene clings to the crucified Jesus's feet. The drooping head of the dead Christ and the upward thrust of the soldier's lance draw attention to the opened side of Christ, the focus of this scene. Sacred Heart devotion takes up an early Christian insight that the Church was born when the soldier "opened" Jesus's side as he slept dead on the cross (John 19:34), just as Eve was drawn from the sleeping Adam's side. From the Sacred Heart flowed blood and water, the Eucharist and Baptism, sacraments of rebirth available in the Church. The triangle created with the halos of Jesus, John, and the Virgin Mary not only symbolizes the Trinity, but also draws attention to their figures, framing the piercing of Jesus's heart.

The Pieta, the fifth scene, presents Our Lady of Sorrows, the patroness of the Congregation of Holy Cross, holding her dead son at the foot of the cross. His heart, even in death, burns and radiates divine love. Her heart is surmounted with fire and pierced with seven swords, her seven sorrows, as prophesied by Simeon (Luke 2:24–25). At her feet are some of the instruments of the Passion: the crown of thorns, the three nails, the sponge, and the spear. The ladder and rope used to take Jesus's body down from the cross lie nearby with the burial cloth. With Our Lady of Sorrows is Saint John the Evangelist, Mary Magdalene with her jar of perfumed ointment, and Joseph of Arimathea, who gave his tomb for Jesus's burial. Jerusalem is in the distance. In the sky are darkness and the eclipse of the sun (Luke 23:45).

In the sixth and final scene of the west windows, *The Risen Jesus and Doubting Thomas*, the disciples gather around the Risen Christ in a room open to the world. Light shines from the opened side of Christ, indicating his Sacred Heart. At Jesus's invitation, the apostle Thomas places his hand in Jesus's side (John 20:24–29). Jesus's side, "opened" at his death, revealed the love of the Sacred Heart. Jesus's raised right arm, lifted to show his wound, points out into the world.

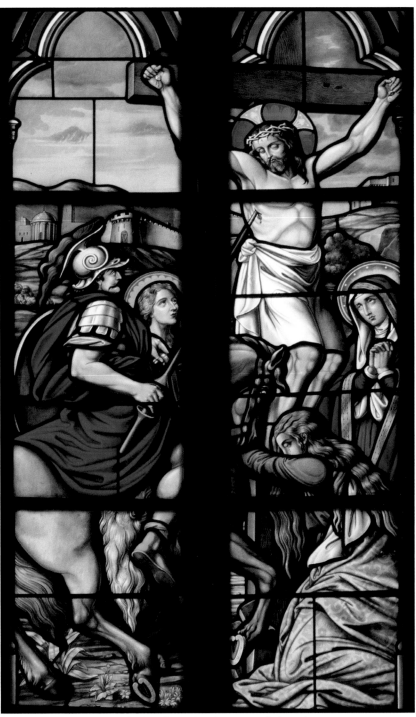

The Crucifixion, Window 3, installed 1884

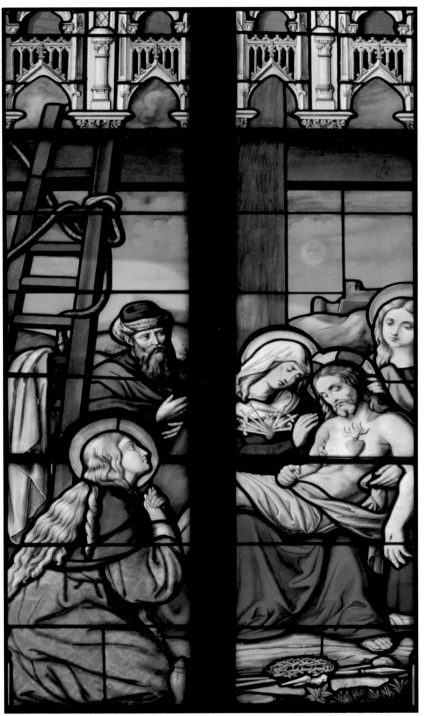

The Pieta, Window 1, installed 1884

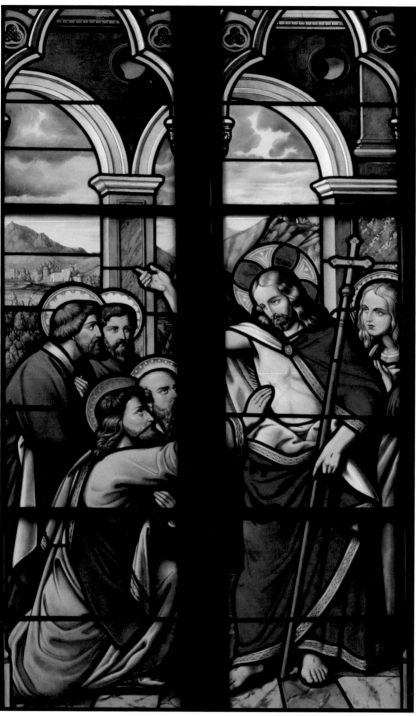

The Risen Jesus and Doubting Thomas, Window 1, installed 1884

Four other disciples gather around Jesus, their hands crossed at their breasts.

The first east window, *Saint Margaret Mary Alacoque's Great Apparition*, begins the presentation of the historical development of Sacred Heart devotion. It illustrates the apparition of Jesus as the Sacred Heart to Saint Margaret Mary Alacoque during the Octave of Corpus Christi in 1678. Margaret Mary, a French Visitation nun, kneels in prayer. The Eucharist, displayed in a monstrance, is on the altar, to accurately depict the eucharistic character of Margaret Mary's vision. A golden light emanates from Jesus and from his Sacred Heart. The cherubim above Jesus indicate his divine presence, and the clouds beneath his feet indicate that he is a vision. His pierced hands point to his Sacred Heart. Directly over Margaret Mary, an angel bears a banner with Jesus's words: *Voici le Coeur qui a tant aimé les hommes*, "This is the heart that has loved mankind so much." By these and other words Jesus requested a devotion to his Sacred Heart, which slowly spread through Visitation convents.

The second scene, *Saint Margaret Mary's Vision in the Filbert Grove*, again presents Margaret Mary Alacoque, emphasizing her importance for Sacred Heart devotion. The Visitation sisters live a life of moderation and common sense, and the experience of extraordinary visions, such as Margaret Mary's, are not part of their tradition. Margaret Mary was assigned the very practical task of keeping the donkey and her foal from straying into the convent garden. Margaret Mary, by the grove of filbert trees, kneels before an extraordinary vision of Jesus as the Sacred Heart. The angel above directs her to Jesus. Her hands, one placed to her own heart and the other open and lowered before her, reflect Jesus's gestures. Dark clouds and blue trees convey night. The other Visitation sisters claimed that the animals were loose in the garden, but no marks or damage were to be found.[22] The Mother Superior believed Margaret Mary's visions and suggested she work with her Jesuit director, Saint Claude de la Colombière (1641–1682), who encouraged her to write her experiences and helped to spread the devotion.

Devotion to the Sacred Heart eventually spread beyond religious communities and became public consecrations to the Sacred Heart. The third scene, *The Consecration of the City of Marseilles to the Sacred Heart*, depicts the last significant bubonic plague of Europe that ravaged Marseille, France, in 1720, killing nearly 50,000 people. While

Saint Margaret Mary Alacoque's Great Apparition, Window 2, installed 1884

Saint Margaret Mary's Vision in the Filbert Grove, Window 2, installed 1884

The Consecration of the City of Marseilles to the Sacred Heart,
Window 4, installed 1884

many fled, Marseille's Bishop Henri de Belsunce (1671–1755), the clergy, and members of religious orders remained. They ministered to the sick and dying and buried the dead. The historic scene presents Bishop Belsunce at the conclusion of a penitential procession, praying before his church in the main square of Marseille. A desperate crowd gathers around him and begs for divine assistance. Belsunce kneels and consecrates Marseille forever to the Sacred Heart of Jesus. The angelic banner reads *Votum Henrici de Belzunce Ep Marseille*, "Vow of Henri de Belsunce, Bishop of Marseille." This scene was common in French history painting. Chroniclers record that the plague subsided within two months. For many French Catholics, the memory of Belsunce's vow illustrated the national healing and restoration that would follow if the French should vow devotion to the Sacred Heart of Jesus. The diocese of Marseille annually renews Belsunce's vow of consecration to the Sacred Heart.

By the eighteenth century, the Visitation Order, the bishops of Poland, and more than one thousand confraternities of the Sacred Heart of Jesus asked the Church for formal approval of the devotion to the Sacred Heart. In the fourth scene, *Pope Clement XIII Proclaims Devotion to the Sacred Heart of Jesus*, the pope is seen at the Basilica of Saint Mary Major in Rome before five Polish bishops and two Polish cardinals. Clement, with papal cross and tiara, holds the 1765 proclamation and blesses the Polish churchmen before him. Clement looks above to the two angels holding a banner that reads *Cordis Jes Cultum in Polon Clemens XIII proclam,* "Pope Clement XIII proclaims the devotion to the Sacred Heart of Jesus in Poland." One angel gestures above to the Sacred Heart.

Unlike the first four scenes in the east chapel windows, the final two do not present actual historical events. The first, *The Homage of France to the Sacred Heart*, is a copy of a popular Catholic lithograph probably printed as part of the public subscription campaign for the construction of the Basilica of the Sacred Heart (Sacré-Coeur) in Paris, popularly called the Church of the National Vow.[23] The scene presents a kneeling and penitent personification of France. Her scepter and crown ornamented with fleur-de-lis have been laid aside and one of her hands cradles her face in sorrow. She extends an *ex voto* rendering of Sacré-Coeur Basilica to Jesus under the title of the Sacred Heart. Above, an angel bears a banner proclaiming the national vow made by many French in 1871 for the construction of Sacré-Coeur: *Sacr Cord*

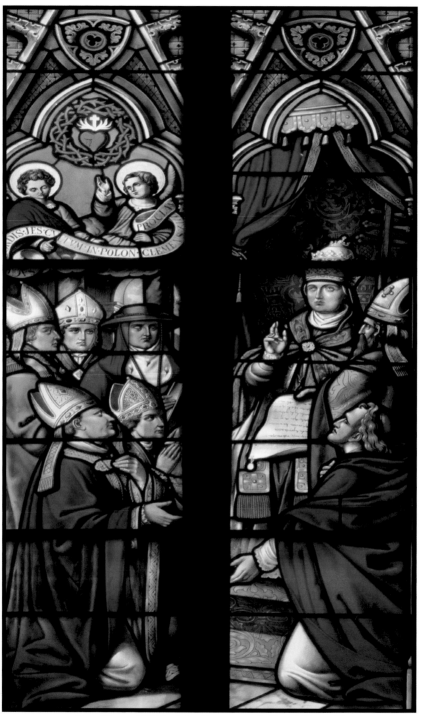

Pope Clement XIII Proclaims Devotion to the Sacred Heart of Jesus
Window 4, installed 1884

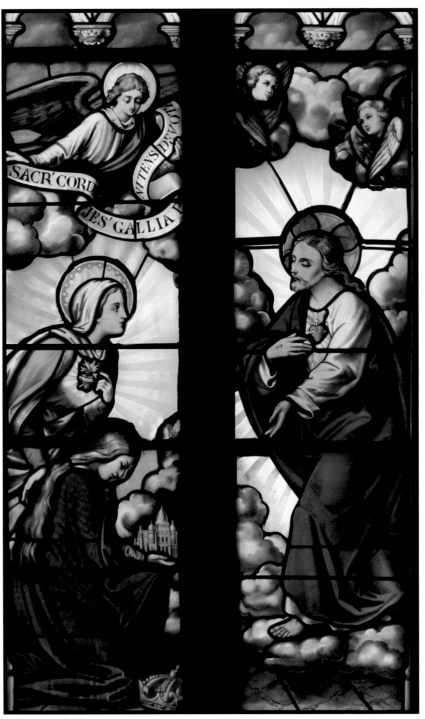

The Homage of France to the Sacred Heart, Window 6, installed 1884

Jes Gallia penitens devote, "To the Sacred Heart of Jesus, from a devoutly penitent France." The Virgin Mary, portrayed under the title of the Immaculate Heart of Mary, touches the woman's back, assuring her. Mary, as intercessor, appeals to her Son. A multitude of black clouds convey the mood. Jesus steps forward and begins to lean down toward the figure of France. There has been uninterrupted perpetual eucharistic adoration at Sacré-Coeur since 1885.

Finally, in a heavenly vision, Jesus as the Sacred Heart and his Mother as the Immaculate Heart show their divine hearts to founders of religious orders who lived from the third to the seventeenth centuries. Though not historical contemporaries, those depicted in *Founders of Sacred Heart Devotion* are bound by their common devotion to the redemptive suffering of Christ. Jesus and Mary are seated on clouds, and the Virgin refers all to her Son. Jesus indicates his heart and gestures toward the women and men gathered below. The women, on the left, are: Saint Bridget of Sweden, wearing the crown of thorns; Saint Teresa of Avila, with her heart pierced by the arrow of God's love; and Saint Margaret Mary Alacoque, her hands characteristically spread in prayer. The men, on the right, are: Saint Bernard of Clairvaux, in the distinctive Cistercian white cowl and holding the symbols of Christ's Passion; a partially hidden Saint Francis de Sales, co-founder of the Order of the Visitation, with his dark hair and receding hairline; Saint Augustine, holding aloft his flaming heart; and Saint Francis of Assisi, clad in the brown robe of the Franciscans. His hands are raised in prayer and bear the stigmata.

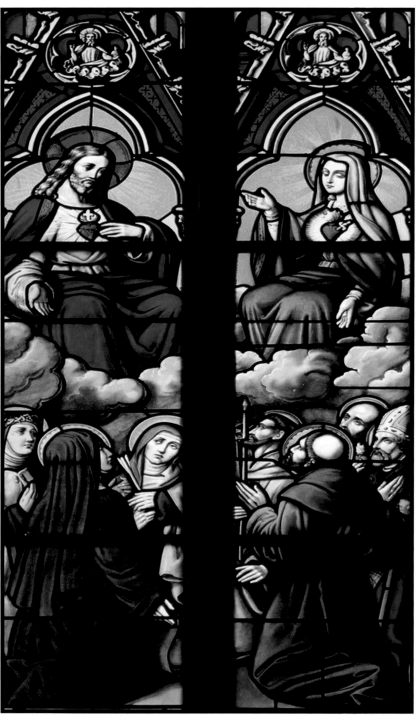

Founders of Sacred Heart Devotion, Window 6, installed 1884

NOTES

Chapter One. Introduction

1. Fr. Moreau "kept a register in which was written . . . a record of the union of prayer and sacrifices which he had established between several other communities and his own." Bernard I. Mullahy, CSC, *The Spirituality of the Very Reverend Basil Anthony Moreau* (Notre Dame, IN: Ave Maria Press, n.d.), 62. A union of prayer was a spiritual friendship between two communities, usually established by a written act, and constituted by the promise of prayer for each other and for a common concern, such as the success of missionary work, the papacy, or for conversion. A union of prayer was not uncommon. One existed between the Le Mans Carmelites and the Sisters of Providence of Saint-Mary-of-the-Woods in Saint-Mary-of-the-Woods, Indiana, a school founded in 1840 by Saint Mother Theodore Guerin, a friend of Fr. Sorin (Sister Diane Ris, SP, and Sister Joseph Eleanor Ryan, SP, *Saint Mother Theodore Guerin: Woman of Providence* [Bloomington, IN: AuthorHouse, 2011], 59).

2. Stéphane Arrondeau, "La Fabrique de vitraux du Carmel du Mans (1853–1903): Chronique d'une grande aventure" 2 vols. (PhD diss., University of Le Mans, 1997), 1:377.

3. Arrondeau, "Fabrique," 1:85.

4. Arrondeau, "Fabrique," 1:89.

5. Arrondeau, "Fabrique," 1:87.

6. Arrondeau, "Fabrique," 1:89–91.

7. Arrondeau, "Fabrique," 1:91.

8. Arrondeau, "Fabrique," 1:92, 96. Only nine of the ten windows needed for their own Notre-Dame-de-Sainte-Croix were completed. When the church was sold in 1868 to satisfy pressing debts, the Jesuits who bought it had the nine windows removed and new ones created by the Carmel du Mans. The Carmelite windows of Notre-Dame-de-Sainte-Croix were lost in a bombing during World War II. The only windows created by the Holy Cross Glassworks that survive are in the small church of St. Martin in Laigné-en-Belin; the windows were a gift to honor Fr. Basil Moreau, who was baptized there. Photos of the win-

dows, featuring St. Martin, can be found in Gilbert Couturier, "Quatre verriè d'exception," *Bienheureux Basile Moreau et de tous les coins de la région* (January 2008), 5, available at soeursdesaintecroix.org/fr/publications/2008/2008_01 _journal.pdf.

9. Archives de la Congregazione Di Santa Croce Casa Generalizia à Rome, Registre du Conseil Général du 08.10.1844 au 15.10.1856, found in Arrondeau, "Fabrique," 1:101n150.

10. Jean-François Lottin, *Vitraux peints Carmel du Mans* (Le Mans: Julien Lanier, 1855), 1, quoted in Arrondeau, "Fabrique," 1:101n153; see also 1:598–605.

11. Arrondeau, "Fabrique," 1:100.

12. Stéphane Arrondeau, "Talk Presented by Dr. Stéphane Arrondeau of Le Mans, France at the Basilica of the Sacred Heart, Notre Dame, Indiana on August 11, 1998," trans. Charles E. Parnell, mimeograph of translation held in the Basilica Museum, 1. For a further count of the number of glassworks, see also, Chantal Bouchon and Catherine Brisac, "Le vitrail," in Chantal Bouchon, Catherine Brisac, Nadine-Josette Chaline, and Jean-Michel Leniaud, *Ces Églises du dix-neuvième siècle: Ouvrage publié avec le concours du Centre National des Lettres*, 215–46 (Amiens: Encrage, 1993), 245.

13. The oldest glass in the Cathedral of Chartres dates from 1145. The Cathedral of St. Julien, located about seventy miles from Chartres, contains glass from 1120.

14. Arrondeau, "Fabrique," 1:193. Quote from the Archives du Carmel du Rouillon, *Notes sur l'Office des Vitraux* 1853.

15. Arrondeau, "Fabrique," 1:193.

16. Arrondeau, "Fabrique," 1:202. The Carmelites described this as a *coulisses*, which means "slider" or "wings." The *coulisses* could also have been a parlor in which one simply left articles to be picked up by someone at a later time, much like an actor would pick up a prop left in the wings and then return to the stage. Special thanks are due to Dr. Keith J. Egan, TOC, for his helpful suggestions about Carmelite life.

17. Arrondeau, "Fabrique," 1:190, quoting *Lettre Circulaire de Mère Marie Alphonsine* no. 37, Archives du Carmel du Rouillon.

18. Eugène Hucher, *Calques des vitraux peints de la Cathédrale du Mans* (Le Mans: Monnoyer, 1865).

19. The Nazarene School was the popular name for the Brotherhood of Saint Luke, which was founded on July 10, 1809, for the renewal of Christian art. It was centered in Rome and led by the artist Johann Friedrich Overbeck (1789–1869). The Nazarene interest in fresco drawing and painting was easily adapted to stained glass windows.

20. Cordula Grewe, *Painting the Sacred in the Age of Romanticism* (New York: Routledge, 2016), 22.

21. Arrondeau, "Fabrique," 1:240.

22. Stefano Cracolici, "Ushaw and the Art of the Nazarenes," in *Treasures of Ushaw College: Durham's Hidden Gem*, ed. James E. Kelly (Durham University: Scala, 2015), 151. See also Giovanna Capitelli, *Johann Martin Von Rohden and*

His Nazarene Circle: Watercolours, Preparatory Drawings and Figure Studies, trans. Sophie Henderson (Rome: Galleria Carlo Virgilio & C., 2016). A copy of Franz's beautiful *Virgin and Child*, awarded "La Croix de Chevalier de François Joseph" at the Universal Exposition in Vienna in 1873, is found in Notre Dame's east sanctuary window (Arrondeau, "Fabrique," 3:366). Franz von Rohden was one of the "pope's painters," a hand-selected group of artists commissioned by Pope Pius IX to create religious art for exportation around the globe. Pope Pius IX's exportation project existed from 1850–1870. He blessed many of the commissioned art pieces before he sent them off and, like the Carmelites, saw art as an effective ambassador for the faith. See Stefano Cracolici, "The Global Patronage of Pius IX," *L'Osservatore Romano* 52 (December 28, 2011), 12–13.

23. The price per square meter of stained glass by François Fialeix ranged from 180 to 400 francs (Bouchon and Brisac, "Vitrail," 244). The price per square meter of the Carmelite windows, as advertised by Fr. Lottin in his 1855 brochure, ranged from 130 to 300 francs. Double glass, a second, clear glass placed on the facing of the stained glass, added 20 francs more per square meter. Notre Dame's windows were double glass, which helped protect the windows from damage during the four thousand mile trip from Le Mans to Indiana. "Confirming price of Fr. 160 (discount of Fr. 40)," from a letter of E. Hucher to Rev. Fr. Sorin, Le Mans, April 24, 1876, Holy Cross Archives, Notre Dame, Indiana. In 1881, when Hucher wrote Fr. Sorin that he needed to increase the price of his windows because he had augmented the salaries of his workers, Fr. Sorin actually negotiated a decrease in price by 5 francs per square meter (Arrondeau, "Fabrique," 1:199–200).

24. Words taken from Lottin, *Vitraux*, found in Arrondeau, "Fabrique," 1:603.

25. Arrondeau, "Fabrique," 1:600.

26. Arrondeau, "Fabrique," 1:312n353. Master techniques, such as the "carmin" of the Küchelbeckers, are usually unknown to future glass artists because such techniques die with each master.

27. Arrondeau, "Fabrique," 1:305n334.

28. Arrondeau, "Fabrique," 1:119.

29. It is not known what became of these first Carmelite windows. They were probably stored in the old Main Building, which was completely destroyed, along with several campus buildings, in the great Notre Dame fire of April 1879.

30. Arrondeau, "Fabrique," 1:422.

31. Arrondeau, "Fabrique," 1:160.

32. The terms of the sale required that Edouard Rathouis take Frédéric Küchelbecker as partner, an arrangement the Carmelites felt acknowledged their great debt to the Küchelbecker family (Carl had died in 1869). When Rathouis refused this arrangement, the Carmelites in turn refused to allow him to use the Latin signature they had employed in their windows, that of Carmel Cenom (Latin for "the Carmel of LeMans"), and instead allowed only the French signature Carmel du Mans. Certainly the few first Carmelite windows bought by Notre Dame, those for the wooden church that had preceded the current brick basilica, carried the Carmel Cenom signature. It is interesting to note, as well,

that Eugène Hucher had hoped to purchase the glassworks, but the Carmelites declined to sell it to him because they had been unhappy with some of the decisions he had made in the past concerning the care of their workers, decisions that the Carmelites had immediately corrected. With the sale to Rathouis, Hucher withdrew from the glassworks. Several years later Rathouis hired Hucher to assist with the Carmel du Mans, giving him an arrangement similar to the one the Carmelites had originally desired for Frédéric Küchelbecker.

33. Probably the first to be installed were the *Saint Genevieve* and *Saint Valentina* windows, because the patterned red glass above their heads was mistakenly switched. There were no local workers skilled in stained glass, and so they learned as they worked. Arrondeau, "Fabrique," 1:466.

34. Arrondeau, "Fabrique," 1:396. The advertisement appeared in *Ave Maria* 22, August 14, 1886.

35. Arrondeau, "Fabrique," 1:438. The Carmel du Mans guaranteed their work for two hundred years.

36. Bernard E. Gruenke, Jr., "Notre Dame's Sacred Heart Chapel," in *Professional Stained Glass* 9, no. 10 (October 1989), 17.

37. Arrondeau, "Fabrique," 1:469n199.

38. Ferdinand's death in 1903 brought about the end of the Carmel du Mans Glassworks.

39. Arrondeau, "Fabrique," 1:377.

40. *Circular Letters of the Very Rev. Edward Sorin, Superior General of the Congregation of the Holy Cross and Founder of Notre Dame* (Notre Dame, Indiana, 1885), 143 (hereafter cited as Sorin, *Letters I*).

41. Gabriele Finaldi, *The Image of Christ* (London: National Gallery Company, 2000), 48.

42. A letter from Mother Eléonore to Fr. Sorin, dated November 4, 1858. Arrondeau, "Fabrique," 1:372. Mother Eléonore is speaking of a window made for Notre Dame's wooden church that preceded the current brick church.

43. University of Notre Dame Archives, Edward Sorin Collection, Letter of Edouard Rathouis to Eugène Hucher, Nantes, April 23, 1876.

44. Translation and French original of E. Sorin, CSC, to M. Hucher, 26 Sept [18]76, Notre Dame Miscellaneous University Records (UNDR) 3/04, University of Notre Dame Archives (herafter UNDA).

45. Arrondeau, "Fabrique," 1:422n116. Only a copy of one Notre Dame letter, dated September 26, 1876, and addressed to the Carmel du Mans, is in the Edward Sorin Collection at the University of Notre Dame Archives. What remains is only one side of the correspondence, consisting of letters sent from France to Notre Dame. These eighty-eight pieces of correspondence, conserved in Notre Dame and Holy Cross archives, span thirteen years, and provide only indirect information.

46. The Carmel du Mans also made windows for Saint Edward the Confessor Chapel in Saint Edward Hall at Notre Dame and for the Church of Our Lady of Loretto at Saint Mary's College. Some of the Saint Mary's College windows can now be seen in the chapel of Le Mans Hall at Saint Mary's College.

47. Sorin, *Letters I*, 144.

48. In the late 1860s the Archconfraternity of Our Lady of the Sacred Heart was established at Notre Dame and promoted in the Notre Dame weekly journal founded by Fr. Sorin, the *Ave Maria*. By 1879, Notre Dame had enrolled 120,000 names in the confraternity. The "liberality" of its members contributed significantly to the construction costs of the church. The request for prayers in 1877 was such that a "praying legion" had been organized in the novitiate at Notre Dame from 8 to 9 pm, "The Hour of Grace," before the statue of Our Lady of the Sacred Heart. See Joseph M. White, *Sacred Heart Parish at Notre Dame: A Heritage and History* (Notre Dame, IN: Sacred Heart Parish, 1992), 45; and "Prayer Association of Our Lady of the Sacred Heart," *Ave Maria* 8, September 21, 1872, 613. In 1992, the church was named a minor basilica by John Paul II. It is now called the Basilica of the Sacred Heart.

49. Sorin, *Letters I*, 164.

CHAPTER TWO. THE NARTHEX

1. As the French art historian Émile Mâle states, "In the thirteenth century the thought of the Last Judgment was a familiar one. . . . The sculptured scenes of the Last Judgment in the church porches moved the souls of men more profoundly than we can now imagine. They were not looked at with minds free from anxiety, for the faithful, passing through the doorway, believed that the scene above their heads might at any moment become a fact, and the trump of the angel sound in their ears." *The Gothic Image: Religious Art in France of the Thirteenth Century*, trans. Dora Nussey (New York: Harper & Row, 1958), 355–56.

2. Jesus revealing his wounds is usually portrayed in the Last Judgment. Émile Mâle writes of "that sublime gesture of the Saviour when on the Day of Judgment He shows His wounds to mankind"; Mâle, *Gothic Image*, 4. And later, "'He shows His Wounds to bear witness to the truth of the gospel and to prove that He was in truth crucified for us.' . . . Thus by this gesture Christ proclaims that He is Redeemer, Judge and living God" (369).

3. The Catechism of the Council of Trent (1545–63) affirmed, "every pious and holy action done by one belongs and is profitable to all, through charity which seeketh not her own"; pt. 1, chap. 10.

4. Sorin, *Letters I*, 225.

5. Sorin, *Letters I*, 226. The duration of the benefit was fifty years.

6. Sorin, *Letters I*, 248.

7. Sorin, *Letters I*, 248.

8. Sorin, *Letters I*, 243.

CHAPTER THREE. THE NAVE

1. *The Life of Saint Elizabeth, of Hungary, duchess of Thuringia by the Count de Montalembert*, 2nd American ed., trans. Mary Hackett (New York: Kenedy, [1886]), 337.

2. Translated in "La Femme Catholique," *Ave Maria* 1 (July 15, 1865): 152.

3. "La Femme Catholique," *Ave Maria* 1 (July 15, 1865): 152.

4. "La Femme Catholique," *Ave Maria* (July 15, 1865): 151.

5. "La Femme Catholique," *Ave Maria*, (July 15, 1865): 151. See, for instance, some other pieces in the *Ave Maria* concerned with the important role of women: "Learned Women and Studious Women," by Msg. F. Dupanloup, Bishop of Orleans, in 1868; "Woman, as Developed in the Church," in 1867; and "Catholic Industries for Catholic Women," by Eliza Allen Starr, in 1874.

6. The fascination with the role of women in the Church was a Catholic interest of the nineteenth century. Msg. Georges Darboy, the Archbishop of Paris who was executed in 1871 by the Paris Commune, wrote a book on women saints, *Les saintes femmes: Fragments d'une histoire de l'église; Avec portraits des femmes remarquables de l'histoire de l'église* (Paris: Granier Frères, [18—]). It can be found on the shelves of Notre Dame's Hesburgh Library, and still bears the nameplate of Fr. John Zahm, CSC (1851–1921).

7. Marvin R. O'Connell, *Edward Sorin* (Notre Dame, IN: University of Notre Dame Press, 2001), 627. Note Fr. Sorin's words, in Sorin, *Letters I*, 219: "Again, in our Colleges and Academies students are to be trained for higher circles in society, where they are naturally expected to exercise a greater influence, if properly fitted for the important posts or offices they will soon occupy. Most of them, indeed, will soon be active leaders in commerce or politics, according to their acquirements in sciences or the standing of their families."

8. *Circular Letters of the Very Rev. Edward Sorin: Superior General of the Congregation of the Holy Cross and Founder of Notre Dame, Volume II* (Notre Dame, IN, 1885), 82 (hereafter cited as Sorin, *Letters II*).

9. *Constitutions and Statutes of the Congregation of Holy Cross* (Rome: [The Congregation], 1988), 9.

10. Sorin, *Letters I*, 186.

11. Edward Sorin, CSC, *Chronicles of Notre Dame du Lac*, trans. John M. Toohey, CSC, and ed. James T. Connelly, CSC (Notre Dame, IN: University of Notre Dame Press, 1992), 133.

12. On Saint Patrick's Day in 1881, Fr. Alexis Granger notes in the *Book of Church Services* he kept for the Basilica: "V. R. F. Gen [Very Reverend Father General Edward Sorin] had suggested to suppress this celebration of a high mass [on St. Patrick's feast day, March 17] in order to solemnize St. Joseph's Feast [celebrated on March 19], according to our Rules, [St. Joseph] being one of the titular feasts of the Congregation. It is now 5 years since St. Joseph's Day is not kept here. St. Patrick's became only prominent since the accession of R. F. Patrick Dillon as President." Fr. A. Granger, CSC, *Book of Church Services 1869–1887*, p. 90, Sacred Heart Church (Notre Dame, IN) Records, CSHC, UNDA.

13. Sorin, *Letters I*, 216–17.

14. "Catholic Pilgrimage—A Beginning," *Ave Maria* 15 (October 11, 1879): 818.

15. Thomas J. Schlereth, *A Spire of Faith: The University of Notre Dame's Sacred Heart Church* (Notre Dame, IN: University of Notre Dame Alumni Association, 1991), 40.

16. Sorin, *Letters I*, 90.

17. *The Scholastic Year* 1:40 (May 25, 1868), 8, UNDA.

18. From Saint Clare's "A Letter to Blessed Agnes of Prague," in *Escritos de Santa Clara y documentos complementarios*, ed. Ignacio Omaechevarrie (Madrid: Biblioteca de Autores Cristianos, 1970), 339–41.

19. Granger, *Book of Church Services*, p. 123, CSHC 1/02, UNDA.

20. *Nicene and Post-Nicene Fathers*, 1st ser., vol. 11, ed. Philip Schaff (Peabody, MA: Hendrickson Publishers, 1994), 335.

21. "Saint Jerome—September 30," *Ave Maria* 1 (Sept. 30, 1865): 309.

22. *Scholastic* 4, no. 11 (February 11, 1871), 7–8, UNDA.

23. Granger, *Book of Church Services*, p. 93, CSHC 1/02, UNDA.

24. Sorin, *Letters I*, 157, 158.

25. Sorin, *Letters I*, 194–95.

26. "How a Depraved Woman Became a Saint," *Ave Maria* 4 (February 22, 1868): 117.

27. Jacobus de Voragine, *The Golden Legend: Readings on the Saints*, trans. William Granger Ryan (Princeton: Princeton University Press, 1993), 409–12.

28. The phrase used by Edouard Rathouis in his letter to Eugène Hucher in 1876, referring to the plan for Notre Dame's windows, as it was agreed upon with Fr. Sorin. University of Notre Dame Archives, Edward Sorin Collection, Letter of Edouard Rathouis to Eugène Hucher, Nantes, April 23, 1876.

29. Sorin, *Letters I*, 170.

30. This window is the work Julius Schnorr von Carolsfeld, and can be found in his *Die Bibel in Bildern*, published in 1860.

31. Sorin, *Letters I*, 167.

CHAPTER FOUR. THE TRANSEPT

1. In a *sacra conversazione* the figures interact "in a spontaneous manner, united by reciprocal spiritual understanding around a central presence"; Timothy Verdon, *Mary in Western Art* (New York: Hudson Press, 2005), 73.

2. Sorin, *Letters I*, 192, 193.

3. Sorin, *Letters I*, 194.

4. Sorin, *Letters II*, 85.

5. Sorin, *Letters I*, 165.

6. Sorin, *Letters II*, 72.

7. Sorin, *Letters II*, 60–63, 61, 72.

8. Sorin, *Letters I*, 271–72.

9. Sorin, *Letters I*, 198.

10. Sorin, *Letters I*, 271–72.

11. Sorin, *Letters I*, 271–72.

12. Sorin, *Letters I*, 271–72.

13. Sorin, *Letters I*, 271–72.

14. Sorin, *Letters I*, 271–72.

15. Sorin, *Letters I*, 260.

16. See Thomas Franklin O'Meara, OP, *The Basilica of the Sacred Heart at Notre Dame: A Theological Guide to the Paintings and Windows*, 3rd rev. ed. (Notre Dame, IN: Ave Maria Press, 1991), 29n17.

17. The image of the Good Shepherd was often "blended" with the image of the Sacred Heart. In Sacred Heart iconography "Christ looks directly at the viewer, underscoring the person-to-person nature of His love for and relationship with each soul. This theme is also a part of the Biblical parable of the Good Shepherd: He knows His sheep, and they know Him and heed His voice (John 10:14, 16)." "Eventually the Church officially approved the Good Shepherd as a way of understanding the Sacred Heart by making the former the theme of Year C in the three-year cycle of Scripture readings in the post-Vatican II Lectionary for the feast." Joseph F. Chorpenning, "Blending Christological Images: José Cayetano Padilla's The Sacred Heart of Jesus as the Good Shepherd," *Confluencia: Revista hispánica de cultura y literatura* 30, no. 3, spec. ed. (2015): 131, 129.

18. This medallion window is a copy of "I will seek that which was lost," a drawing by Eduard Von Steinle (1810–1886), a member of the Nazarene School. The drawing can be found in "The Good Shepherd and the Sacred Heart," *The Messenger of the Sacred Heart: A Magazine of the Literature of Catholic Devotion* 7, n.s. (1892): 409. See Steinle's drawing on p. v.

19. Sorin, *Letters I*, 186.

20. Letter of Sorin to Battista, September 27, 1881, found in O'Connell, *Edward Sorin*, 675–76.

21. Sorin, *Letters I*, 270.

22. Mullahy, *Spirituality of the Very Reverend Basil Anthony Moreau*, 53.

23. O'Connell, *Edward Sorin*, 356.

24. O'Connell, *Edward Sorin*, 356, quoting Fr. Sorin.

25. Primaticcio was an Italian artist invited by the French king Francis I to decorate his palace at Fontainebleau in 1532. His work included painting combined with stucco and sculpture. He also designed tapestries for the king. He remained in Fontainebleau for the rest of his life, and died in 1570 in Paris.

26. Arrondeau, "Fabrique," 1:455. The Carmel du Mans also made this window at La Ferté-Bernard (Sarthe) in 1877, without the halos.

27. Jacobus de Voragine, *Golden Legend*, 464.

28. Gary A. Anderson, "Mary in the Old Testament," *Pro Ecclesia* 16 (2008): 50.

CHAPTER FIVE. THE SANCTUARY

1. This devotion was taught in Sulpician spirituality, from which developed the Congregation of Holy Cross. Quoted from Edward Healy Thompson, *The Life of Jean-Jacques Olier* (London: Burns and Oates, 1886), 165, in Mullahy, *Spirituality of the Very Reverend Basil Anthony Moreau*, 14.

2. See, especially, "Icon of Family and Religious Life: The Historical Development of the Holy Family Devotion" and "The Earthly Trinity, Holy Kinship, and Nascent Church: An Introduction to the Iconography of the Holy

Family" in Joseph F. Chorpenning, OSFS, *The Holy Family as Prototype of the Civilization of Love: Images from the Viceregal Americas* (Philadelphia: Saint Joseph's University Press, 1996).

3. See "The Holy Family" in Mullahy, *Spirituality of the Very Reverend Basil Anthony Moreau*, 43–66.

4. Mullahy, *Spirituality of the Very Reverend Basil Anthony Moreau*, 47.

5. *The Virgin and Child* is a copy of the stained glass window "La Vierge à l'Enfant" ("The Virgin and Child"), which the Carmel du Mans exhibited at the Universal Exposition in Vienna in 1873. It was awarded "La Croix de Chevalier de François Joseph." The Carmel du Mans gave the original to St. Laurence College in Montreal, owned by the Congregation of Holy Cross. "La Vierge à L'Enfant" was drawn by Franz von Rohden (1817–1903) for the Carmel du Mans, and the faces of the Virgin and the Child are done in the mysterious carmin technique of the Küchelbeckers, giving them great clarity and definition.

6. This scene is also found in the first tympanum in the nave.

7. Sorin, *Letters I*, 170.

8. Sorin, *Letters I*, 263.

9. "Patron of the Catholic Church and of North America," *Ave Maria* 8 (September 7, 1872): 569.

CHAPTER SIX. THE RADIATING CHAPELS

1. Schlereth, *A Spire of Faith*, 19.

2. Joseph is portrayed in this chapel as both elderly and young. This is evidence that the windows in this chapel were drawn from previously commissioned cartoons.

3. Chorpenning, *Holy Family*, 17.

4. Sorin, *Letters II*, 69.

5. Sorin, *Letters II*, 69, and Sorin, *Letters I*, 170.

6. Sorin, *Letters II*, 69.

7. Sorin, *Letters I*, 115–16.

8. Sorin, *Letters I*, 116.

9. Sorin, *Letters I*, 143.

10. Eliza Allen Starr, *The Life and Letters of Eliza Allen Starr*, ed. Rev. James J. McGovern (Chicago: Printed at the Lakeside Press, [ca. 1904]), 229–30. Eliza Allen Starr (1824–1901) was an internationally known Catholic art critic and artist, author, lecturer and teacher, and a friend of Fr. Sorin. She was the third recipient of the Laetare Medal, and was the first woman to receive it. Miss Starr was often featured in the *Ave Maria*, and she was the founding chair of the art department at St. Mary's College.

11. "Father Moreau had a great devotion to the Way of the Cross. He used to make the Stations every day in the crypt of the Mother Church, and after he had been forced to leave Notre-Dame de Sainte-Croix, he continued the practice in the chapel of the Marianites." Mullahy, *Spirituality of the Very Reverend Basil Anthony Moreau*, 68.

12. Sorin, *Letters I*, 68.

13. Sorin, *Letters II*, 56.

14. Edward Sorin, *Via Crucis: The Way of the Cross*, 2nd ed. (Notre Dame, Ind.: [s.n.], 1888), BX 2040 .S6 Volume, Notre Dame Collection (NDC), UNDA.

15. Sorin, *Via Crucis*, 9.

16. Sorin, *Via Crucis*, 10–11.

17. Sorin, *Via Crucis*, "Introduction," iv.

18. Sorin, *Via Crucis*, 11–12.

19. Sorin, *Via Crucis*, 15–16.

20. Sorin, *Via Crucis*, 14–15.

21. Sorin, *Via Crucis*, 17–18. This window is taken from Julius Schnorr Von Carolsfeld's *Die Bibel in Bildern* published in 1860.

22. "During his [Fr. Moreau's] life there were frequent pilgrimages to the shrines of the Blessed Mother, particularly Chartres and Notre-Dame des Victoires in Paris. . . . At Notre-Dame des Victoires he enrolled his religious in the Archconfraternity of the Holy and Immaculate Heart of Mary." Mullahy, 53–54.

23. Eliza Allen Starr, *Pilgrims and Shrines*, vol. 1 (Chicago: printed by the author, 1885), 14.

24. Starr, *Pilgrims*, 15.

25. Fr. Sorin's closing words in a letter he wrote on board the *Ville de Brest*, dated December 15, 1875: "One more remark, and I close. Much as I have travelled in my life, no journey has left on my mind such consoling impressions. . . . It seems that I have commenced here to know and love our Blessed Mother. . . . My confidence in her was great before; now it is boundless. May her sweet name be forever on our lips and in our hearts! Once more I thank with my whole soul every one who has prayed for me; may the same mercy accompany me till I reach the port of eternity." Sorin, *Letters I*, 89–90.

Chapter Seven. The Apsidal Chapels

1. Quoted in Jacob Riyeff, OblSB, *The Reliquary Chapel of the Basilica of the Sacred Heart: Veneration of Saints and their Relics and A Brief History of the Reliquary Chapel* (Notre Dame, IN: The University of Notre Dame). Pamphlet is available in the Relic Chapel.

2. *The Martyrdom of Polycarp*, volume 1 of Ante-Nicene Christian Library, trans. Alexander Roberts and James Donaldson (Edinburgh: T. & T. Clarke, 1867), 93–94.

3. "Ad Riparium," *Patrologia Latina* 22, 907; the translation is from Wm. Henry Fremantle's 1893 translation of Ambrose's Epistle 109, to Riparius, available in the St. Pachomius Orthodox Library, voskrese.info/spl.

4. "St. Joseph's Day," *Scholastic* 2, no.33 (April 24, 1869), 261, UNDA.

5. "St. Joseph's Day," *Scholastic* 2, no. 33 (April 24, 1869), 261, UNDA.

6. Granger, *Book of Church Services*, p. 5, CSHC, 1/02, UNDA.

7. "Mr. Leo Dupont was with us in the coach from Mans to Havre. He had volunteered to accompany us to the sea and to arrange everything for our embarkation. We were intimate friends. He served us admirably for three days. Without him we might have found it impossible to take the sea." Sorin, *Chronicles*, 510.

8. Sorin, *Letters II*, 34.

9. The priest Lucian's first-person account of the discovery of Saint Stephen's relics, recorded by Avitus of Braga, can be found in *Patrologia Latina* 41, 805–18. A more recent edition is available in *Revue des Etudes Byzantines* 4 (1946): 178–217.

10. See, for example, Augustine's account of Stephen's relics in *City of God*, book 22.

11. This window is a close copy of a window in the Royal Chapel at Dreux, France, the work of the great French artist J. A. D. Ingres (1780–1867).

12. The first interpretation is given in Schlereth, *Spire*, 67. The second is found in O'Meara, *Basilica*, 33. Arrondeau agrees with O'Meara, see Arrondeau, "Fabrique," 2:27.

13. The complete and documented account of the relics of Eutropius can be found in Louis Audiat, *Saint Eutrope et son prieuré, documents inédits* (Saintes: Z. Mortreuil, 1877), https://play.google.com/books/reader?id=VNEGAAAAQA AJ&hl=en&pg=GBS.PA472.

14. Audiat, *Saint Eutrope*, ii.

15. See, for example, in Valentine Long, OFM, *The Angels in Religion and Art* (Paterson: St. Anthony Guild Press, 1970), 38: "His intelligence and will in perfect accord with God's give the angel his characteristic beauty. It is of an unimaginable charm. But nineteenth-century art, thinking to capture that charm as nearly as human effort possibly could, decided to womanize its angels. Every age follows its own trends, only to be ridiculed for them by the next. . . . The fact is that, to emphasize angelic beauty over angelic power, nineteenth-century art did make its typical angel into a model of womanly grace, clad in the long pleated gown then in fashion, showing off great coils of hair, a general delicacy of feature, and, to enhance all this, a set of neatly trimmed wings."

16. For instance, "Contributions for the Holy Father. Mrs. Hattie Townsend, Berrien Springs, Michigan . . . \$2.00. Joey McKue, New Albany, Ohio . . . \$0.10. John, Frank, Neal and Badjee Ewing, of Lancaster, Ohio, (4th contribution,) . . . \$1.10. Minnie Bosler, Steubenville, Ohio . . . \$1.00"; *Ave Maria* 7 (August 6, 1870): 500. In a letter sent by Fr. Sorin from Rome on January 5, 1870, he reports he has "paid the amount received to date by the *Ave Maria* for the assistance of the Holy Father, viz., 1065 francs"; *Ave Maria* 7 (February 12, 1870): 106.

17. Sorin, *Letters II*, 30.

18. This spatial "pause" behind Mary, an outdoor scene presented through an open window, illustrates the temporal lapse between the angel's invitation and Mary's response. "Spatial depth defined by linear perspective introduces us . . . into the mystery of a fecund virginity"; Verdon, *Mary*, 98–99.

19. Translation and French original of E. Sorin, C.S.C., to M. Hucher, 26 Sept [18]76, Notre Dame Miscellaneous University Records (UNDR) 3/04, UNDA. Devotion to the Sacred Heart was "particularly strong" in Le Mans (Mullahy, *Spirituality of the Very Reverend Basil Anthony Moreau*, 61).

20. Schlereth, *A Spire of Faith*, 35.

21. Fr. Jean-François Lottin, a friend of the Carmelites of Le Mans, explains the importance of the modest fish in a small book he wrote on the Carmel du Mans windows installed for the Sisters of Providence: M. L'Abbé Lottin, *Description iconographique des vitraux peints de l'église conventuelle des Soeurs de la Providence de Ruillé-sur-Loir (Sarthe) au Diocèse du Mans* (Le Mans: Monnoyer, Imprimeur-Libraire, 1858), 22–24.

22. Monseigneur Bougaud, Bishop of Laval, *Revelations of the Sacred Heart to Blessed Margaret Mary, and the history of her life*, trans. by a Visitandine of Baltimore (New York: Benziger, [1890]), 104–5.

23. The lithograph is printed in *Messager du Sacré-Coeur* 39, no. 2 (January 1881) and appears in Raymond Jonas, *France and the Cult of the Sacred Heart: An Epic Tale for Modern Times* (Berkeley: University of California Press, 2000), 199.

INDEX

Page numbers in italics indicate illustrations.

Teresa of Avila, Saint, 44, *46*, 48, *55*, 56, 201, *202*
Thomas, Saint, 190, *193*
Tobit and Raphael, 85, *88*, 89
Trinity, 59, 68, *93*, 94, *126*, 147, 190

union of prayer, 1, 11
Ursula, Saint, *22*, 23, 53
Ursulines (Company of Saint Ursula), 23, 48, 53

Valentina, Saint, *28*, 29
Ventura, Fr. Gioacchino, 20
Veronica, 151, *155*, 157
Visitation Order (Institute of the Visitation of the Blessed Virgin Mary), 50, 115, 194, 198, 201
Von Rohden, Franz, 7

Zechariah, 78, 180, *183*, 185

NANCY CAVADINI
(Marquette University, M.A. in Theology) has served in religious
formation for the Congregation of Holy Cross and as an
ecumenical and interfaith officer.

CECILIA DAVIS CUNNINGHAM
(Florida State University, M.A. in Art History) became a tour
guide at the Basilica of the Sacred Heart in 1999. Her years of
teaching have allowed her to introduce numerous visitors to the
art and history of the basilica.